Ultimate
Celebration
Over 200 card designs for special occasions throughout the year

Cards

EDITED BY Sarah Crosland

D&C
David and Charles
www.mycraftivity.com

A DAVID & CHARLES BOOK
Copyright © David & Charles Limited 2008

David & Charles is an F+W Media, Inc. Company
4700 East Galbraith Road, Cincinnati, OH 45236

First published in the UK and US in 2008

Text and photographs copyright © *Crafts Beautiful* 2008, *Quick & Crafty!*
2008 and *Let's Make Cards* 2008
Layout copyright © David & Charles Limited 2008

A catalogue record for this book is available from the British Library.

ISBN-13: 978-0-7153-3170-5 hardback
ISBN-10: 0-7153-3170-1 hardback

ISBN-13: 978-0-7153-3007-4 paperback
ISBN-10: 0-7153-3007-1 paperback

Printed in China by SNP Leefung
for David & Charles
Brunel House Newton Abbot Devon

Commissioning Editor: Jennifer Fox-Proverbs
Desk Editor: Emily Rae
Art Editor: Sarah Clark
Designer: Sabine Eulau
Photographers: Paul Barker and Ant Jones
Production Controller: Beverley Richardson

Visit our website at www.davidandcharles.co.uk

David & Charles books are available from all good bookshops;
alternatively you can contact our Orderline on 0870 9908222 or write to
us at FREEPOST EX2 110, D&C Direct, Newton Abbot, TQ12 4ZZ (no stamp
required UK only); US customers call 800-289-0963 and Canadian
customers call 800-840-5220.

The designers featured in this book:

Jill Alblas
Emma Beaman
Sarah Beaman
Sharon Bennett
Caroline Blanchard
Corinne Bradd
Susan Cobb
Sam Currie
Tracey Daykin-Jones
Lucinda Ganderton
Glennis Gilruth
Zoe Halstead
Brenda Harvey
Maria Mcpherson
Natalie McVean
Sharon de Meza
Elizabeth Moad
Julie Nyanyo
Paula Pascual
Kim Pearce
Françoise Read
Sarah Rushton
Annette Simpson
Naomi Sisson
Sally Southern
Lisa Steed Davey
Amanda Walker
Dorothy Walsh
Paula Whittaker
Kirsty Wiseman

Contents

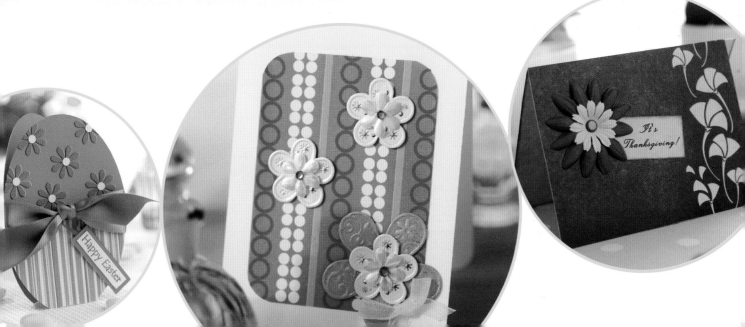

Introduction

Card-making is an undeniably pleasurable hobby – it's immensely satisfying and gives you a chance to indulge family and friends with handmade tokens that show just how much you care. But why wait for birthdays and special announcements to let someone know you are thinking of them? With the help of hundreds of card ideas you'll be inspired to put your own mark on stunning greetings that can be used to celebrate events throughout the year, from Hannukah to Halloween and from Chinese New Year to Christmas.

Whether you are a seasoned card-maker or a complete beginner, a flick through the pages is bound to get your brain buzzing with ideas and your fingers tingling to get to work! But that's not all, as many of the cards also embrace a veritable pot-pourri of favourite papercraft techniques. So now's your chance to be dazzled by the glossy allure of embossing, amazed by how easy yet effective tearing and pricking can be, and to delight in the sheer joy of punching, stamping and quilling. Many of the projects are inspired by paper and

card as well as the occasion, and with such an array on the market it's easy to see why. Paper manufacturers are continually updating ranges that give your creativity fresh impetus and papers are available in such a choice of colours, patterns and textures that they cry out to be transformed into unique and special greetings – and this book shows you how!

If this is your first foray into card-making, all the information needed to get you started is here, including detailed step-by-step instructions and handy tips. Techniques and timing are listed with every card, and each one comes with a note of any supplies you might need above and beyond your basic tool kit.

Divided into bright and beautiful seasonal sections, you will find greetings created by talented designers and also a gallery at the end of each part packed with even more ideas. Pick and mix the projects to suit your time, budget, and the occasion you are designing for and stamp each card with your own individual style!

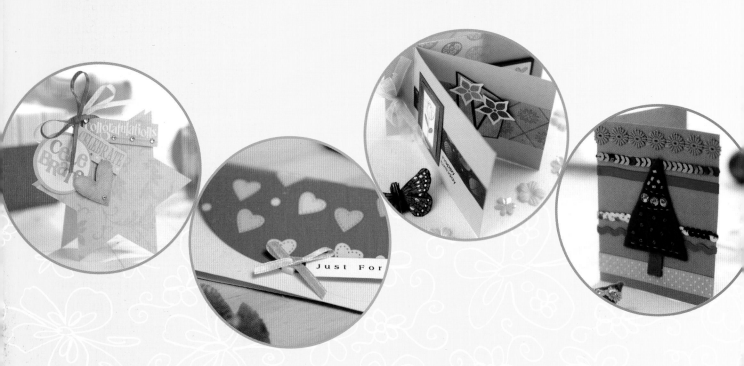

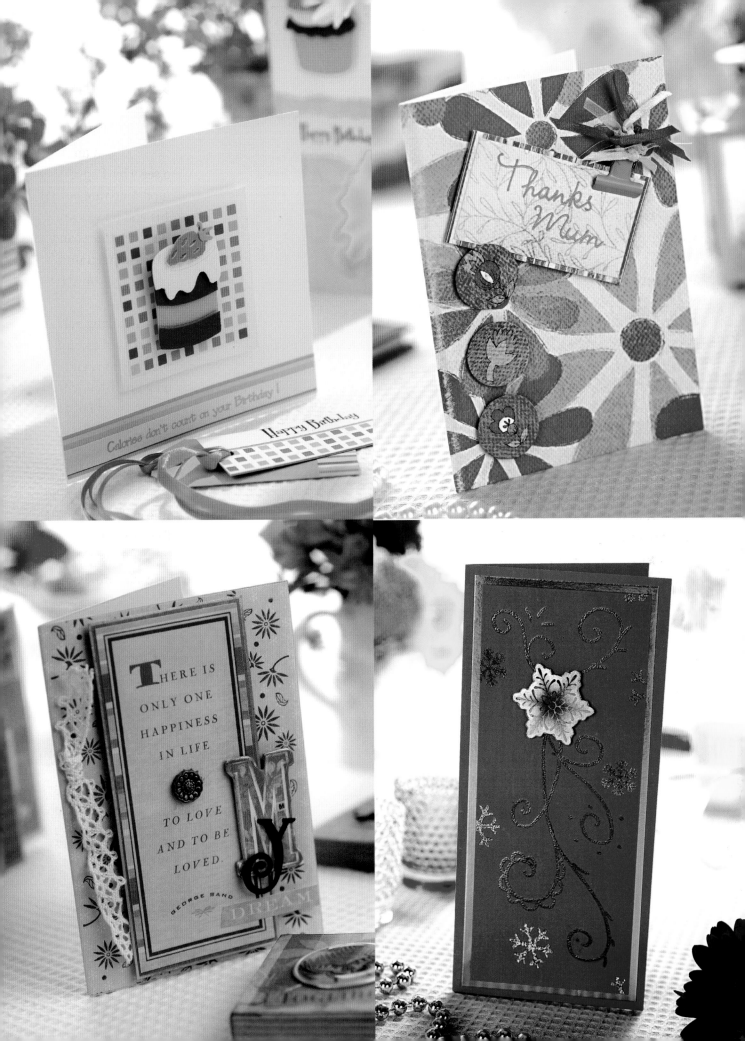

Calories don't count on your Birthday !

Happy Birthday

Thanks Mum

THERE IS
ONLY ONE
HAPPINESS
IN LIFE
TO LOVE
AND TO BE
LOVED.

GEORGE SAND

M
Y

DREAM

Basic Tool Kit

It is useful to gather together a basic tool kit before you begin to make your cards, as you will need this equipment again and again. Listed below are the basic items that are necessary for making cards – you might find that you already have some of these at home. You will also need a few additional items for each project, as well as the appropriate paper and card (see pages 8–9), and these are listed with the project instructions.

Pencil, eraser and sharpener: a simple lead pencil with a sharp point is essential for marking your card accurately. Always use a good, soft plastic rubber that does not smudge.

Scissors: you will need a large pair for trimming and a small pair for more intricate work.

Cutting tools: always use a craft knife with a metal ruler – the knife can cut nicks in a plastic one, making it unusable. Replace the blades regularly, as a blunt blade will not leave a clean cut. Ideally, use a self-healing cutting mat, as they are smooth, flat and are easier to cut on than other surfaces. It will also protect your work surface.

Get Stuck in!

Different types of glue and adhesive are neded in cardmaking for different purposes, so it is important to keep a range in your kit to achieve the best results.

PVA glue: safe, inexpensive, all-purpose glue, which becomes transparent when dry.

Glue stick: tubes of solid glue that can be rubbed over areas to leave a sticky residue; good for applying an even coat of adhesive.

Clear adhesive dots: these are perfect for sticking fiddly shapes to card. Place your item over the glue dots and firm down, so that the glue dots stick to them.

Adhesive foam pads: these are great for achieving a raised effect. They are adhesive on both sides – simply remove the backing paper and stick to the card or item.

Double-sided tape: this is quick and clean to use and is invaluable for adding layers to a design.

More Useful Tools...

Tweezers: these can be helpful for picking up small items.

Bone folder: this is useful for neatly creasing and folding card, scoring paper and smoothing creases.

Tracing paper: use this for tracing the patterns and templates used in this book (see pages 180–181). Inexpensive copier paper can also be used.

Colour and Embellishments

There is a huge range of decorative materials to choose from to add colour, textural and dimensional interest to your cards. Using a wide range of colour will really brighten up your cards and pretty embellishments always add that extra-special touch.

Brads: these come in many different designs, including circles, squares, hearts and flowers. To attach, simply cut a slit in the card, push the brad through, turn the card over and open out the legs.

Eyelets: use an eyelet punch, setter tool and hammer to attach eyelets. Working on a cutting mat, use the punch to create a hole in the card for the eyelet. Next, place the eyelet upside down and the card wrong side up and line up the hole with the eyelet. Use the setter tool to set the eyelet in your card.

Colouring mediums: pencils, chalks, paints, brush markers and felt pens are the main colouring mediums used in cardmaking. Each of these mediums can be used to create different effects. Experiment to find the ones you feel most comfortable using.

Rubber stamps and ink-pads: there are thousands of stamp designs available and many different ways to use them to create quick motifs that you can colour and embellish any way you please.

tip

Make sure your work surface is firm and steady when punching as some punches are quite stiff. You may need to stand up to apply more pressure to the punch.

Peel-off stickers: these are so simple to use and come in a multitude of colours and designs. Simply peel an image off the sheet and stick it on to your card.

Punches: these come in many different sizes to impress motifs into paper and lightweight card. They produce a shaped hole and a punched-out shape, either of which can be used in your projects.

Other Ideas

Glitter: this comes loose or pre-mixed with glue and is available in opaque and transparent colours. The finer the glitter, the better the transparency and coverage.

Embossing powders: to emboss, use a rubber stamp to stamp an image, apply the embossing powder, and then heat the powder using a heat tool. This creates a raised outline or surface on stamped images.

Ribbons: these can really add the finishing touch to your cards. There are so many different styles and sizes to choose from – plain, sheer, patterned, thin and wide.

Paper and Card

Paper and card are vital ingredients in cardmaking, and there is a wide variety to choose from, including plain, pearlescent, mirror, patterned, vellum, and many more. Go for the best quality you can find. Paper is sold in A4 (US letter) sheets, in scrapbooking sizes – 30.5 x 30.5cm (12 x 12in) or 20.3 x 30.3cm (8 x 8in) pieces – or in pads of various sizes.

Look out for different finishes and patterns, some examples of which are shown below. Patterned papers are very popular and come in every design you can think of, suitable for many uses and occasions. A touch of shimmer can make a card special and an ornate card only needs a simple design to make it sensational. Using different textures will also add interest and another dimension to your cards. Such an abundance of choice exists in terms of colour, feel, finish, weight and size that no two cards need ever look the same!

Mulberry Paper

Patterned Paper Vellum

Patterned Paper Vellum

Other Ideas

Gift wrap: why not try using gift wrap, which is quite sturdy and comes in a wide range of patterns? Use the pattern as a decorative background or cut out individual motifs and use them as embellishments.

Mulberry paper: there are lots of fibres in this lovely handmade paper. Use a paintbrush to mark where you want to tear the paper, then tease the dampened fibres apart to create a delicate wispy edge.

Metallic foil: on these striking papers, the pattern has been applied with foil that resembles shiny metal. Pearlescent and shiny papers can be difficult to work with but give great results.

Handmade paper: these come in fabulous colours, but it is their different textures and surfaces that set them apart from machine-made papers. They often have natural elements, such as grasses, petals or leaves embedded in them, which makes them thicker than everyday paper.

Vellum paper: a translucent paper with a smooth finish, available in a variety of colours, patterns and finishes, including embossed varieties.

Handmade Paper

Metallic Foil

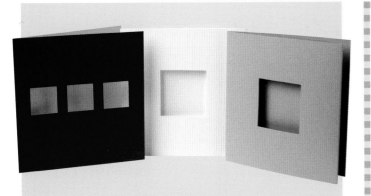

Card Blanks

If you don't want to buy card and score it and fold it yourself, blank cards are available in many different colours, shapes and sizes and in different finishes: from plain to pearlized, patterned to textured. They are more expensive than buying card and scoring and folding it yourself, but you may decide they are worth the money for the crisp, clean look they produce. Card blanks with ready-made apertures (see above) are also available, which have small shapes cut out of them in all sorts of sizes, including circles, squares, ovals and rectangles. These apertures are ideal for displaying small embellishments.

Storage

A good storage system is essential for finding the paper and card you need, when you need it. Follow these tips to keep your paper and card easily accessible and in perfect condition.

Patterned paper: store this in a folder (below) divided up into colour sections.

Scored and folded card: organize your cardstock first by size, then by shape, colour, texture, aperture and so on.

A4 (US letter) card: keep a store of various colours easily available for scoring and folding your own cards.

To give your cards the all-important professional finish why not embellish the envelope to match the card inside? This will create a wonderful first impression!

Envelopes

There is a wide range of envelopes available to buy, in all sorts of colours and sizes. However, these are very easy to make yourself. Just look at an envelope and see how simply the shape is constructed. Always make sure the top flap is deep enough to allow you to seal the envelope without the glue touching the card inside.

Basic Techniques

As well as buying pre-cut card blanks, you will also need to make your own from a special piece of card. Uneven cutting can really stand out, and if you notice that something is not quite straight, then the recipient will too. Here are some simple papercrafting techniques that will ensure you produce professional-looking cards in next to no time. Follow these instructions for cutting, scoring and folding card, making card inserts for adding a special message inside, and using templates.

Scoring and folding: scoring paper allows it to be folded neatly and easily, giving a crisp, professional looking finish.

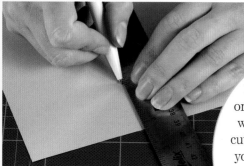

1 Make two pencil marks where you want the score line on the wrong side of the card or paper and line up the ruler with these marks. Draw an empty ball-point pen (or scoring tool) all the way along the line so the paper is indented. The scored line will become the inside of the fold.

2 Use both hands to fold the paper or card along the fold line. To make the fold line sharp, use either a bone folder on its side or the back of a clean metal spoon to press along the line.

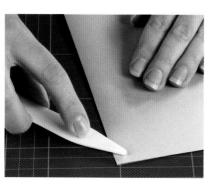

Cutting: make the cleanest cuts with a flat, clean surface, a sharp craft knife and metal ruler, and a steady hand.

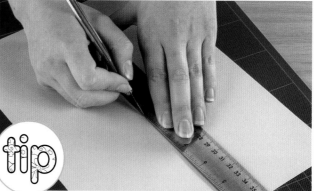

tip

For larger sheets of paper or card, mark the cutting line with three pencil marks and cut about 20cm (8in). Keeping your knife in the paper, move your hand down the ruler, press firmly and continue cutting. Repeat several times using a long ruler.

1 Using an HB pencil and metal ruler, make two or three pencil marks on the card where you want the cutting line. With the card on a cutting mat, place the metal ruler along the line to be cut. It is best to stand when cutting with a craft knife. Press down on the ruler to hold it in place, while you draw the knife towards you in a single motion. Cut with the section you wish to use under the ruler, to ensure the knife will cut into the waste part if it slips.

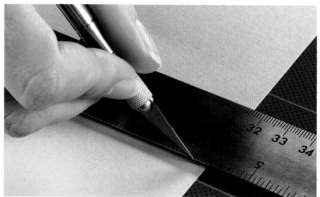

2 Keep the blade of the craft knife at a 45-degree angle when cutting. Make sure you don't press too hard as you draw the knife across the paper, or it will wrinkle and leave an uneven edge. If you are cutting thick card or paper, draw the blade across once without too much pressure, then cut again with more pressure to make the final cut.

Adding inserts: adding an insert is a great way of adding a final, professional touch to your cards. They don't always have to be white or cream. You could try using papers in pastel shades or bright colours, patterned papers and pretty vellums. Inserts are also a simple way of including an additional decorative element to your cards.

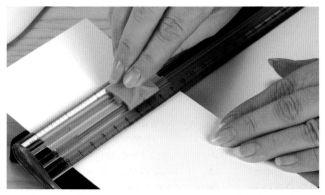

1 You can either use a paper trimmer or a craft knife, cutting mat and ruler (as explained on the previous page), to cut your insert. First, measure the width of your folded card and subtract 5mm (³⁄₁₆in) from it (W). Next, measure the height of the card and subtract 1cm (⅛in) from it (H). Fold the insert paper in half and crease well. Measure out from the fold and trim to W then measure up the fold and trim to H.

2 Apply 3mm (⅛in) wide double-sided tape or a thin line of glue to the back of the folded insert along, but not over, the fold. Open the card and, keeping the distance between the top and bottom edges of the card equal, butt the insert up to the card fold. Press in place.

Using Templates: you will find templates for some of the shapes used in this book on pages 180–181; just enlarge them on a photocopier set at 200% before you transfer them. Using templates to copy an image that you might otherwise find difficult to scale up and draw is easy – just follow the simple instructions below.

1 Use an HB pencil and tracing paper to trace the chosen image from the template, or photocopy the image on to paper. Cut around the image using scissors.

2 Place the paper template on scrap card. Hold the paper in place and draw around the paper template using a pencil.

3 Cut out the image from the cardboard to form the template. Discard the paper template, as this will not be sturdy enough. You can label and store your cardboard templates in plastic sleeves in a ringbinder for future use.

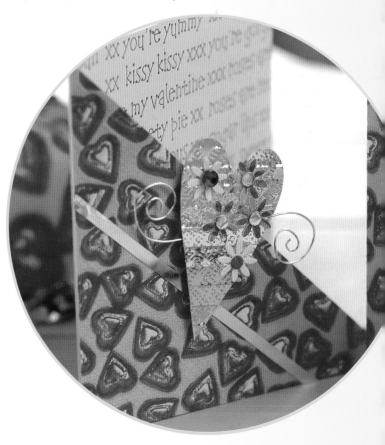

Spring Joy

congratulations
CELEBRATE
cele Brate

HAPPY EASTER

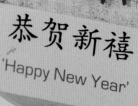

恭贺新禧
'Happy New Year'

Calories don't count on your Birthday !

Happy Birthday

Fire Starter

In China, the dragon is a symbol of good luck, and magnificent parades are held to welcome the New Year. This stunning greeting perfectly evokes the spirit and excitement of the occasion and the marabou feathers add texture and movement.

techniques
punching, stamping

time
45 minutes

designer
Brenda Harvey

materials

Pigment ink, gold embossing powder

Card: white, gold mirror, red

Paper: double-sided red/ green/yellow; white, black, orange

Tools: circle and butterfly punches, Chinese Happiness stamp, heat gun, deckle-edged scissors

Decorations: orange satin ribbon, marabou feathers

tip

If you can't find double-sided coloured paper for the dragon's tail, ordinary paper will work as well for this design – just be sure to use two strongly contrasting shades

1 Fold a white horizontal card blank and layer with gold mirror, then red card. To make the dragon's face, punch out three 2.5cm (1in) yellow circles and arrange as shown. For the eyes, cut out three pairs of tear-drop shapes in white, orange and green, each slightly larger than the last. Position between the yellow circles with 3-D foam pads.

2 Punch out four black 0.5cm (¼in) circles and glue in place for the eyes and nostrils. Add a crescent shaped piece of red for the mouth, then stick on a short length of orange satin ribbon for the tongue, and tiny triangles of white for the fangs.

3 Punch out two black butterflies and glue behind the lower yellow circle so that only one half can be seen protruding on each side. Stick one red and two yellow marabou feathers directly on to the red backing panel and stick the dragon's face on top with 3-D foam pads. Stick on another orange feather where the end of the tail will sit.

4 Cut 2cm (¾in) wide strips of double-sided coloured paper – you will need a total length of 75cm (30in) in each of two colourways. Glue the end of one strip to the other and fold alternately backwards and forwards, creasing neatly every 2cm (¾in), as if plaiting, to form the concertina-like shape of the dragon's tail. Stick each end down on the red background.

5 Stamp the happiness image with pigment ink on to white card, sprinkle with gold embossing powder and heat until melted. Trim with deckle-edged scissors, mount on to gold mirror card and attach to your greeting.

technique
concertina-folding
time
30 minutes
designer
Amanda Walker

materials
Card: white
Paper: textured, flower patterned
Tools: computer, scanner and printer
Decorations: red embroidery thread, metal pendant, red flower

Fan Out

A far eastern-inspired fan and metal pendant are the perfect way to bring in the Chinese New Year.

1 Make a white blank, 15.5 x 10.5cm (6 x 4in), then stick textured paper to the top two-thirds using spray adhesive. Cut out a semicircle from a flowered sheet, diameter 12.5cm (5in).

2 Measure and mark at 1cm (³⁄₈in) intervals around the outside of the semi-circle. Mark the centre of the straight line then score lines from this point to the outer marks.

3 Draw another semicircle inside the first, diameter 4.5cm (1¾in), and cut this section away. Fold along each of the scored lines, first one way, then the other, creating a concertina effect.

4 Turn the fan to the right side – if the two end folds are pointing upwards cut these segments away. Trim six short lengths of red embroidery thread then stick them to the back base of the fan.

5 String on the metal pendent and curl one length of thread up to the back of the fan. Stick in place to stop the pendant from un-threading. Stick the fan to the textured panel at an angle, using foam pads, then glue the flower alongside it.

6 Scan relevant Chinese characters into a computer and type the words 'Happy New Year' underneath, changing the type to red. Print out, then cut a rectangle, 10.5 x 4.5cm (4 x 1¾in), around the wording to fit the base of the card and stick in place.

tip

To cut out the semicircle in step 1, use a compass to create an arc

Bowled Over

The authentic-looking chopsticks in this bowl are actually cocktail sticks in disguise! Why not welcome in the Chinese New Year with this easy-to-make greeting?

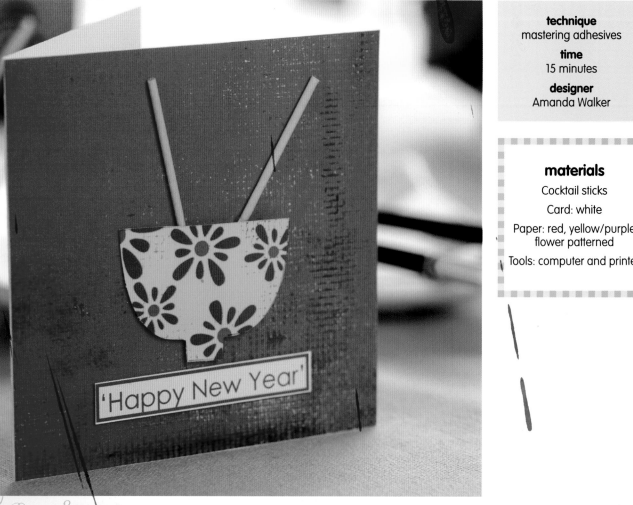

technique
mastering adhesives

time
15 minutes

designer
Amanda Walker

materials

Cocktail sticks

Card: white

Paper: red, yellow/purple flower patterned

Tools: computer and printer

tip

When spraying adhesive use a cardboard box as a 'spray booth' to stop the glue from dispersing over other areas

1 Make a white card blank 10cm (4in) square then stick red backing paper to the front with spray adhesive.

2 Use a craft knife to cut out a simple bowl shape from flower patterned paper.

3 Cut off the ends of two cocktail sticks then position them behind, and to the top of, the bowl at slight angles. Secure with narrow double-sided tape.

4 Stick the bowl to the front of the card with 3-D foam pads. On a computer, type out the words 'Happy New Year' in red.

5 Place a red border around the sentiment and print out. Cut out the greeting and stick it centrally to the base of the card with foam pads.

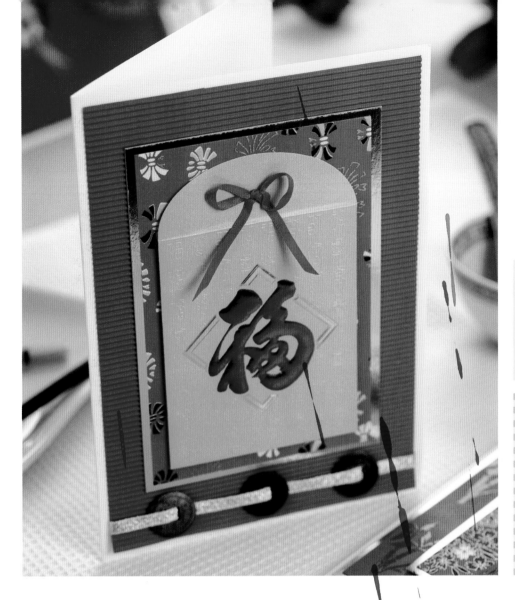

technique
mounting
time
30 minutes
designer
Brenda Harvey

materials

Card: white, gold mirror, red corrugated

Paper: oriental patterned

Decorations: gold money pocket, red bow, gold metallic ribbon, Chinese coins

Pocket Money

Celebrate the Chinese New Year in style by giving a loved one a cash gift, made all the more alluring by its intriguing presentation.

1 Fold white A4 card in half to form a blank. Cut gold mirror card, 15.5 x 11cm (6 x 4¼in), and mount with a slightly smaller panel of oriental patterned paper.

2 Attach 3-D foam pads to the reverse of the gold money pocket, leaving the area where the flap tucks in free. Stick in place and add a tiny satin bow to decorate.

3 Thread gold metallic ribbon through three Chinese coins and attach to the bottom of red corrugated card, slightly smaller than the card front, with double-sided tape. Wrap the ends around the edges and secure on the reverse with tape.

4 Stick the red corrugated card to the front of the white blank using double-sided tape. Attach the gold mirror panel with double-sided tape, leaving the top flap of the envelope open to insert any money.

If, during mounting, glue smudges on mirror card, quickly remove it with moist wipes before it has time to dry

Some Like it Hot

Fire up the passions with a simply-styled card that combines sizzling colours and tactile decorations to achieve an eye-catching effect.

techniques
cutting, folding

time
20 minutes

designer
Tracey Daykin-Jones

materials

Card: pink, deep red

Paper: decorative, 'romance'

Decorations: clear crystals, ribbons

1 Trim and score a bright pink A6 card blank. From a sheet of decorative paper, trim the word 'romance' and mount on to bright pink card. Attach three ribbons to the back of the mounted word and assemble on to deep red card to leave a narrow border. Position as shown, slightly above the centre.

2 To complete the card, fix clear crystals around the letter 'o' and trim the ribbons to form a diagonal line at the bottom.

tip

By keeping these cards free of messages you can use them for many romantic occasions – engagements, anniversaries or just to say 'I love you'

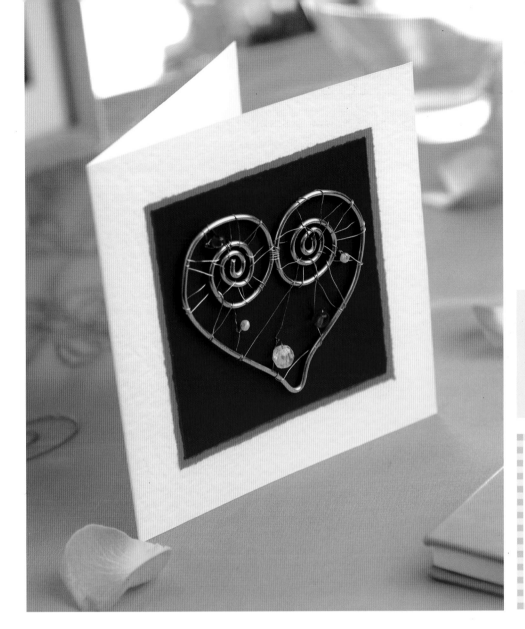

techniques
tearing, wire-shaping
time
20 minutes
designer
Emma Beaman

materials

Thick and thin wire

Card: white hammer finish

Paper: maroon, red

Tools: jewellery pliers, pin

Decorations: red and clear beads

From the Heart

Employ a basic jewellery making technique to create a dimensional card with a delightfully decorative motif – you'll find it satisfying as well as a visual treat.

1 Fold a white hammer finish card into a 13cm (5⅛in) square blank. Tear a 9cm (3½in) square of maroon paper, and a 9.5cm (3½in) square of red. Apply spray adhesive and fix them together. Cut 30cm (12in) of thick silver wire, then bend in the middle to form the heart's tip. Using jewellery pliers, coil both ends into a spiral on the inside of the heart shape.

2 Cut a long length of thin wire and, starting at the point where the spirals meet, wrap it around several times to secure the heart. Continue winding the wire around the right-hand coil, down the right-hand side over the main body of the heart, and up around the left-hand coil. Don't forget to thread on beads as you go.

3 Make the bead patterns random, twisting the wires to keep them firm. Once the heart is complete, position it on to the maroon square and make pin pricks through the paper in several points. Attach the heart to the background with wire. Stick the square centrally on the front of the card.

Once you have mastered the wire shaping techniques, the hearts look very effective tied around candles or napkin rings

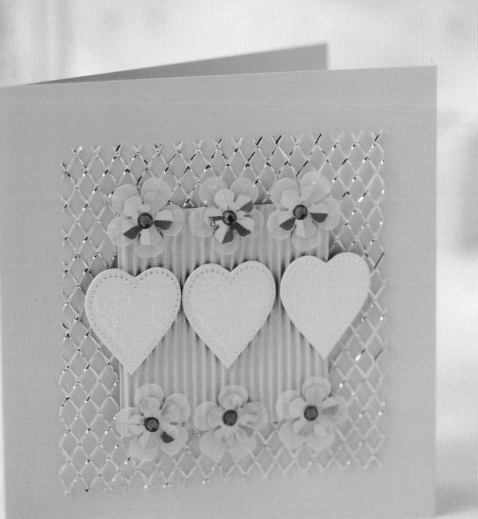

technique
layering

time
10 minutes

designer
Jill Alblas

materials

Card: plain and corrugated pink

Decorations: silver mesh, heart embellishments, pink and sequin flowers, pink crystals

Flower Power

These simple heart embellishments are the perfect focal point for a loving greeting.

1 Trim a pink blank, 11.5cm (4½in) square then, with double-sided tape, attach a small square of silver mesh in the centre. Stick pink corrugated card in the middle and fix a row of three heart embellishments on top.

2 To decorate, layer and stick three large white sequin flowers, three small pink blooms and pink crystals, across the top and bottom of the corrugated panel.

tip When making cards with lots of different elements, lay out the design on a sheet of paper beforehand to see how it will look

Loving Feeling

If you'd prefer to stay away from the usual reds and pinks, these pretty pastel greetings in subtle lilacs and greens are the perfect alternative.

techniques
tracing, stamping

time
40 minutes

designer
Sharon Bennett

materials

Paints: 3-D parma, silver argent, light silver

Card: lilac, white

Paper: white

Tools: water-colour pens in silver, purple and green

Decorations: iridescent heart sequins, silver peel-off sentiment

Template: heart

1 To make the 'Just for You' card, trace the heart template from the pattern pages on to white paper and go over it in silver pen. Cut out in a square around the image and attach centrally on to a lilac blank, 9 x 11cm (3½ x 4¼in).

2 Using a pale green water-colour pen, colour in between the curls around the heart motif, then shade the centre of the design in purple. Stick two iridescent heart sequins to the bottom corners on either side of the panel.

3 Use 3-D paint in parma to add a large dot in each corner of the card, with three smaller spots on either side. In silver argent, add four dashed lines on each side. Fix a silver peel-off sentiment centrally to finish.

4 To make the lilac card, transfer the heart template, without enlarging it, all over the front of a lilac blank, 10cm (4in) square. Go over it in silver, then transfer a larger single silver version to white card and cut out.

5 Attach the heart panel towards the right-hand side of the greeting with 3-D foam pads. Apply dots of light silver 3-D paint around the outer line of the main heart.

tip
Use foam pads and sticky fixers to give these designs a real 3-D feel

Be Mine

Create computer generated wonders embellished with a hint of silver for a fresh and modern greeting.

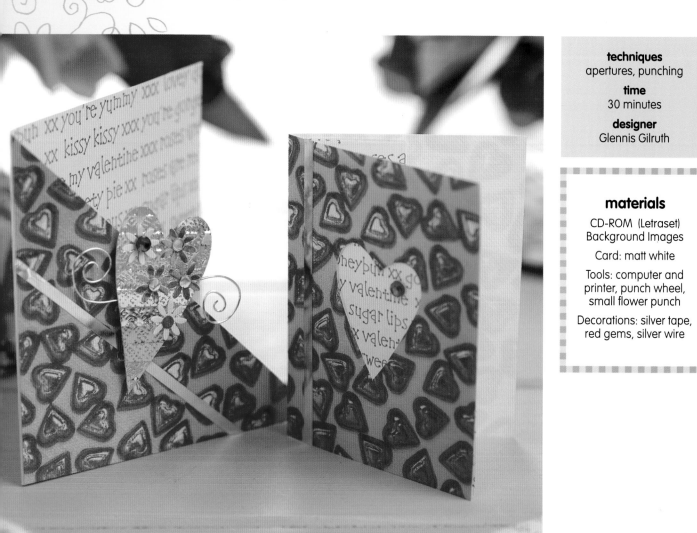

techniques
apertures, punching

time
30 minutes

designer
Glennis Gilruth

materials

CD-ROM (Letraset) Background Images

Card: matt white

Tools: computer and printer, punch wheel, small flower punch

Decorations: silver tape, red gems, silver wire

tip Don't waste time typing the same words out over and over to make the backing sheet, instead type a few chosen phrases, then copy and paste to fill the page

1 Print a red hearts sheet from the CD on to matt white card. Create a panel of romantic text paper, by choosing a decorative font and typing your words and phrases in bold, interspersed with kisses. Print in red on to matt white card.

2 To make the mini greeting, fold red heart card, 12 x 8cm, (4¾ x 3¼in) in half. Cut a heart-shaped aperture in the front and place a strip of silver tape along the creased edge. Fix a fold of text inside the card, so that it is visible through the heart window, then add a red gem.

3 Create the diagonal greeting by first making a 9cm (3½in) square fold of romantic text with the words on the inside. Add a triangle of red hearts to the front and cut it diagonally. Fix a strip of silver tape, as shown. Place several adjacent strips on to scrap card and distress it with a punch wheel.

4 Snip a heart shape then decorate it with punched flowers and a red gem. Attach a scroll of silver wire to the reverse of the heart motif using a foam adhesive pad, then fix the shape to the card.

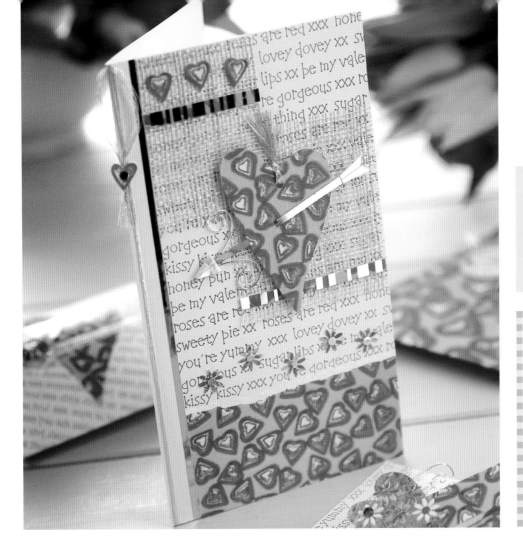

techniques
tearing, punching

time
30 minutes

designer
Glennis Gilruth

materials

CD-ROM (Letraset)
Background Images

Card: white, matt white

Tools: computer and printer,
small flower punch

Decorations: pink mesh,
heart embellisments, silver
circles and silver tape,
thread and wire

All Hearts!

With a PC and printer, you can create beautiful decorative papers
'hot off the press', to clip and snip into seriously gorgeous greetings.

1 Print a red hearts sheet from the CD. Create a panel of romantic text paper, by choosing a decorative font and typing your words and phrases in bold, interspersed with kisses. Print in red on to matt white card.

2 Cut a panel of the text, 9 x 18cm (3½ x 7in), and cover the lower part with a torn strip of red hearts paper. Attach two panels of pink mesh, one 6.5 x 4.5cm (2¼ x 1¾in) and another slightly larger, as shown, with adhesive tape.

3 Fix small hearts and punched flowers in place, adding small silver circles to the centres of the blooms. Make a stripes patterned sheet by laying sections of silver tape on to red heart paper. Cut two narrow strips and attach to the greeting, as shown.

4 Cut a large heart. Make a hole and slit, as shown, then tie silver threads through the piercing. To form the shaft of the arrow, stick 6cm (2¼in) of silver tape on to card and cut out. Thread through the slit,

then use foam pads to attach the heart to the card. Make a curl of silver craft wire and sew in position.

5 Cover a scrap of card with silver tape, trim the 'point' and 'flight' of the arrow, then glue in place using PVA. Attach the decorative panel to a fold of white card, 18 x 10cm (7 x 4in), aligning it with the opening edge. Add a stripe of silver down the left-hand side. Knot matching threads along the fold and decorate with a heart motif.

For ultra-smooth styling, print the designs from your computer on to glossy photo paper; it is more expensive but the effort is worth it

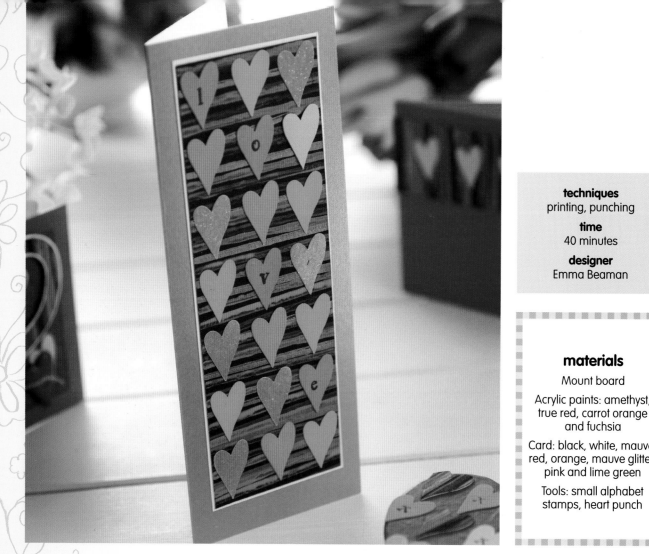

techniques
printing, punching
time
40 minutes
designer
Emma Beaman

materials

Mount board

Acrylic paints: amethyst, true red, carrot orange and fuchsia

Card: black, white, mauve, red, orange, mauve glitter, pink and lime green

Tools: small alphabet stamps, heart punch

Heart to Heart

Show someone just how much you care with this heart-filled greeting, on which a contemporary painted effect cleverly enhances the funky motifs.

tip

If you aren't confident about spacing them, punch the hearts on to scrap card first, you'll soon get a feel for it

1 To make the striped background, first cut black A4 card in half lengthways. Place one section on a scrap of mount board to protect your work surface. Cut out four small strips of board, the width of the black card, one for each colour of paint.

2 On to an old plate, squirt lines of each acrylic paint; amethyst, true red, carrot orange and fuchsia. Dip the edge of a piece of board in the amethyst, and print across the black card, being careful not to smudge.

3 Print at intervals all the way down, reloading the colour as required. Repeat with red, then orange and fuchsia. Let some lines overlap and slightly angle others. Put aside to dry and continue with the other half of black card.

4 To assemble the greeting, cut out the painted background, 18 x 6cm (7 x 2¼in), and matt this on to white card, leaving a thin border all around. Attach the painted panel to the front of a mauve portrait blank, 20.5 x 8cm (8 x 3¼in).

5 Punch out 21 hearts from coloured card, four red and the rest a selection of orange, mauve glitter, pink and lime green. Stick the hearts on the painted panel, as shown, then stamp letters to spell the word 'love' on the red hearts.

Candy Stripes

Soften stripes with a swirling, romantic motif, and opt for bold colours, to create a really romantic gesture that cannot fail to please.

techniques
printing, punching

time
30 minutes

designer
Emma Beaman

materials

Mount board

Acrylic paints: amethyst, true red, carrot orange and fuchsia

Card: black, red duplex, purple metallic, white, lime green

Tools: heart punch

Decorations: Red heart button, orange thread

Template: Curly heart

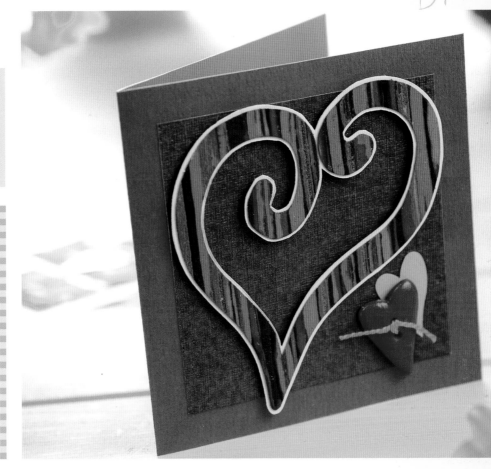

1. To make the striped interior of the heart, cut black A4 card in half lengthways. Place one section on a scrap of mount board to protect your work surface. Next, cut out four small strips of board (the width of the black card), one for each of the four colours of paint.

2. On to an old plate, squirt lines of each acrylic paint; amethyst, true red, carrot orange and fuchsia. Dip the edge of a piece of board in the amethyst, and print across the black card, being careful not to smudge.

3. Print at intervals all the way down, reloading the colour as required. Repeat with red, then orange and fuchsia. Let some lines overlap and slightly angle others. Put aside to dry and continue with the other half of black card.

4. To make the greeting, cut a blank, 10cm (4in) square, from red duplex card and matt a purple metallic 8cm (3¼in) square centrally, using spray glue.

5. Take the painted background and trace on the curly heart from the pattern pages. Cut out, mount on to white card and trim, leaving a thin border inside and out.

6. Attach the heart, at an angle, to the front of the blank using 3-D foam pads. Punch out a lime green heart and stick to the card, behind a red heart-button tied with orange thread.

tip

Finishing this project off with a bold red heart-shaped button adds a real 3-D feel to your greeting

Sweet Nothings

Rich metallic colours and funky lettering create just the right effect for this sultry token.
Try making a small wallet to go with it to hold tickets for a romantic outing.

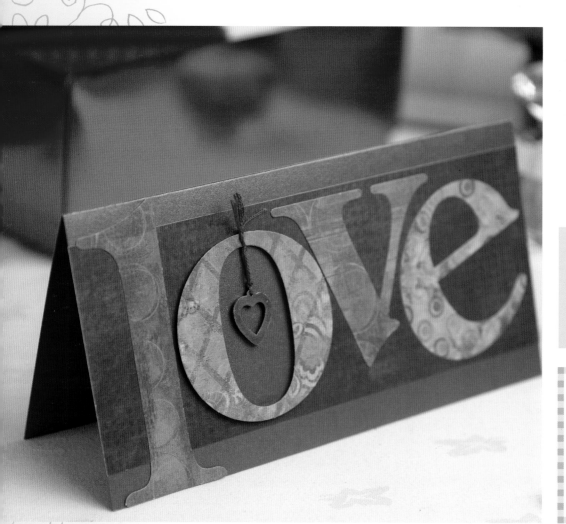

techniques
cutting, collage

time
15 minutes

designer
Sarah Beaman

materials

Pre-punched letters

Card: pearlised copper

Paper: maroon patterned

Decorations: heart charm,
thread

tip

Basic Grey
Fusion range make
it easy to create a
collage effect on
cards and gift
items

1 Make a tent-fold blank from pearlised copper card, 10.5 x 21cm (4¼ x 8¼in) when folded. Cut an 8 x 21cm (3¼ x 8¾in) panel of maroon patterned paper and lay it on the card face. Next, pop the pre-punched letters from the sheet and trim to neaten.

2 Lay the letters in the maroon panel as shown, marking their positions. The 'l' will touch the top and bottom edges of the card. Draw around the inside of the 'o'. Lift the letters and the panel and use a craft knife to cut an oval hole in the panel, where the 'o' had been, just outside the pencil line.

3 Stick the panel to the card and then the letters 'l', 'v' and 'e'. Tie a heart charm to the top of the 'o', allowing it to hang in the aperture. Trim and fray the ends. Secure the 'o' using foam pads.

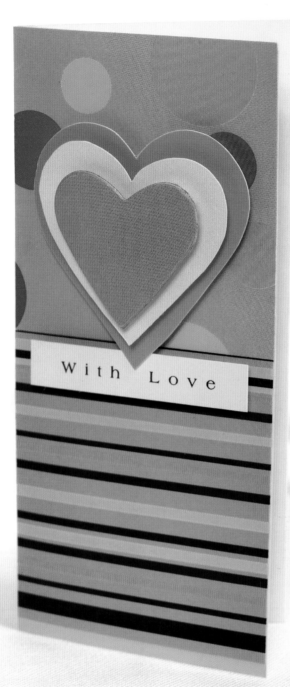

techniques
cutting, layering
time
15 minutes
designer
Jill Alblas

materials
Card: white, pink, cream
Paper: striped, spotted
Decorations: 'With Love' greeting

Trace heart shapes on to card before cutting out, to give you a chance to adjust the shape and size before committing yourself

With Love

Create a beautiful 3-D greeting by building up layers of different-coloured card – and make a stunning heart design that leaps from the page!

1 Create a blank, 17 x 6cm (6¾ x 2¼in), and stick striped paper on the bottom half and spotted paper on the top, cutting away any excess.

2 Cut a heart motif from pink card then cut another, slightly larger, from cream. Add a third, a little bigger again, from bright pink.

3 Use 3-D foam pads to fix a 'With Love' greeting at the bottom of the spotted paper, as shown. Fix the largest heart just above it, followed by the next size, then the smallest.

Crafty Tipple

If you have never dabbled with alcohol inks before, now is your chance to have a bit of fun. These fast-drying transparent dye inks are specially formulated to give a polished stone effect on a whole range of surfaces.

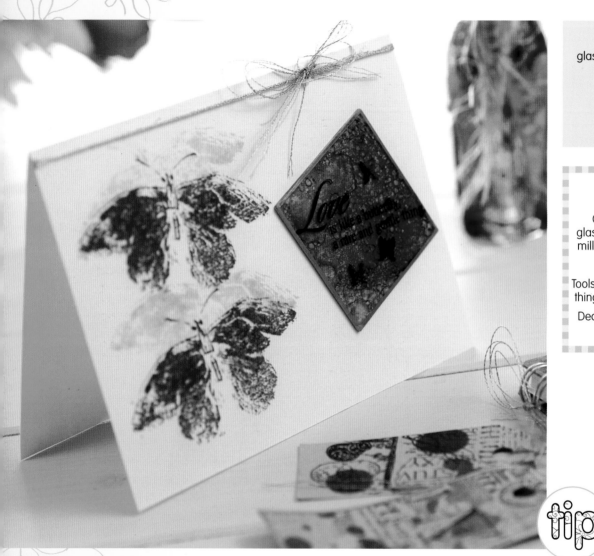

techniques
glass painting, stamping

time
20 minutes

designer
Dorothy Walsh

materials

Gold pen, memory glass, alcohol inks: black, milled lavender, rueberry

Card: cream

Tools: ink applicator, 'gentle thing' and 'wings' stamps,

Decorations: gold thread

tip

Isopropyl alcohol can remove alcohol inks from glass, plastic and metal if you want to start over or change colours

1 Shade memory glass with alcohol inks by applying them with a small felt rectangle attached by hook tape to a small wood-handled applicator. Add a drop of two or three different colours to the felt, then randomly stamp and twist the applicator on the surface of the glass until it is mostly coloured.

2 Colour the 'gentle thing' stamp with black ink and print on to the glass, edging with a gold pen. Ink the wings stamp with milled lavender and apply twice to the left side of a top-folded A5 card blank.

3 Ink the wings again with rueberry and print over the top of the original images, but slightly offset. Now stick the stamped glass on to the right side of the card using double-sided tape. Tie gold threads around the top-folded edge to finish.

Beautiful Angel

If you're on the hunt for an unusual addition to that special card then look no further. Available in a seemingly endless array of colours, foam is versatile, easy to work with, and produces stunning results every time.

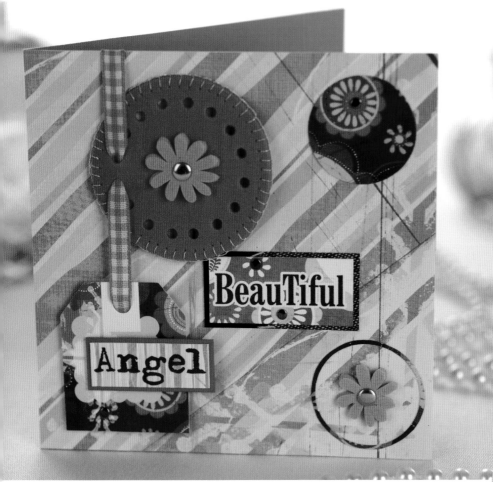

techniques
stitching, mounting

time
20 minutes

designer
Corinne Bradd

materials

Foam: dark pink

Card: floral patterned

Paper: diagonally striped

Tools: adjustable punch

Decorations: metallic thread, pink flowers, faux brads, pink gingham ribbon, floral tag, pre-printed 'Angel' and 'Beautiful' panels

1 Trim a card blank, 11.5cm (4½in) square, and cover with diagonally striped paper. Using metallic thread, edge a 5cm (2in) diameter circle of dark pink foam in blanket stitch. Create a series of small equidistant holes, 5mm (¼in) in from the circumference with an adjustable punch, then glue a small pink flower to the middle and add a faux brad.

2 Thread a length of thin pink gingham ribbon through two of the holes on the circle, and pass one end into the perforation of a floral tag. Tape at the back to secure. Fix the tag to the bottom left of the card with 3-D foam pads and pull the ribbon taut, positioning the foam circle above this before neatly gluing the remaining end of the ribbon inside the card.

3 Add a matted 'Angel' panel to the tag and mounted 'Beautiful' panel below the circle. Stick a patterned circle of card to the top right-hand corner and carefully cut out a hollow ring to add at the bottom. Decorate the motifs with faux brads and a foam flower.

tip
Use your punches on a few sheets of kitchen foil to sharpen before pressing out shapes from foam

technique
stitching

time
50 minutes

designer
Lucinda Ganderton

materials

Red and white linen, fusible web, mount board

Tools: dressmaker's pen, iron

Decorations: coloured thread, lace

Tempates: 'To My Valentine', heart

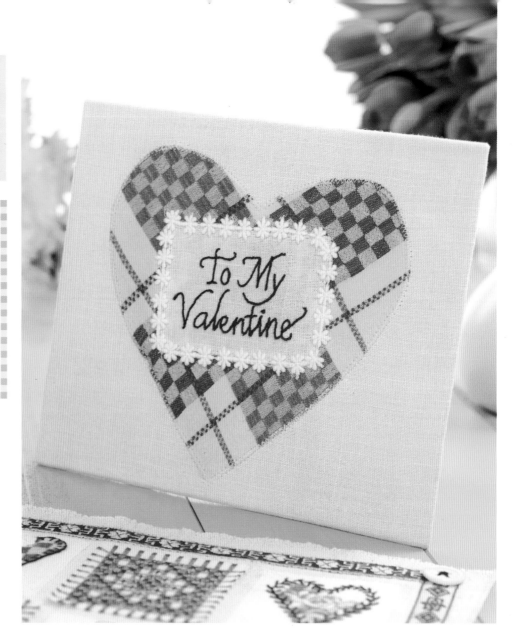

Labour of Love

The home-made appeal of these vintage-style samplers is created with basic stitching, so they are perfect if you want to brush up on your needlework skills.

tip

The red and white colour scheme is inspired by 19th century darning and stitching samplers

1 Trace the 'To My Valentine' text from the pattern pages, in the centre of a white linen square, using a dressmaker's pen. Embroider the writing in whipped running stitch with two strands of thread.

2 Next, draw around the heart found on the pattern pages on to fusible web. Cut the motif out and bond centrally to red and white linen.

3 Attach more bonding web to the back of the embroidered fabric and trim, 6 x 8cm (2¼ x 3¼in). Iron to the centre of the heart and sew lace around the edge. Stretch the linen over mount board, 18 x 20cm (7 x 8in), and secure with strips of double-sided tape at the back.

Think Pink

This simple project uses foam, which is ideal for giving a soft, feminine touch to a greeting. It also adds that all-important dimensional feel that really bring designs alive.

techniques
apertures, punching

time
20 minutes

designer
Corinne Bradd

materials

Foam: orange, light and dark pink

Card: pink

Tools: deckle-edged scissors, hole punch

Decorations: metallic cord, heart and gift motifs

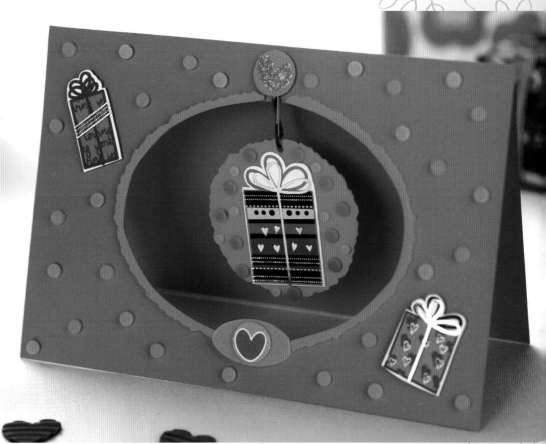

1 Take a pink card blank, 11.5 x 17cm (4½ x 6¾in), and cut a large oval aperture from the front. Edge with a thin strip of orange foam, trimmed along one side only with deckle-edged scissors, to attractively hide any flaws in the curve of the shape.

2 Cut a 6cm (2¼in) diameter circle of orange foam with deckle-edged scissors and pierce a small hole near the rim. Pass a short length of metallic cord through and fix to the top of the oval, covering the ends of the thread with a heart motif.

3 Trim a shape from pale pink foam to glue to the bottom edge of the oval, so that half is on the card and half in the aperture. Top with another heart motif to complement the first.

4 Place a gift motif on either side of the aperture and fill in the plain areas on the blank with small circles of orange and pink foam, cut using a hole punch. Fix a larger gift motif to the centre of the hanging circle and add more foam dots in a darker pink.

tip

Don't let anything go to waste! In papercrafting, even the smallest, seemingly most insignificant items, can be put to good use

Layered Hearts

There's nothing more romantic than the traditional heart motif, so put it to good use in a simple greeting that combines a mix of patterns and plains that really stand out on a white background.

techniques
punching, cutting
time
15 minutes
designer
Caroline Blanchard

materials

Card: red, white

Paper: red patterned

Tools: heart punch (optional), scalloped-edged scissors

Decorations: glitter flowers, faux brads, heart embellishment

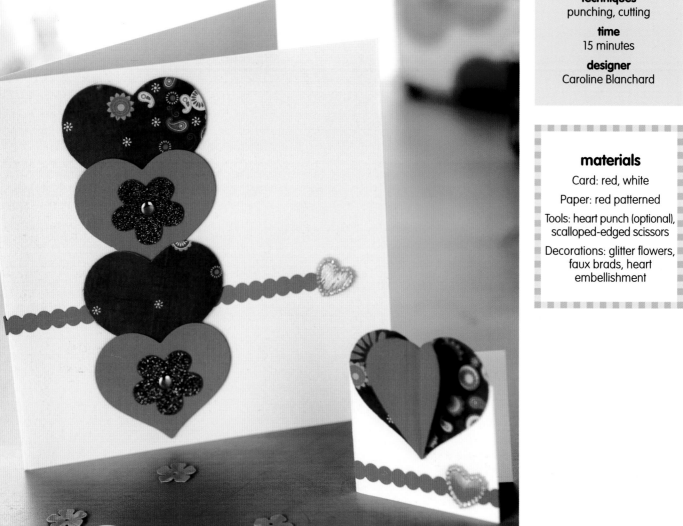

tip

In keeping with the theme, why not use a heart corner punch for a really beautiful effect?

1 Cut, punch or die-cut four heart shapes from red card and patterned paper. Add two red glitter flowers to the centre of the plain motifs and finish off with two faux brads in each flower centre.

2 Cut a strip of red card with scallop-edged scissors and stick this to the front of a white blank, 13cm (5⅛in) square, as shown. Add a small heart decoration to the end of the strip.

3 Layer the four hearts in a row, slightly towards the left of the greeting, and stick down using double-sided tape.

technique
stamping

time
20 minutes

designer
Sharon Bennett

materials

Silver ink, antique rose 3-D paint

Card: bright pink, white

Tools: Large 'heart splash' stamp

Silver Lining

Combine subtle, silver stamped motifs with vivid colours to create eye-catching designs that are surprisingly easy to decorate.

1 Using silver ink, stamp a large 'heart splash' four times on to bright pink card, in a vertical line. Cut out, leaving no space on either side of the motifs. Stick centrally on to a white blank, 21 x 9cm (8¼ x 3½in) using adhesive sheets.

2 Dot a line of 3-D antique rose paint on to the white background, to the left of the pink panel, then add a few more spots around the hearts where the design lends itself.

tip These motifs could easily be transferred on to a matching gift tag to complete the set

Green with Envy

Making a Valentine's card for a man can be a challenge, as most greetings involve feminine pinks and reds. This design uses a more masculine dark green as a central panel, but still manages to retain that romantic feel.

techniques
cutting, folding

time
10 minutes

designer
Amanda Walker

materials

Card: silver, olive green, embossed

Decorations: green glitter hearts, purple gems

tip The minimal look is in, so this simple to design greeting is the perfect way to take advantage of it

1 Take silver card and fold in half to create a top fold blank, then stick a rectangle of olive green card in the centre.

2 Trim three hearts from embossed card and attach to each a small green glitter heart with a purple gem glued in the centre.

3 Stick vertically down the centre of the green rectangle with 3-D foam pads, then add 'With Love' wording at the base.

technique
highlighting patterns

time
10 minutes

designer
Amanda Walker

materials

Card: white, pearlised embossed

Paper: yellow floral patterned

Decorations: silver roses, pink heart gems, yellow flowers

Mellow Yellow

Feminine, floral greetings like this are perfect for Valentine's Day, but the alternative colours mean that they could just as easily be used as a birthday or thank you card.

tip
To achieve a really neat edge along the top and bottom of your card, cut the patterned paper longer than you need and trim neatly to fit afterwards

1 Take a white card blank and turn it so that the spine is at the top, then attach a strip of yellow floral patterned paper to the left-hand side.

2 Cut a square of pearlised embossed card to fit the front of the blank, then stick on nine silver roses in a grid. Attach this to the front of the greeting.

3 Add pink heart gems to the fronts of three yellow flowers, sticking one to the centre rose on the grid and the remaining two in the right-hand corners of the card.

techniques
stamping, embossing, tearing

time
20 minutes

designer
Brenda Harvey

materials

Pigment ink, brown embossing powder

Card: pink, pearlised blue

Paper: spotted

Tools: 'with love' stamp

Decorations: pink satin ribbon

with love

tip

Don't feel that you have to stick to the colour schemes shown here. Experiment with different shades to give these greetings your own spin

Romantic Intentions

It's always good to tell someone that you care; but if cute, fluffy cards aren't to your taste, try these stylish alternatives, which balance pink with attractive, blues and browns.

1 To make the taller greeting, fold A5 pink card in half lengthwise and cover the left-hand side with spotted paper. Stamp 'with love' using pigment ink and heat emboss in brown.

2 Cut a large heart in pealised blue card and attach with 3-D foam pads. Tie a short length of pink satin ribbon in a bow and fix to the heart with small pieces of double-sided tape.

3 To make the smaller greeting, first tear spotty paper to 7cm (2¾in) square. Layer on to a 7.5cm (3in) square of pearlised blue, then a square of small pink. Cut two large hearts, one in pink and the other in pearlised blue card, and attach them to the blank with 3-D foam pads.

Blind Date

Spell out your sentiments and get your message across using pre-punched letters and an opulent colour scheme.

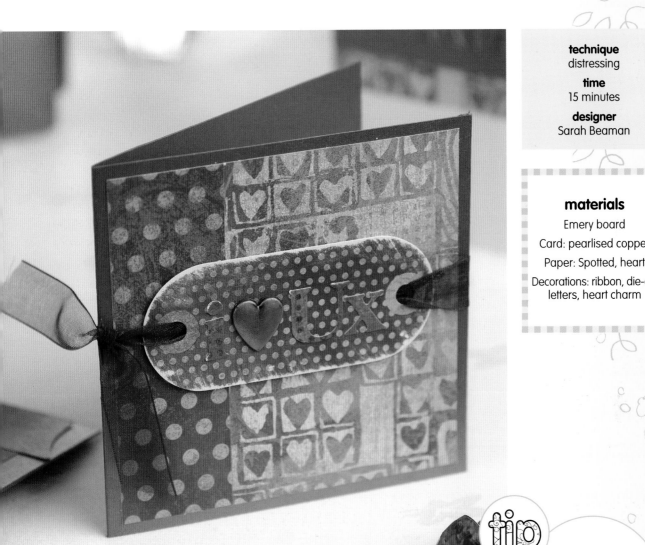

technique
distressing

time
15 minutes

designer
Sarah Beaman

materials

Emery board

Card: pearlised copper

Paper: Spotted, heart

Decorations: ribbon, die-cut letters, heart charm

tip

Before sticking the letters in place, position their base against a ruler to help you align them accurately

1 Make a 12cm (4¾in) square card blank from a sheet of pearlised copper card. Cut a 11 x 3.5cm (4¼ x 1³⁄₈in) panel of spotted paper and 11 x 7.5cm (4¾ x 3in) tall panel of heart paper. Stick these to the card front as shown.

2 Cut a tag shape from patterned paper and use an emery board to distress the edges – this will produce a white line and ensure that the tag stands out from the patterned background. Thread ribbon in and out through the holes of the tag and fix to the card using foam pads.

3 Cut a small slot in the fold of the card that corresponds to the position of the ribbon. Wrap the ribbon that emerges from the right hole around the edge and across the inside of the card. Push the end through the slot in the fold and tie. Make the motto by decorating the tag with letters and a heart charm.

Daisy Days

Subtle and stunning vellum is a clearly wonderful way of presenting your sentiments – combine with beads and wire for a seasonal greeting that's as fresh as a daisy!

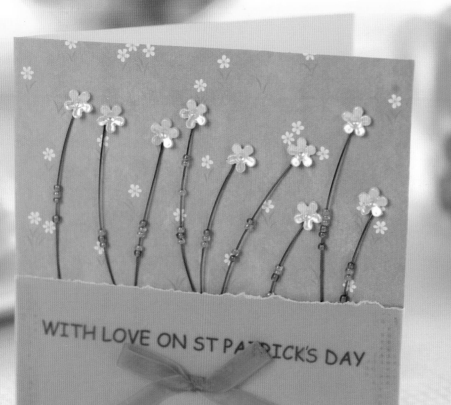

techniques
stamping, tearing

time
35 minutes

designer
Jill Alblas

materials

Green ink-pad

Card: green

Paper: green scrapbook, white vellum

Tools: 'with love on St Patrick's day' stamp

Decorations: green wire, rocailles or seed beads, sequin flowers, green organza bow

1 Trim a blank 11.5cm (4½in) square and cover the front with scrapbook paper. Cut nine lengths of green wire each about 6cm (2¼in) long. Thread each wire with a few green rocailles or seed beads.

2 arange the beaded wires across the front of the blank with the ends about 4cm (1½in) from the bottom. Use strong craft glue to secure the wires and beads in place then glue a tiny flower at the top of each one and leave to dry.

3 Trim green card 4.5cm (1¾in) deep and fix along the bottom of the card so the tips of the wires are hidden. Print the sentiment in green ink on white vellum. Tear along the top of the vellum and fix across the bottom of the card. Finish with a green organza bow, below the words, in the middle of the vellum panel.

tip

Economy brands of craft glue are fine for most paper crafts but you need strong, good quality adhesive for fixing beads and wire in place

Emerald Island

Give a tradional blessing a fresh, elegant edge with bold colours and a contemporary presentation.

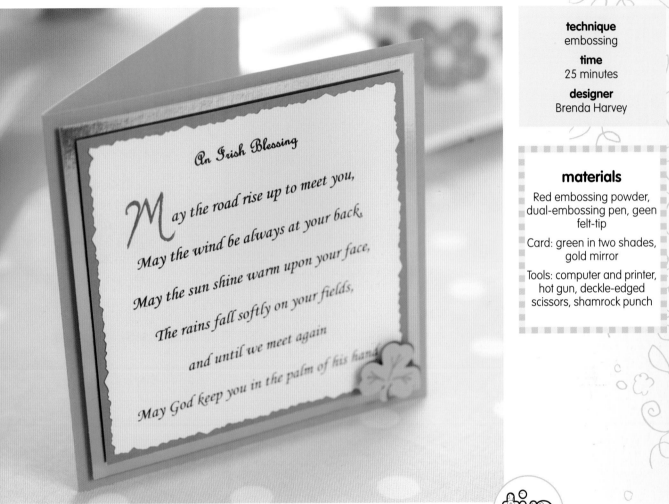

An Irish Blessing

May the road rise up to meet you,
May the wind be always at your back,
May the sun shine warm upon your face,
The rains fall softly on your fields,
and until we meet again
May God keep you in the palm of his hand

technique
embossing

time
25 minutes

designer
Brenda Harvey

materials

Red embossing powder, dual-embossing pen, geen felt-tip

Card: green in two shades, gold mirror

Tools: computer and printer, hot gun, deckle-edged scissors, shamrock punch

1 Fold green 14cm squared (5½in) card blank. Fix a slightly smaller square of gold mirror card on top with foam pads. Print out your blessing on to white paper using French Script font for the title and Monotype Corsiva font to do the verse, omitting the first letter of the text.

2 Using the chisel tip of a dual embossing pen write the letter 'M', then sprinkle red embossing powder over it and blast with a craft heat gun. Trim all four edges using deckle-edged scissors, layer on to a square of dark green card then secure with foam pads.

3 Punch out a shamrock from each of the two shades of green. Layer and fix to the bottom right-hand corner using foam pads, making sure to keep the palest one uppermost. Add vein detail with a green felt-tip pen.

tip

The simple illumination-style first letter of the blessing works well and is an idea that could be transferred to other similar cards, perhaps using poems or prayers

Spring Green Shamrock

The clever use of punched hearts to create shamrocks makes this quaint card perfect for St Patrick's Day. Use spring colours and add a fresh touch with fringed, quilled daisies.

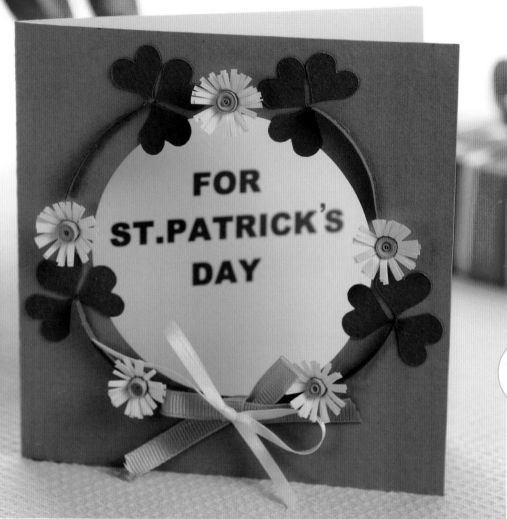

techniques
punching, quilling

time
one hour

designer
Jill Alblas

materials

Card: green in two shades, white

Paper: yellow, white

Tools: computer and printer, shape cutter, quilling tool, heart punch

Decorations: ribbon, yellow and white

Experiment with different widths and lengths of paper to vary the size and shape of your fringed flowers

1 Trim a green blank, 13cm (5⅛in) square and cut a circle 8cm (3¼in) diameter from the front. Print out your sentiment on to white card in green using Arial Black, 28pt. Centre the greeting, trim to 13cm (5⅛in) square and fix behind the aperture. Tie bows from yellow and white ribbon then secure at the bottom of the aperture.

2 To make the daisies; cut five strips of yellow paper, 12 x 0.6cm (4¾ x ¼in). Wind each strip tightly round a quilling tool and secure with a spot of glue. Cut five strips of white paper, 5 x 1cm (2 x ⅜in). Fringe the length of the paper using small scissors, then wrap tightly round the coiled, yellow paper and secure with glue. Gently press and fan the fringing into a daisy shape.

3 Glue quilled and fringed daisies around he aperture, as shown. Punch 12 small hearts from dark green card and arrange them in sets of three, to form shamrock shapes, either side of the daisies. Cut four strips of card, run them along your thumbnail to curl slightly, then glue between the shamrocks and daisies.

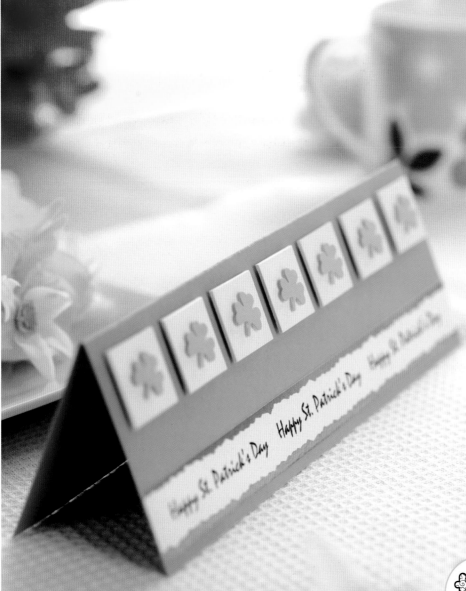

techniques
tearing, punching

time
25 minutes

designer
Brenda Harvey

materials

Card: green, gold mirror, white

Tools: computer and printer, shamrock punch

tip

This punched motif design could easily be adapted for a general spring-time greeting – try combining turquoise card with a row of tiny yellow daisies

Green Day

Create a St. Patrick's Day design that's as fresh as a shamrock-filled field!

1 Fold an A5 sheet of green card in half to form a horizontal blank. Cut a strip of gold mirror card, 2cm (¾in) wide, and glue in place along the bottom.

2 Print the message on a computer, three times, in Mistral font on to white paper. Tear the top and bottom edges to make a message strip, then stick to a slightly wider piece of gold mirror card. Trim neatly to fit the greeting and fix in place along the bottom.

3 Cut seven 2.3cm (⅞in) squares from white card. Punch seven shamrocks out of green card and fix one in place on top of each square using foam pads. Arrange the mounted motifs in a line across the top.

Dairy Queen

Add a little luxury to your Easter celebrations this year, with an 'eggstra' special chocolate-inspired greeting.

technique
pricking

time
25 minutes

designer
Elizabeth Moad

materials

Card: cream

Paper: striped, spotted

Tools: computer and printer, paper pricker

Decorations: bronze satin ribbon

tip

When pricking holes in card, protect your work surface from being marked with a foam pad on a cutting mat

1. Type various words associated with Easter into your computer using different sized fonts. Select varying shades of brown to colour the lettering, then print out on to cream card.

2. Trim card, 8 x 14cm (3¼ x 5½in), and attach to striped paper, 10 x 23cm (4 x 9in), as shown. Fold it in 4cm (1½in) from the left-hand side to create a flap. Cut an egg shape from dotted paper.

3. Prick holes in wavy horizontal lines across the egg, to border the spots. Tie bronze satin ribbon around the shape, securing neatly in a bow, then stick it to the flap.

Hole Story

Turn simple cards into fun, textured designs – by adding stitched borders and pricked patterns your greetings will take on a whole new dimenson!

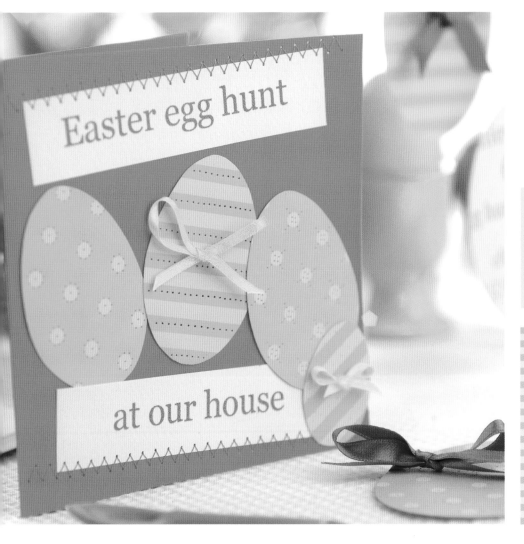

techniques
stitching, pricking

time
30 minutes

designer
Elizabeth Moad

materials

Card: white, pink

Paper: orange, striped and spotted

Tools: computer and printer, sewing machine, paper pricker

Decorations: thin yellow ribbon

1 Print out 'Easter egg hunt at our house', in light brown, on to white card. Place on a pink blank. With a sewing machine set to a zigzag, stitch across both pieces. Tidy the thread ends on the reverse and secure with a sticker.

2 Cut three large and one small egg shape from dotted and striped orange paper. Take a large spotted egg and place on to a foam mat, pattern side up. Prick around the spots then through the centre of each one.

3 Take a large striped egg, make two holes in the centre, then thread thin yellow ribbon through each one. Tie in a bow at the front then repeat for the smaller egg shape. Attach the eggs to the pink card, as shown.

Add fancy feathers for a fluffy finish

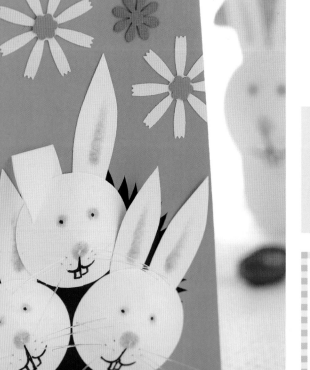

techniques
apertures, punching

time
30 minutes

designer
Emma Beaman

materials

Pink chalk, black felt pen, nylon thread

Card: green, brown, white, pink, orange

Tools: flower punches

tip

Place a piece of sticky tack behind the nose of the rabbit when making holes for the whiskers, to give you something flexible to push a needle into

Bunny Show

Use chalk to add depth of colour and character to cute critters that are sure to enthrall the kids.

1 Make a 15.5 x 10cm (6 x 4in) green card and cut out a 7cm (2¾in) aperture from the front, about halfway down. Use a craft knife to trim around the edge of this, to form the grassy blades, and attach a panel of brown card trimmed to size on the inside front – to represent a rabbit hole.

2 Cut three white circles, 4cm (1½in) diameter; make a straight incision up towards each centre, then stick the edges together to form mini cone shapes for the faces. Trim two pointed shapes for ears and secure behind the faces. Use pink chalk to shade the eyes, ears and noses, add details with a fine black pen, and attach them as shown.

3 Decorate the front of the greeting by adding punched flowers, in different styles and sizes, in white, pink and orange. Arrange them in a random pattern around the blank spaces. To finish, fold one of the bunny ears down for an appealing 3-D effect.

Shelling Out

A torn border makes a perfect platform for a message, and feathers provide a fluffy finishing touch for an 'eggstra' special greeting.

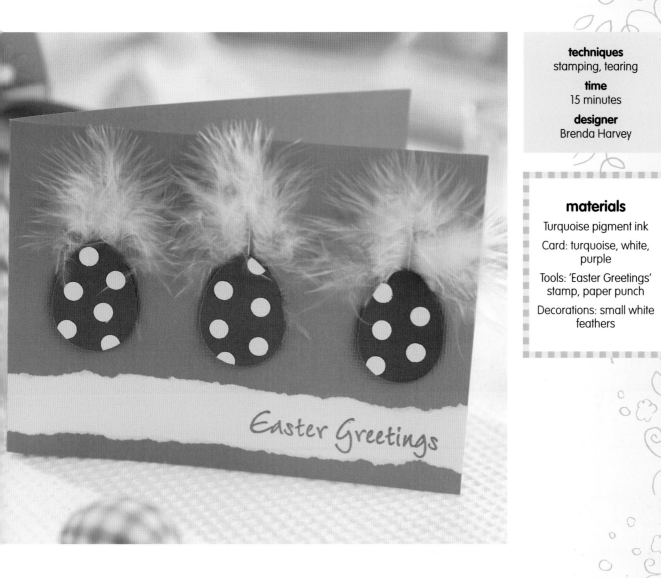

techniques
stamping, tearing

time
15 minutes

designer
Brenda Harvey

materials

Turquoise pigment ink

Card: turquoise, white, purple

Tools: 'Easter Greetings' stamp, paper punch

Decorations: small white feathers

1. Fold a 10.5 x 29cm (4¼ x 11½in) sheet of turquoise card in half. Stamp 'Easter Greetings' with turquoise pigment ink on to white card.

2. Tear the edges of the white panel and glue on to the card blank. Cut three eggs from purple card and decorate each one with punched white circles.

3. Fasten three small feathers to the card with double-sided tape and top with the eggs, attaching using foam pads.

 tip
To attach small feathers to cards, strip a little from the bottom of the spine and position with a small patch of double-sided tape

Cafe Culture

Exploit the shape that's most synonymous with Easter and use it as an original way of presenting words on a sassy seasonal greeting.

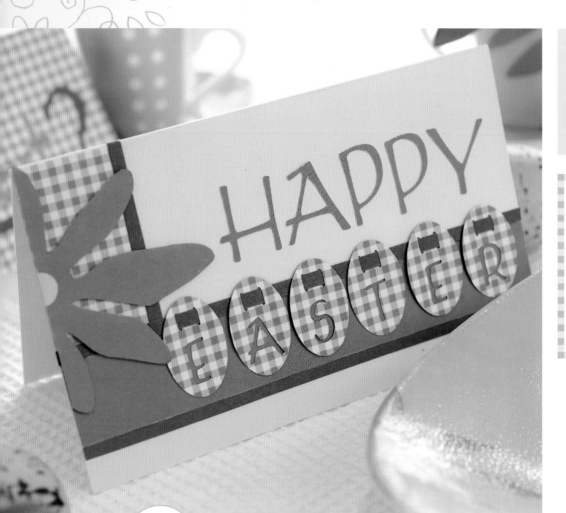

technique
weaving

time
15 minutes

designer
Amanda Walker

materials

Card: white

Paper: purple, green checked double-sided

Tools: Cricut machine, George and Basic Shapes cartridge

tip

Alphabet stencils are an inexpensive yet effective alternative to Cricut Machines

1 Cut out the words 'Happy Easter' using a Cricut machine and green checked paper. Use the George and Basic Shapes cartridge. Cut the 'Easter' using the slotted function. Trim narrow strips from purple paper, threading the 'Easter' on to one of them.

2 Cut two 3cm (1¼in) strips from green checked double-sided paper. Stick one, vertically and checked side-up, to the left of a white horizontal card blank and the other, green side facing, across the base. Attach the slotted letters along the plain green section, adding purple strips to the edges of both the green and checked rectangles, as shown.

3 Cut a green flower using the template, attach a white dot to the central edge then use foam pads to position this on the left-hand side of the card. Finally, stick the 'Happy' letters above the 'Easter'.

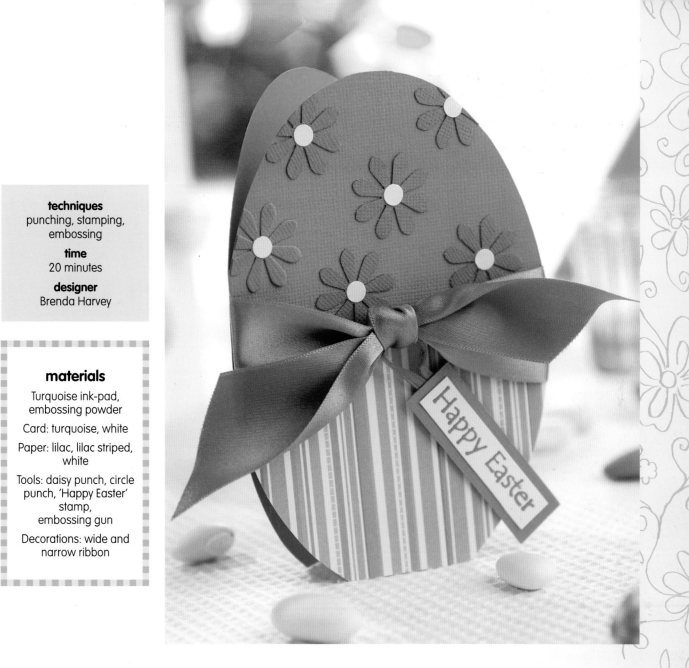

techniques
punching, stamping, embossing

time
20 minutes

designer
Brenda Harvey

materials

Turquoise ink-pad, embossing powder

Card: turquoise, white

Paper: lilac, lilac striped, white

Tools: daisy punch, circle punch, 'Happy Easter' stamp, embossing gun

Decorations: wide and narrow ribbon

Lucky Stripe

Combine rich hues of green and lilac with a cleverly shaped blank for an Easter card with a difference.

1 Draw a large egg shape on to folded turquoise card and cut out to form a blank, ensuring that you have a 5cm (2in) straight edge on the left-hand side. Cover the lower half with striped paper.

2 Punch six daisies in lilac and glue on to the top half of the egg, adding a small punched white circle to each of the flower centres. Stamp the Easter message in turquoise ink on a strip of white card, sprinkle with embossing powder and heat.

3 Layer on to turquoise card and attach a loop of narrow ribbon at the back. Very carefully cut a slit in the fold of the card and thread wider ribbon through, tying in a double knot at the front.

Use wide satin ribbon in a coordinating shade for a luxurious finished effect

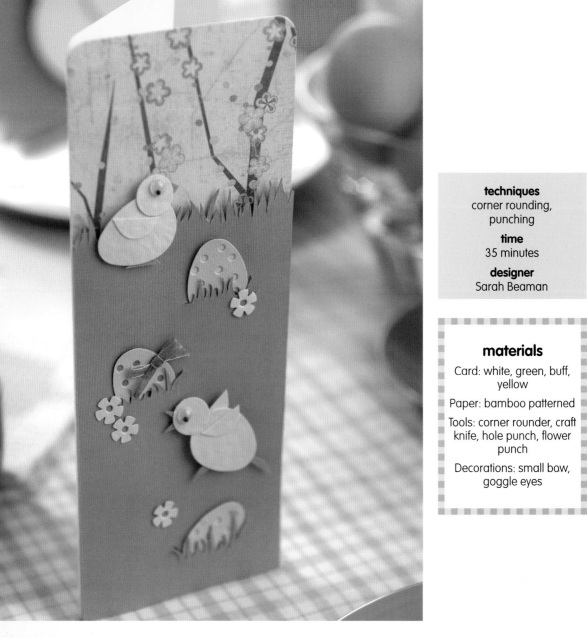

techniques
corner rounding,
punching

time
35 minutes

designer
Sarah Beaman

materials

Card: white, green, buff,
yellow

Paper: bamboo patterned

Tools: corner rounder, craft
knife, hole punch, flower
punch

Decorations: small bow,
goggle eyes

Chic Chicks

Armed with a few decorations it's easy to transform simple shapes into cute Easter motifs that
are perfect invitations for an egg hunt!

**When making
the large animals
experiment with
different sized circles
and ovals to ensure
you have the best
combination**

1 Make a 18.5 x 7cm
(7¼ x 2¾in) white card
blank. Cut a 7cm (2¾in) square
of bamboo paper and stick
it to the top of the card face.
Round off the upper corners.
Cut a 13.5 x 7cm (5½ x 2¼in)
panel of green card and snip
a grass effect along one short
edge. Using a craft knife, cut
three more grass-effect sections,
3cm (1 ⅛in) wide, and spread
randomly down the green panel.

2 Make three eggs from
buff and yellow card,
punching holes in the buff
shapes and layering them on
top of the yellow. Push the
eggs into the snipped slots,
securing with a little glue.
Decorate one with a tiny bow.
Attach the green panel to the
card face using foam pads.

3 Make two chicks from
yellow card: use egg
shapes for their bodies, and
circles and semi-circles for their
heads and wings. Snip small
strips and triangles for their
legs and beaks, add goggle
eyes, then stick them to the
card using foam pads. Punch
tiny flowers and pierce the
centres with a small hole
punch. Stick in place, as shown.

easter bunny

Animal Farm

Make good use of fabric scraps by turning them into an appliquéd motif and presenting them inside an aperture.

technique
appliqué

time
40 minutes

designer
Naomi Sisson

materials

Floral, felt and green gingham fabric scraps

Card: pale pink circular aperture blank

Tools: iron, needle, computer and printer

Decorations: pink, grey and brown thread, small yellow button

Instead of printing out your message, use stick-on lettering or a stencil to achieve different looks

1 Create a background for the appliqué by pressing iron-on interfacing on to floral fabric, 4 x 9cm (1½ x 3½in). Peel off the backing and fix a 9cm (3½in) square of green gingham material halfway up with a hot iron. Press iron-on interfacing on to a small square of felt, draw on a rabbit, then cut out. Iron the motif halfway up the background, as shown.

2 Use pink thread around the insides of the ears in running stitch. Create a 'V' for the nose, with a single stitch underneath, and add whiskers in brown. Use grey to sew lines on the paws and running stitch to define the head from the body.

3 Embroider the eyes with brown thread by making a stitch and horizontally looping another halfway across. Add eyelashes to finish. Sew a small yellow button for a tail and fix the design behind the aperture with double-sided tape. Print out 'easter bunny' in size 14 Tahoma font, cut out and stick to the card.

Good Eggs

Use a combination of stamps with retro-inspired colours to create a subtle and sophisticated Easter greeting.

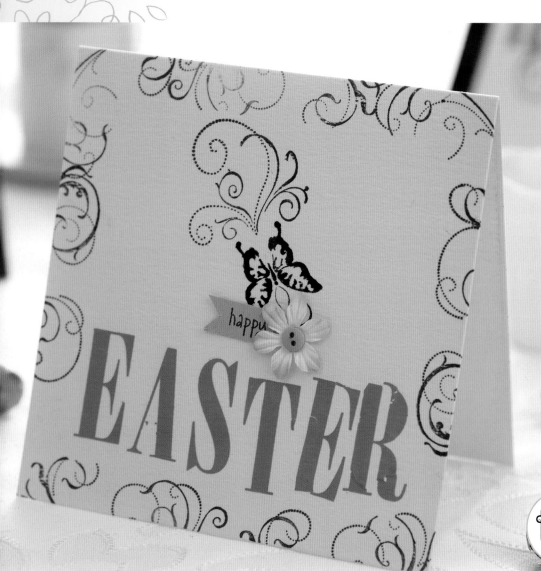

techniques
stamping, rub-ons

time
15 minutes

designer
Paula Pascual

materials

Brown ink-pad, rub-on letters

Card: pale pink

Paper: green

Tools: scroll, butterfly and 'happy' stamps

Decorations: paper flower, button

tip The swirly designs give a sophisticated finish to stunningly original Easter greetings

1 Trim a pre-scored pale pink card to 11.9cm (4¾in) square when folded in half. Stamp the butterfly on the centre of the card. Using a scroll stamp, print the design over the edges with brown ink, as shown.

2 Below the butterfly, apply the rub-on letters to spell 'Easter'. Keep these straight by using low-tack tape to secure the lettering in the right position, then rub over them. To get distressed letters, don't hold too tightly while rubbing them off.

3 Stamp the word 'happy' on green paper, using brown ink. Trim into a small rectangle with a V-shaped end. Attach this panel to the card, just above the 'Easter' rub-on word, then finish the greeting with a paper flower and button on top.

Lime Lights

Team ribbon, fabric flowers and gorgeous paper for contemporary cards that look as fresh as a spring morning.

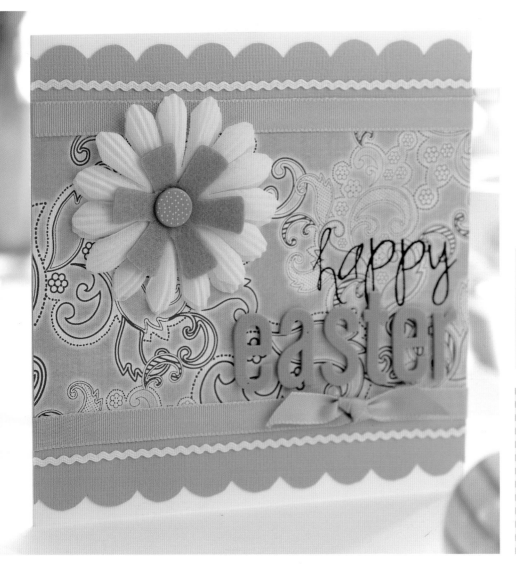

technique
edging

time
15 minutes

designer
Maria Mcpherson

materials

Card: pink

Paper: Sassafras 'Decadent'

Tools: scallop-edged scissors

Decorations: ribbon, ricrac, fabric flower, die-cut letters

1 Cut a pink card to fit the face of a large square blank and scallop the top and bottom edges. Cut a broad strip of 'Decadent' paper and attach it to the pink card.

2 Neaten the edges of the patterned panel with ribbon and ricrac. Add your message, then a fabric blossom to the top left-hand corner, as shown.

tip

Use foam pads as a no-mess adhesive solution that will also add dimension to your cards

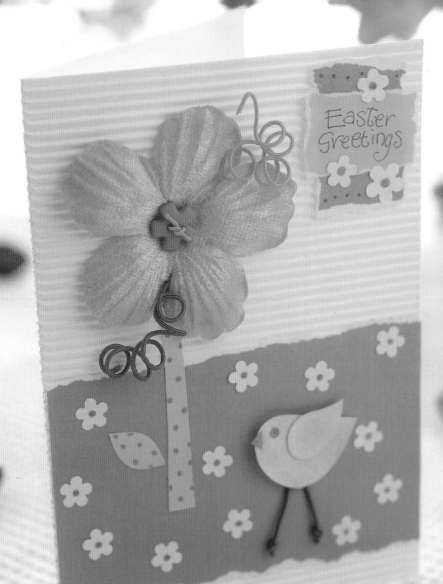

techniques
tearing, chalking

time
20 minutes

designer
Glennis Gilruth

materials

orange glitter pen, orange chalk

Card: plain and corrugated white

Paper: green and lime green

Tools: flower punch

Decorations: orange fabric flower, threads, orange button

Pot Luck

Accent your designs with colouring tools that make a subtle yet eye-catching difference.

tip

To gain more leverage, always stand up when punching, and always punch down on to a hard surface

1 Make a 14 x 10cm (5½ x 4in) fold of white corrugated card and attach a 6cm (2¼in) wide strip of torn green paper across the lower front. Cut a stalk and leaf in lime green paper, decorate with orange glitter pen dots, and attach to the greeting, as shown.

2 Add a dusting of orange chalk around the petals of an orange fabric flower and fix it to the card using glue dots. Fix a couple of thread spirals under the petals. Tie some thread through a small orange button and add it to the centre of the flower.

3 Make a bird out of white card. Add colour with orange chalk and glitter pen, then attach legs of knotted thread. Stick the bird to the card and decorate with white punched flowers. Make a layered greeting panel.

Cutie Pie

Water-colour paper in cool blue and green hues provides the perfect backdrop for a stamped spring motif.

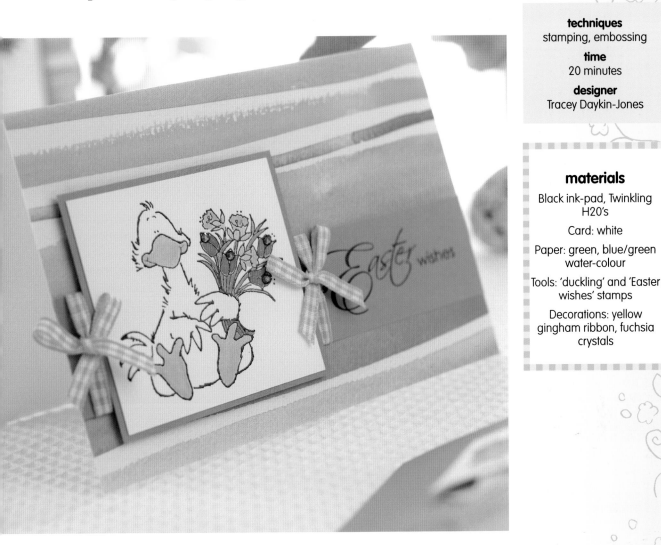

techniques
stamping, embossing

time
20 minutes

designer
Tracey Daykin-Jones

materials

Black ink-pad, Twinkling H20's

Card: white

Paper: green, blue/green water-colour

Tools: 'duckling' and 'Easter wishes' stamps

Decorations: yellow gingham ribbon, fuchsia crystals

1 Cover the front of an A6 horizontal card blank with blue/green water-colour paper trimmed to fit. Add a wide plain green paper panel all the way across the bottom, about two-thirds down.

2 Tie two lengths of yellow gingham ribbon into bows, attach each one to a longer length, and stick them along the join between the papers, as shown. Stamp a duckling on to white card using black ink then clear emboss and colour with Twinkling H20's.

3 Trim and mount on to green paper and stick to the left-hand side of the card, between the bows, using foam pads. Hot-fix fuchsia crystals to the flowers on the stamped image. To complete, stamp on the 'Easter wishes' to the green panel at the bottom of the card.

Make templates on scrap card for cutting out stamped images, this allows you to position the image more neatly

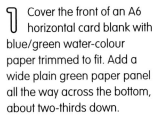

tip

Free Range

You don't have to be a seamstress to create a pleasing cross-stitch design – combined with mixed media, it can make the perfect Easter offering.

technique
cross-stitch

time
one hour

designer
Zoe Halstead

materials

Aida, white, 14 count

Card: orange, orange spotted, lime green

Decorations: orange spotted brad, buttons, thread, lime ribbon, spotted lime grosgrain, alphabet beads

tip

When cross-stitching, be sure that the upper half of all crosses lie in the same direction throughout

1 Work your own framed egg design on to Aida. Trim, fray the edges, and iron on to interfacing. Make an orange card, 15cm (6in) square. Cut a 7 x 7.5cm (2¾ x 3in) panel of spotted card; stick the stitching to it and mount on to lime card, trimming to form a border.

2 Fix the panel on to the greeting, as shown. Cut a strip of lime card, place a spotted brad at the top and layer buttons (knotted with thread) below on sticky pads. Fix this panel to the card then add a narrow border of lime card and spotted grosgrain across the bottom.

3 Thread up alphabet beads as shown. Mount to a lime panel securing thread and ribbon ends at the back. To finish, fix towards the opening edge of the card blank, on top of the grosgrain border, with sticky pads.

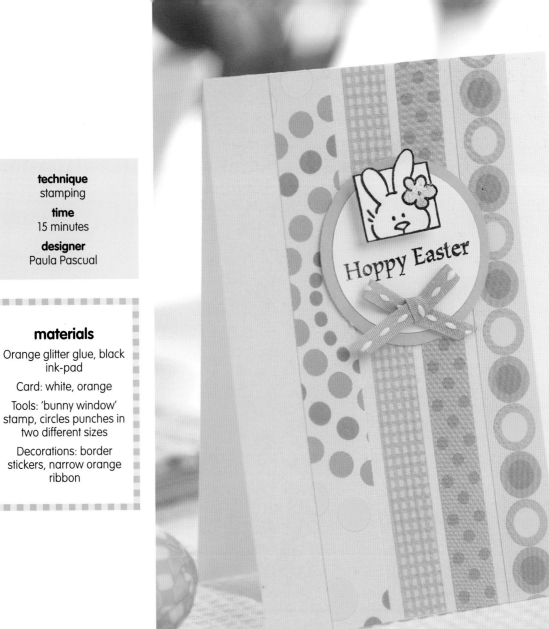

technique
stamping

time
15 minutes

designer
Paula Pascual

materials

Orange glitter glue, black ink-pad

Card: white, orange

Tools: 'bunny window' stamp, circles punches in two different sizes

Decorations: border stickers, narrow orange ribbon

Citrus Chic

Combine circles of different sizes and zesty springtime shades for a citrus-fresh greeting that almost bounces off the card.

1 Attach the border stickers to a top-fold card leaving space between them, as shown. Stamp the image on to white card and colour in. Add glitter glue and leave to dry. Print your message and punch it out into a circle.

2 Punch out a larger circle from orange card and stick the white circular greeting on top. Cut around the stamped image and attach it to the centre top of the round panel, leaving the orange border visible, as shown.

3 Make a bow with narrow orange ribbon and attach centrally to the bottom of the white circle, using a dot of clear glue. Fix the mounted circular panel to the top half of the card with double-sided tape.

To attach border stickers neatly hold them from both edges, to make sure that the strip is straight, before smoothing in place

tip

Spring sensations

Shining star

Celebrate in style by cutting a six-pointed star from a card blank and adding ribbons, greetings and gems

In full bloom

Roll a cone from scrap card and use it as the focal point of a card that seems to burst into full bloom. Ribbon, curled paper strips, and flowers attached with foam tabs add some real posy pizzazz

Going for gold

Be indulgent and create a luxurious look by adding gold patterned paper, beads and stars to a dazzling birthday greeting

Pretty in pink

For a feminine, frivolous touch, tie organza ribbon around the spine of a card packed with fun 3-D decorations

Paisley petals

Pick flower motifs to complement colours of a paisley-patterned background then arrange them above torn green paper on an attractively curved spring greeting

Stitched up

For a design that really ties up, border a computer-printed greeting with faux stitches, to match a scrap of grosgrain, and arrange them on a stylish tab with a flower

Swagger and swirl

Stamp swirls, in vibrant colours
to match an instant greeting,
for impact and a real feeling of
movement on a plain white card

Fondant fancy

Opt for mouth-watering motifs in zesty colours
to add zing to a plain white card. With
matching borders and fun, relevant words,
this example looks good enough to eat

Cutting edge

Make good use of heart-shaped flowers
by using them as a platform for your
greeting as well as decorative elements
on a card. Trim with fancy scissors for
a design that really has the edge

In full bloom

Subdued colours and flowers are a fail-safe way of creating elegant cards. Try layering pale patterned paper on to a plain blank and topping it with a single white bloom

Sweet sixteen

Polka dot and candy stripe paper set the tone of a fun greeting that celebrates a milestone birthday. Add 3-D figures, butterflies and a ribbon border for a really alluring design

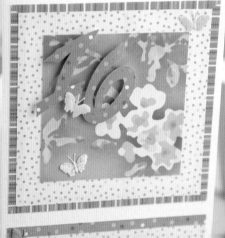

Elegant embossing

Use chipboard greetings to create an elaborate design by embossing them! Build up the layers so that they are super-smooth, mount on to an embossed frame, and highlight with glitter glue for sparkle

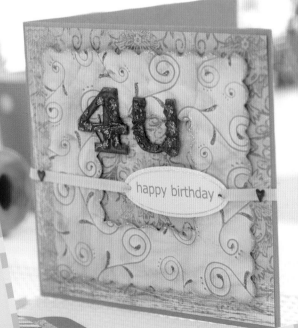

Bright blooms

A panel of patterned vellum can add an air of intrigue to a winning design that makes inventive use of silver cord, square stickers and gems

Thank you

have a great day

Round and round

Mirror jazzy spot-patterned paper by rounding panels at the corners. Accent a computer-printed greeting with a button for a simple but stylish finishing touch on an all-purpose card

Button up

Round buttons make perfect centres
for paper flowers. Tape wide organza
and narrow satin ribbon to a card
so that it can act as a stem for
a selection of beautiful button blooms

Petal panels

Print greetings on plain pastel panels with
rounded corners and mount them on to funky
flower-patterned paper for instant effect.
Letter stickers, punched flowers and ribbon
bows provide feminine finishing touches

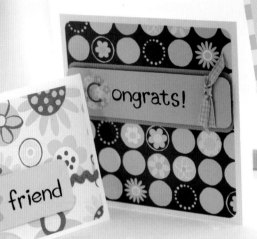

Candy-floss colours

Criss-cross paper borders and mount on to pastel
panels for a real confection of a card. Narrow ribbon
provides additional decorative detail and, with
pre-printed text paper, there is no need for words

Summer Celebrations

COOL BIRTHDAY BOY

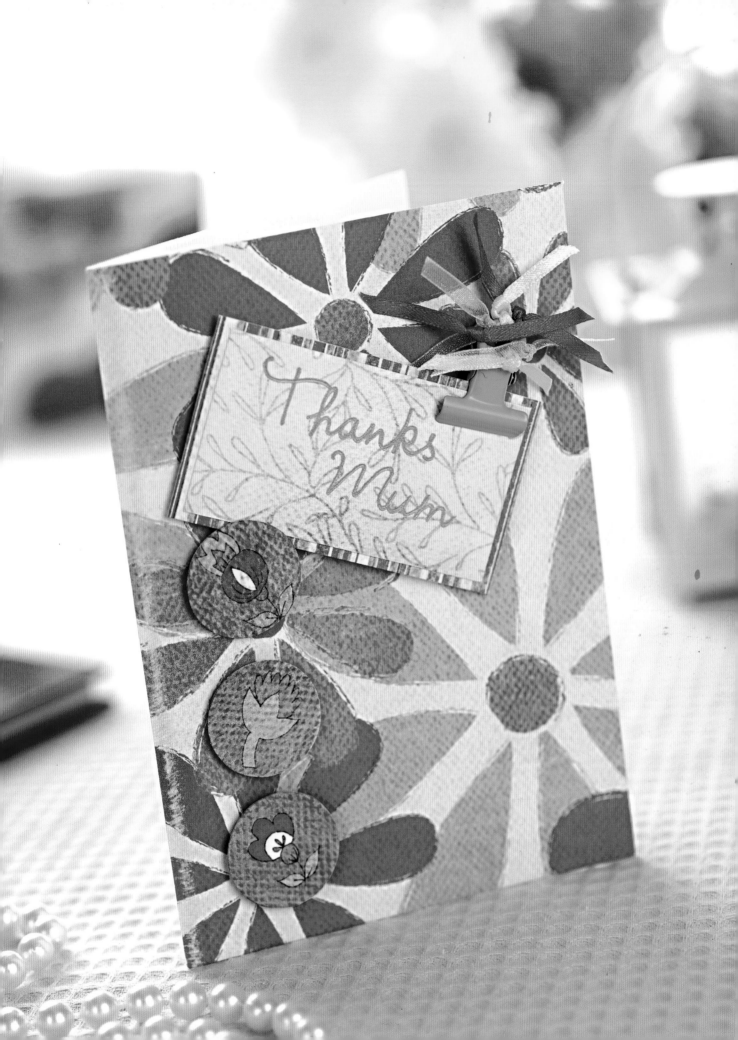

Thanks
Mum

technique
adding borders
time
15 minutes
designer
Sharon de Meza

materials

Black pen

Card: pink

Paper: orange bead patterned

Decorations: paper frill, ribbon, handbag brad, clear gems, crystal

Top Spot

Take mum back in time by using retro-styled paper with a distinctly funky feel – then add feminine finishing touches.

tip

When fixing the brad, first pierce the paper with a pricking tool to avoid distorting the card

1 Fold A5 pink card in half horizontally, and add a strip of paper frills across the bottom, leaving a 1cm (³⁄₈in) border.

2 Cut orange beads patterned paper to size and cover the rest of the front. Loop a length of ribbon so it conceals the join in the paper, then add a handbag brad.

3 Use clear gems to decorate random circles in the pattern and neatly write the greeting in black pen, embellishing with a crystal.

Just to Say

Pick out designs on patterned paper and mount them on circles to create your own unique motifs – like this floral fantasy!

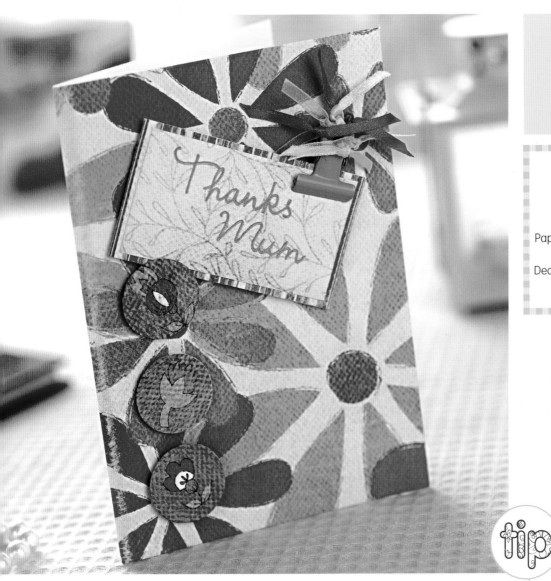

technique
making motifs

time
15 minutes

designer
Corinne Bradd

materials

Metallic gel pen

Card: white

Paper: large and medium floral patterned

Decorations: ribbons, mini bulldog clip

tip

Experiment with different paper designs to create unique circular motifs for a completely new adaptation

1. Cut and fold white A5 card into an A6 blank. Cover with neatly trimmed large floral print paper. Take a coordinating sheet that has a smaller pattern and snip three 2.5cm (1in) circles from it, incorporating a motif inside each one. Mount circles on to card, then fix to the left-hand edge of the greeting using 3-D foam pads.

2. Sketch your message on to plain paper in pencil and trace over it in metallic gel pen. Leave the ink to dry, then erase any remaining lines. Matt the written panel on to a patterned scrap leaving a narrow border.

3. Take several short lengths of coordinating ribbon and feed them through the hole in a decorative mini bulldog clip, tying tightly to secure. Adhere to the top right-hand edge of the message then fix on to the front of the card at an angle using foam tape, as shown.

Happy Snapper

Click your phone's camera to capture off-the-cuff moments from family gatherings. They don't need to be picture perfect!

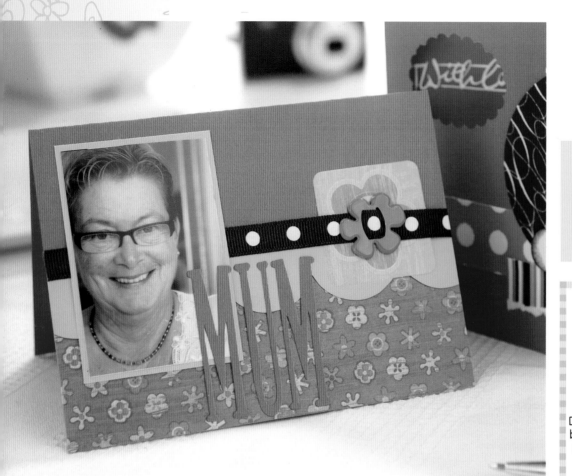

technique
adding photos

time
20 minutes

designer
Kirsty Wiseman

materials

Copy of a photo

Card: raspberry, yellow, apple green

Paper: button-flower patterned

Decorations: die-cut flower, brown ribbon, flower brad, die-cut or adhesive letters

tip

Use scanned copies of your photos and select relevant sections to fit in with your designs – you may not need unwanted scenery

1 Cut raspberry card to A5 size and fold in half to form a horizontal blank. Trim a piece of patterned paper to line the bottom half of the blank. Cut a scallop border in yellow card to cover the join. At the right edge, add a die-cut flower, and layer ribbon over this with a floral brad at one end, as shown.

2 Apply double-sided tape to the reverse of the ribbon and stick it along the top edge of the scalloped card. Mount a photo on to apple green card and stick it on the left-hand side. Arrange the letters to spell 'mum' and fix to the centre of the card.

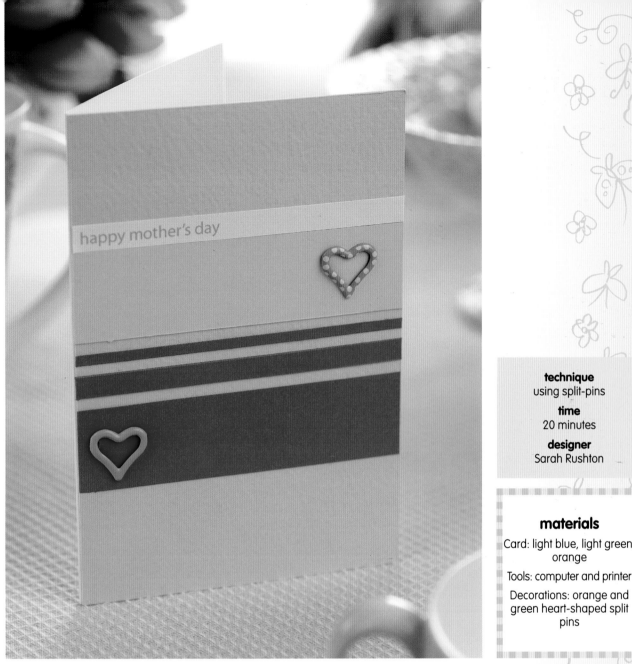

technique
using split-pins
time
20 minutes
designer
Sarah Rushton

materials

Card: light blue, light green, orange

Tools: computer and printer

Decorations: orange and green heart-shaped split pins

Mother's Pride

Experiment with split pins for instant decorative interest on your greetings – and show that you care in no time at all!

1 Cover the front of a 15 x 10cm (6 x 4in) card blank with light blue card, fixed in place with spray adhesive. Trim off any excess using a craft knife. Cut a strip of light green, 2.5cm (1in) wide, and position 5cm (2in) down the card front.

2 Cut three strips of orange, the first 0.5cm (¼in) wide, the second 1cm (³⁄₈in) and the third 5cm (2in). Fix below the green card as shown, spacing each one 0.5cm (¼in) apart. Print out a 'happy mother's day' label, using a light blue easy-to-read font. Trim and stick to card front.

3 Place an orange heart-shaped split pin to the right-hand edge of the green panel. Mark two holes with your craft knife to push the ends through. Repeat with a green split-pin to the left of the largest orange panel.

When sticking down wider pieces of card, use repositional spray adhesive to guarantee a smooth and durable finish

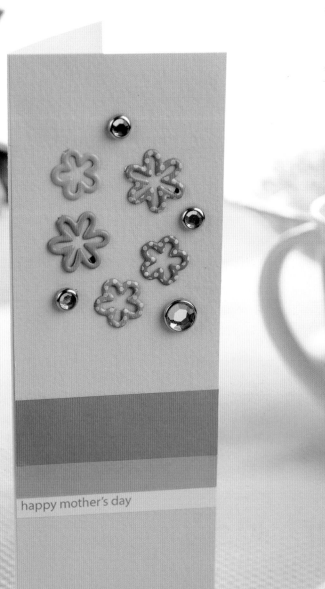

technique
cutting

time
30 minutes

designer
Sarah Rushton

materials

Card: white, light green, dark pink, light pink

Tools: computer and printer

Decorations: assorted flower split pins, jewel gems

Hello Petal

Highlight creamy pastels by arranging them in panels of varying widths then use jewel gems and split pins for charming accents.

tip

Use a panel of white card to cover the split pins on the inside of the greeting

1 Spray the front of a tall white card blank with adhesive and cover with light green card. Cut a 2.5cm (1in) wide strip of dark pink card and another, 1.5cm (⅝in) wide in light pink. Position on the front, as shown.

2 Print out 'happy mother's day' on a computer in pink using a font of your choice. Trim the label into a long strip the width of the card and stick it underneath the lighter panel.

3 Arrange five flower split pins and four jewel gems on the front, using a craft knife to poke small holes through the card to make it easier to attach the pins.

Candy Colours

If light colour schemes are just your bag you'll enjoy making this pretty card for Mother's Day. Its combination of ribbon, gems and gorgeous papers is a real winner!

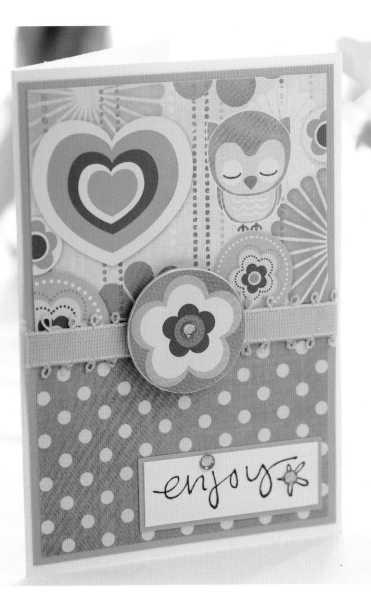

technique
combining patterns
time
15 minutes
designer
Maria McPherson

materials

Black ink-pad

Card: pink, white

Paper:' Indulgent', 'Green Apple'

Tools: sentiment stamp

Decorations: ribbon, crystals

1 Cut a pink card, 14 x 10cm (5½x 4in). Trim 9.5 x 7.5cm (3¼ x 3in) pieces from Indulgent and Green Apple paper. Stick on to the pink card to overlap slightly at the centre. To tie in the colours, and for a neat finish, trim the join with coordinating ribbon.

2 Cut a flower circle from Indulgent paper and attach to the centre of the ribbon trim. Stamp your greeting on to white card then mount it on pink and attach it to the decorated panel. Finish by sticking everything to an A5 card blank. Adding some crystals to finish.

tip

When mixing patterns choose complementary colours or shades that contrast with one another

technique
stamping

time
20 minutes

designer
Sharon Bennett

materials

Pink pastel ProMarker,
inks in pink, light green,
turquoise

Card: white

Paper: white

Tools: flower stamp

Don't blend
the colours on the
stamp too much – when
you've stamped a
couple of times you
get a lovely faded
effect

Girl Power

Stamp flowers on to pastel backgrounds, and shade them in three
different hues, to prove that multi-coloured can be tasteful too.

1 Fold white card blanks
in two different sizes.
Cut white paper to fit each
blank, leaving various lengths
of borders. Shade in the
backgrounds of the paper with
pink ProMarker or pastel paint,
varying the effect by making
some areas lighter, as shown.

2 Apply ink to the flower
stamp with a dauber.
Use three different shades
to get a multi-coloured effect.
Add pink at one side, light
green in the middle and
turquoise on the remaining
part. Stick one panel to the
centre of the smallest card
and embellish with tear-drop
gems top and bottom.

3 For the tall card, try
cutting out the stamped
flowers in circles and
mounting them vertically with
foam pads, putting the central
motif on a decorated panel.

Bloomin' Marvellous

For times when a mum-to-be perhaps isn't feeling her most glamorous, cheer her up with this ultra-feminine greeting.

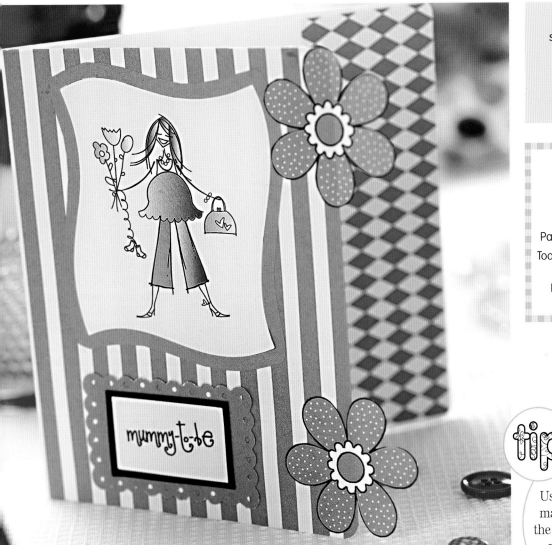

techniques
stamping, punching

time
35 minutes

designer
Kim Pearce

materials

Ink-pad

Card: pink. lilac

Paper: striped, harlequin

Tools: 'mum-to-be' stamp, scallop punch

Decorations: flowers

tip

Use an eyelet punch to make the holes around the edge of the sentiment panel as this can be easily lined up

1 Trim 3cm (1¼in) from the right-hand edge of a 15cm (6in) square blank. Cut striped paper to fit the face of the greeting and stick in place. Repeat with a harlequin pattern on the inside panel as shown. Stamp a 'mum to be' design on pink card and colour in.

2 Cut around the motif in a wavy pattern, as shown, then trim a slightly larger wavy lilac border to edge it. Write, or print, a suitable sentiment on to pink card, snip it into a 4.5 x 2.5cm (1¾ x 1in) panel, then layer it on to a slightly larger black panel.

3 Punch a scalloped 7.5cm (3in) lilac rectangle and make small holes around the edge. Stick the sentiment to the scalloped panel, then to the card front. Cut two flowers and mount half of each one along the right-hand edge, at the top and bottom of the card front.

technique
chalking

time
40 minutes

designer
Sarah Beaman

materials
Decorating chalk

Card: white, green, deep pink

Paper: floral, gingham

Decorations: pink doily, narrow ribbon, flower button

tip

Rummage around charity shops to find fabric doilies that you can dye, embellish, and use as focal points on your card designs

Rainbow Brights

With the 'granny chic' style becoming increasingly popular, even the humble doily gets a new lease of life!

1 Fold a 14.5cm (5¾in) square blank from white card and cover the face with green. Trim a 12.5cm (5in) square of floral paper and glue it centrally on the green square. Trim a 10cm (4in) square from gingham paper and glue it to a slightly larger square of deep pink card. Fold a small pink doily into quarters and trim along the straight edges to make four sections of doily with 5cm (2in) edges.

2 Colour around the edges and pick out details of each section using decorating chalk. Use spray adhesive to glue the sections on to the gingham square as shown, leaving a small border visible around the edge. Attach the decorated panel to the centre of the card with foam pads. Mount a 3cm (1¼in) square of floral patterned paper on to a slightly larger square of green card.

3 Use foam pads to stick the square point-up in the centre of the card. Glue an embroidered flower, snipped from some trim, in the centre. Tie narrow ribbon around the fold of the card, passing the ends through a flower-shaped button, before knotting them and trimming at an angle.

Buckle Up

Bringing back memories of days gone by and tattered antique photographs, Basic Grey's collection of decorative papers make for a trendy, unique look. With vintage style and worn textures, this classy number is sure to turn heads. Mix with decorative rub-ons and embellishments to make stunning, any-occasion cards.

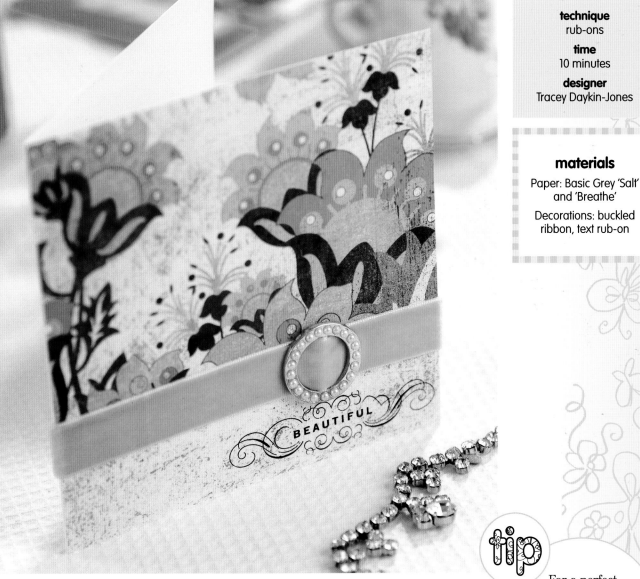

technique
rub-ons

time
10 minutes

designer
Tracey Daykin-Jones

materials

Paper: Basic Grey 'Salt' and 'Breathe'

Decorations: buckled ribbon, text rub-on

1 Cut and fold a 14cm (5½in) square card blank. Cover the bottom quarter with a panel of Basic Grey 'Salt' paper and the top section with 'Breathe' paper.

2 Carefully stick a pink velvet ribbon with attached pearl buckle across the join in the papers using double-sided tape. Add a rub-on sentiment underneath the buckle.

tip
For a perfect finish when adding ribbon to your cards, use a piece of double-sided tape to keep it in place

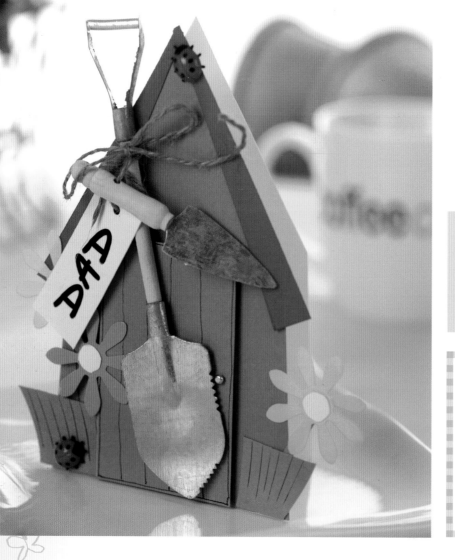

technique
3-D effects

time
one hour

designer
Jill Albas

materials

Soft pencil, fine pen

Card: brown, red, green, white

Tools: hole punch

Decorations: brad, die-cut flowers, string, miniature gardening tools, ladybirds

Green Shoots

Our garden shed is bound to stand out from the crowd. It does take a little time to make but we think special Dads are worth it.

tip

Draw the shed on tracing paper first then trace it on to the blank. This will give you a useful template for the future

1 Use a soft pencil and ruler to draw a simple shed shape on a brown blank: position one side along the fold and make the base 9cm (3½in) wide; the sides 7cm (2¾in) and the measurement from apex to base 14.5cm (5¾in). Trim two red card strips about 9.5cm (3¾in) long and fix in place to make the roof.

2 Cut brown card 8 x 5cm (3³⁄₈ x 2in) for the door. Fix a small brad halfway down one side, to make the handle, then use sticky tabs to fix in the centre of the shed. Add panelled details with a fine pen. Cut slim strips of green card, for stems, and glue either side of the door. Die cut flowers and fix to the top of the stems. Fringe green card and glue either side of the door.

3 Write 'DAD' on white card, trim and punch a hole through one end. Thread the tag with string and tie round the top of a couple of garden embellishments. Lay the card flat on your work surface and use strong craft glue to securely fix the tag and embellishments in position. Leave to dry and set thoroughly before moving. Finish off the decoration with a couple of ladybird embellishments.

Green Fingers

The 'grass roots' of any greeting is designing it for your target audience and then making it seem real – which is where quilling comes into its own!

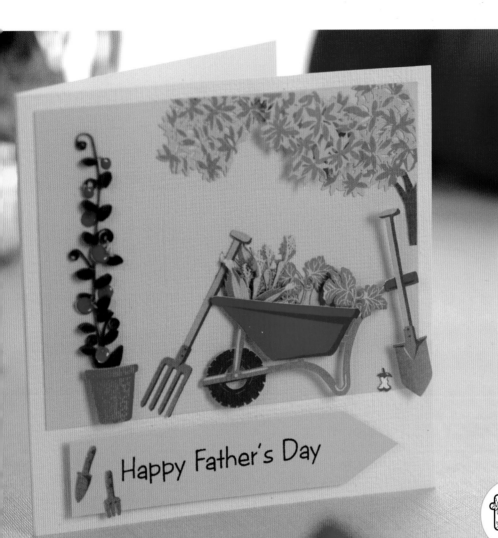

technique
quilling
time
50 minutes
designer
Elizabeth Moad

materials

Black ink-pad

Card: green

Paper: quilling, green and red

Tools: 'Happy Father's Day' stamp, computer and printer, quilling tool

Decorations: garden laser-cut shapes

tip Try varying the width of your quilling paper to achieve different results – coiled shapes are fun to experiment with

1 Print 'Happy Father's Day' on to green card using a computer. Trim to resemble the shape of a plant label and attach to the bottom of a blank. Mount a green panel to fit the front of your card blank above this, leaving a narrow border all around.

2 Cut out gardening shapes then position a plant pot on to a foam mat and rub with a bone folder to curve it. Mount on the main panel of the card. Make an open coil at one end of a strip of green quilling paper and glue above the pot. Create a closed loose coil with green quilling paper, pinch to a leaf shape, and glue to the greeting, as shown. Form more leaves and fix to the card. Coil red tomatoes and attach those too.

3 Mount the wheelbarrow with foam pads and secure vegetables along the top. Attach the fork and spade next to the wheelbarrow and stick an apple core in the bottom-right corner. Cut the tree into two sections and stick one half directly on to the greeting, fixing the other on with foam pads for dimension. To finish, stick a trowel and fork in place, as shown.

Best Man

Surprise your dad with the perfect card, decorated with sea blue stripes and large chipboard letters, to ensure his special day doesn' go unnoticed.

technique
easy apertures

time
30 minutes

designer
Tracey Daykin-Jones

materials

Large chipboard letters, lagoon blue, sea foam and lime ink-pads, clear embossing powder, slip ring

Paper: 'Seabreeze' striped and colour block

tip

Build up the gloss on chipboard letters with two or more coats of clear embossing powder

1. Cover the inside of an A6 card with 'Seabreeze' striped paper. Cover the front with 'Seabreeze' colour block paper. Trim the middle two squares from the front of the card creating an aperture. Ink large chipboard letters using lagoon blue, sea foam and lime ink-pads respectively. Ink several times to get an even colour, leaving to dry between applications.

2. When a solid colour is achieved, emboss the letters using clear powder. For a super-glossy finish, ink one final time. Stick the two 'd's either side of the aperture using foam pads, as shown. Punch a tiny hole in the centre of the card just above the aperture and, using a tiny slip ring, attach the letter 'a' so that it dangles.

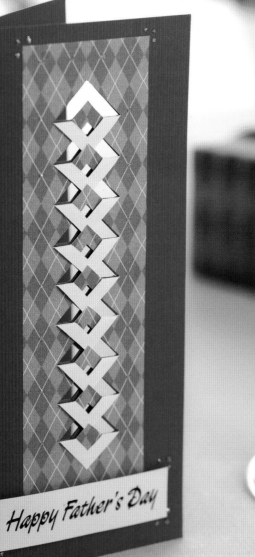

technique
lacé

time
40 minutes

designer
Elizabeth Moad

materials

3-D paint, silver

Card: blue, white

Paper: blue harlequin patterned

Tools: lacé template, craft knife

Decorations: rub-down lettering

tip

When cutting the lacé pattern from the template, keep moving both the guide and sheet so you are always working towards yourself

Lacey Days

Use lacé to create fascinating and adaptable designs that are especially effective on masculine-themed greetings.

1 Position the lacé template on to patterned paper, 15 x 4.5cm (6 x 1¾in), and secure in place with low-tack tape. Using a mat and craft knife, cut through each slot. Remove the guide, checking all corners have been cut – you will need to snip into the points of each one so that they are free.

2 Fold over every other triangular cut section and tuck it under the next point to create a linked effect. Put the paper to one side. Place a blue single-fold blank, opened out, on to a cutting mat. Position the lacé template on to the front panel and snip through the slots as before. Score a line across every other cut triangular piece.

3 Fold every other section over on the inside of the card and tuck it under the next. Mount the patterned paper to the front of the greeting. Add silver 3-D paint to the cross points and corners of the patterned paper. Leave to dry. Use rub-down transfer lettering or a pen to write 'Happy Father's Day' on white card. Mount to the greeting with foam pads.

Number One

If you don't have a badge maker to use, try laminating
the card and attaching a pin instead.

technique
shape cutting

time
15 minutes

designer
Elizabeth Moad

materials

Card: large star patterned,
plain blue and yellow

Tools: badge-making
machine, shape cutter or
computer and printer

Decorations: Rub-down
letters

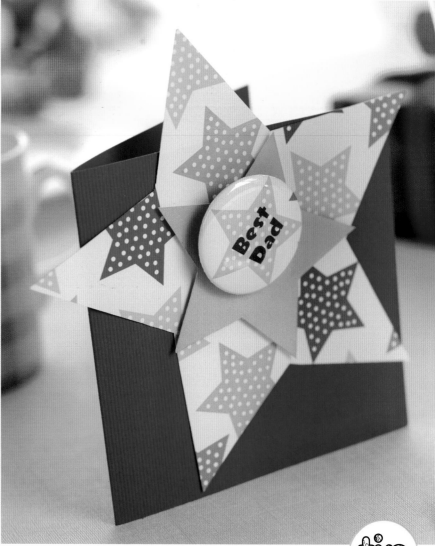

1 Cut a circle around a single star from patterned card, to fit the badge you are making. Use rub-down transfer letters or a black pen to spell 'Best Dad', as shown. Push into the machine with clear acetate and metal piece. Turn the handle, then insert the backing sheet. Turn again, then remove the finished item. Affix the pin.

2 Trim a large star from patterned card. Use a shape cutter or computer to create the motif, then make your own template if required. Attach the shape to a single-fold blue card at an angle, as shown, ensuring the points do not overlap the bottom edge of the greeting.

3 Snip a smaller star from yellow card and mount on to the larger motif using foam pads. Stick the badge to the shape with low-tack tape.

For quick and easy templates enlarge shapes from children's colouring books on a photocopier

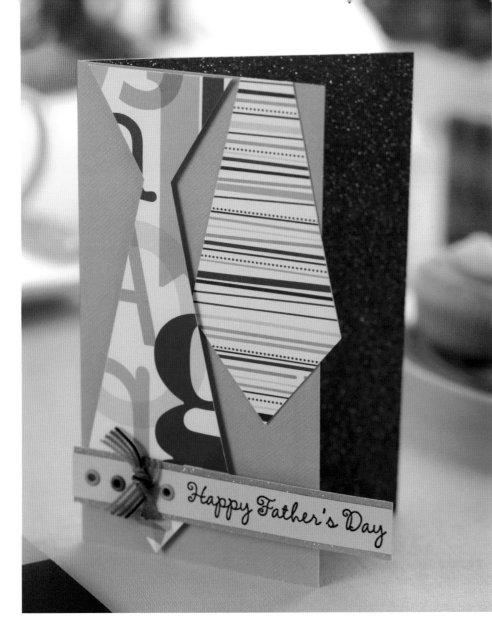

techniques
stamping, eyelet
punching

time
30 minutes

designer
Tracey Daykin-Jones

materials

Midnight ink-pad, clear
embossing powder

Card: blue jean and
pistachio sugar-coated,
white, pistachio

Paper: swimming pool,
seabreeze striped and
spellbound

Tools: 'Happy Father's Day'
stamp, heat tool, hole punch
and eyelet setting tool

Decorations: blue and lime
eyelets, blue striped ribbon

It's a Man's World

Create this fun, contemporary greeting using paper scraps from
your crafting stash then finish with a row of coordinating eyelets.

1 Take an A6 card and
cover the front with blue
jean sugar-coated card. Trim
off a 2.5cm (1in) vertical strip
from the front, along the
right-hand side, and cover
the inside front with swimming
pool paper.

2 Create a tie template
and trim out two motifs:
one from Sea Breeze striped
and another from Sea Breeze
spellbound paper, mounting
the striped tie on to white card
for stability. Use double-sided
tape to stick the spellbound
tie to card first, then add the
striped one, as shown, using
3-D foam pads.

3 Stamp 'Happy Father's
Day' on to pistachio card
using midnight ink and clear
emboss. Trim and mount on
to pistachio sugar-coated
card. Tie blue striped ribbon
around this piece then punch
two holes left of the ribbon and
one to the right. Set blue and
lime eyelets through holes and
mount this to card using 3-D
foam pads.

As the main tie has
been attached with
foam pads, you'll
need to double up on
these when adding
the Father's Day
sentiment

Zig & Zag

Use stars and stripes to decorate the main elements of this brilliant folded greeting, which uses a zigzag blank to announce the occasion.

technique
die-cutting

time
40 minutes

designer
Brenda Harvey

materials

Card: white, red, blue, gold mirror

Tools: Sizzix machine, Sassy Serif alphabet dies, small star punch, computer and printer

tip

Use the simple zigzag shape of this card to add extra interest and dimension to any design

1 Fold white card, 14 x 42cm (5½ x 16½in), twice to form the zigzag blank. Cut out 'U', 'S' and 'A' letters in white. Trim and cover just the top half of the 'U' and 'A', plus the bottom half of the 'S', in blue. Using the small star-shaped punch, press stars out of white and carefully glue in place over the blue backgrounds.

2 Cut strips of red card, 0.5cm (¼in) wide, and glue on to the other half of the letters, leaving a 0.5cm (¼in) gap between them to create the red and white striped effect. Carefully trim away the excess, then attach with 3-D foam pads. To add a little additional interest to this design set the 'U' and 'A' at the top of the page and the 'S' at the bottom.

3 Using a computer print out the 'Happy Birthday America', and 'Happy Fourth of July' messages in blue on to white paper and 'American Independence Day' in red on white paper. Tear the edges, glue on to strips of gold mirror card and attach to the white background, trimming neatly at each edge.

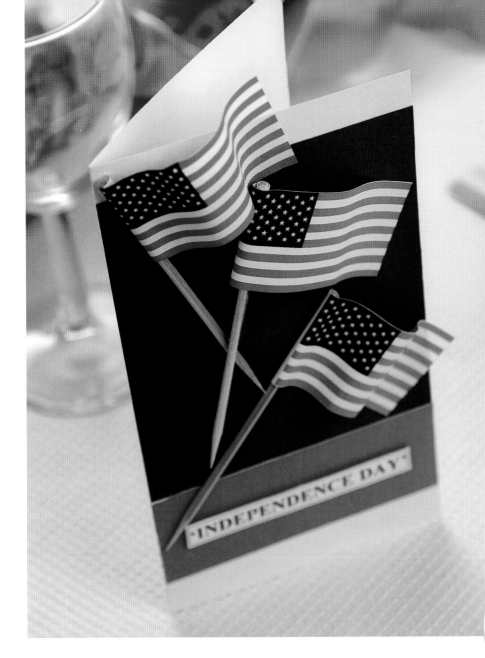

Check that your
cutting blade is sharp
or it will tear the
paper as you work

Flying the Flag

Celebrate Indepedence Day with this bold statement – flag designs
are easy to downoad from copyright-free sites on the internet.

1 Make a white card blank, 21 x 11cm (8¼ x 4 ³⁄₈in). Cut a rectangle of blue card 13.5 x 11cm (5½ x 4 ³⁄₈in) and a 4cm (1½in) trip of red. Stick the coloured cards to the front of the blank with spray glue; the blue at the top with the red underneath. Type and print out the words 'Independence Day' using Times New Roman 22pt in blue with a red border. Trim

to neaten and mount on to card the same size then fix on to red strip with 3-D foam pads.

2 Print out the flag designs three times and trim to 4 x 7cm (1½ x 2¾in) leaving a plain strip on the side of each. Stick a strip of double-sided tape to the back of the plain section of each flag and roll it on to the top

of a wooden skewer cut to 12cm (4¾in) long.

3 Assemble the three flags then fix to the front of the card at various angles, secured with tape. Attach the ends of the flags to the card so that they are slightly bowed, to give the impression that they are flying in the wind.

technique
fraying

time
40 minutes

designer
Jill Alblas

materials

Red fabric

Card: blue, white

Decorations: iron-on diamanté star, crystal gems, red, white and blue narrow ribbon

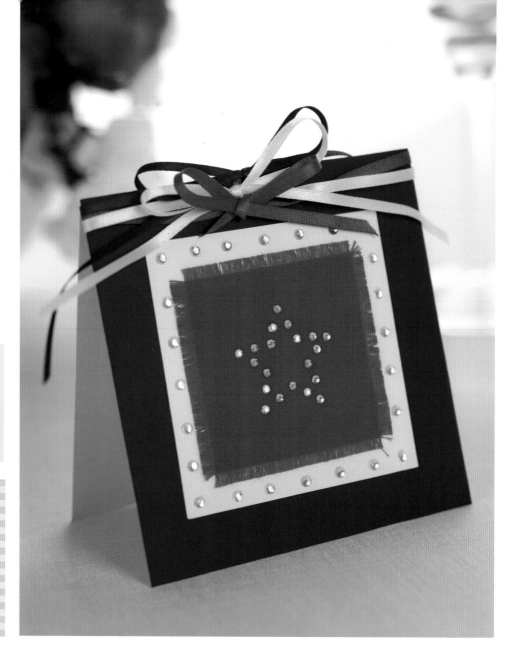

A star shape button or large crystal star could be used as an alternative to the iron-on motif

Square Dance

Add a little glitz to the occasion with a sparkly star and tiny crystal gems. To top off the design, tie red, blue and white ribbons in a bow.

1 Trim a blue blank 10.5cm (4¼in) square and fix white card 7.5cm (3in) square in the centre. Cut red fabric 6cm (2¼in) square and fray the edges. Following the manufacturer's instructions, fix an iron-on diamanté star in the middle of the fabric. Fix the decorated fabric in the centre of the white card.

2 Glue crystal gems around the white card. Position with the fold at the top and tie with narrow red, blue and white ribbons.

Stars & Stripes

What better way to spell out the 4th of July than with the American flag in the background? All you need to do is cut the text from a pre-printed motif.

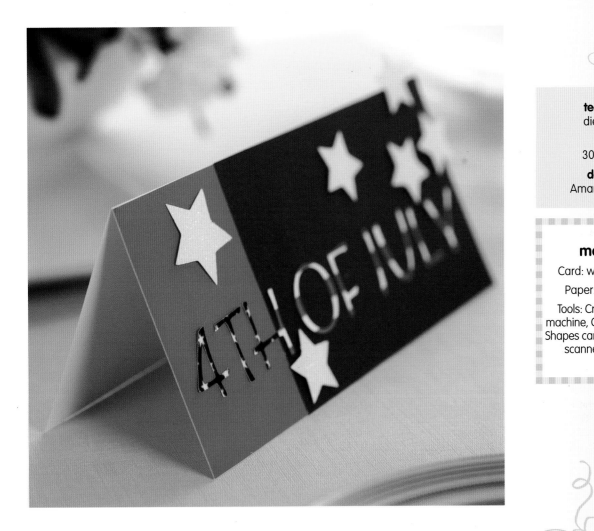

technique
die-cutting

time
30 minutes

designer
Amanda Walker

materials

Card: white, red, blue

Paper: white glitter

Tools: Cricut die-cutting machine, George and Basic Shapes cartridge, computer, scanner and printer

1 Make a white horizontal blank, 9 x 20cm (3½ x 8in). Now stick a red rectangle, 9 x 5.5cm (3½ x 2 ⅛in), to the left-hand side and a blue rectangle, 9 x 14.5cm (3½ x 5¾in) to the right.

2 Scan an American flag motif into a computer, enlarge to 16 x 9cm (6¼ x 3½in), and print out on thin

white card. Snip to fit the size of the Cricut cutting mat, then cut out the words '4th of July' in 2.5cm (1in) high letters, using the George and Basic shapes cartridge.

3 The '4th' should cut out across the stars part of the flag, just edging into the stripes, and 'of July' should all be trimmed in the stripes.

Stick the letters across the blank using spray adhesive. Position the 'H' over the red and the blue edges.

4 Cut out stars in white glitter paper and stick these with foam pads randomly to the front of the card, where space allows.

tip

To stop letters from moving when sticking down, spray a sheet of paper very lightly with adhesive, then place the letters face down on to it

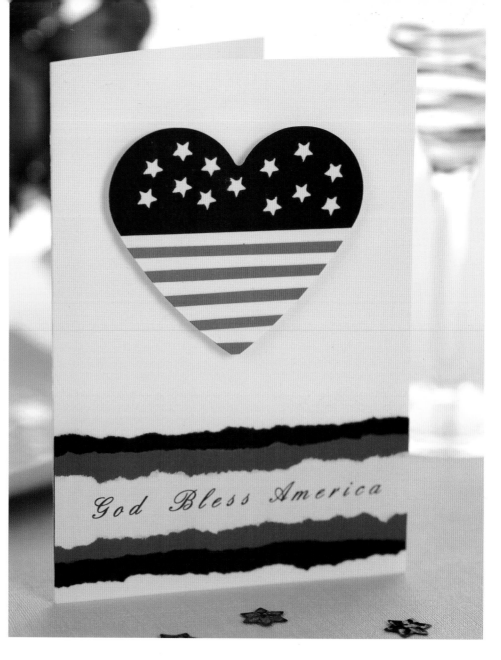

techniques
tearing, punching

time
20 minutes

designer
Brenda Harvey

materials

Card: white,
red, blue

Paper: white

Tools: computer and printer,

large heart and small star
punches

The tiny
white stars on the
top half of the heart have
been punched into blue card
which has then been glued on
top of white. This is much
easier than having
to stick individual
stars in place

God Bless America

Celebrate the fourth of July with this patriotic greeting, which
uses the three colours of the American flag to great effect.

1 Fold A5 white card in half to form a blank. Using a computer print out 'God Bless America' on to white paper in a scripted font. Tear the edges, glue on to a torn strip of red card and then on to a torn piece of blue. Stick the torn panels in place at the bottom of the greeting.

2 Punch the large heart shape out of white card. Press just the top section of the heart out of blue and, using a small star-shaped punch, cut stars from this blue section. Carefully glue the blue piece in place over the white heart, to create the effect of white stars on the blue background.

3 Cut strips of red card, 0.3cm (1/8in) wide, and glue these on to the bottom half of the white heart, leaving a 0.3cm (1/8in) gap between them to create a red and white striped effect. Carefully trim away the excess. Attach the heart to the card with 3-D foam pads.

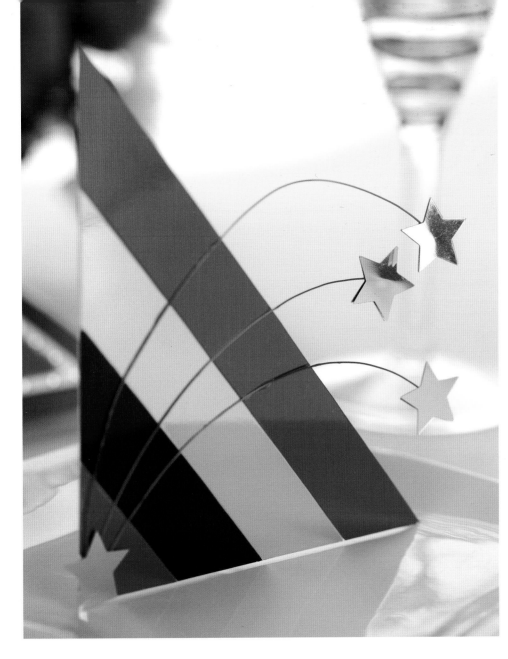

Star Appeal

Striking in its simplicity, this bold design can't fail to be noticed.
Team metallic card with red and blue for a patriotic celebration greeting.

1 Trim a blank diagonally to make a triangle 13 x 10.5cm (5 ⅛ x 4¼in). Cut strips of red, blue and silver mirror card, 2cm (¾in) wide. Fix a red strip along the diagonal then trim the ends neatly. Fix a silver strip next, followed by blue then red.

2 Cut three pieces of wire each about 17cm (6¾in) long and bend into a curve. Glue the end of each wire to a star then glue another star on top. The wire will now be sandwiched between two stars. Leave to dry.

3 Apply glue to the wires and fix across the front so that the tips meet in the bottom left-hand corner. Cover the ends with a star and leave to thoroughly dry.

tip

Apply glue to the wires with the tip of a pin or cocktail stick. This may sound fiddly but it's actually a very quick and clean way to work

Summer Fun

Curves and corners

Mirror the gentle contours of decorative flowers by curving the edges of a card blank and patterned panel – and add petal pizzazz with vibrant colours

Busy and bright

Mount summer-themed motifs on to plain, bold circles so that they project from a busy pattern. Substitute sea with ricrac and make a matching tag from scraps

Presents for pals

Stamp greetings to create gorgeous, glamorous cards for your girlfriends in no time at all! Ink them in colours to match die-cut motifs and zip up the presentation with sizzling spots

Bag it up

Transform a plain card blank into a cute clutch bag by cutting a circle, the same diameter as the width of the blank, from patterned paper and folding it in half along the top spine

Girl power

Stamp funky messages and motifs on to die-cut tags, attach to a patterned panel edged with stars and present them on a vivid yellow blank – perfect for fun-loving teenagers

Stars and stripes

Say 'let's celebrate' loud and clear by mixing contemporary striped paper, stars and bold paper panels. A matching inside strip really provides a cutting edge

Sugar sweet shades

Mouth-watering sugar almond colours make a combination no summer baby can resist. Add crystals to a die-cut butterfly for a glamorous glint

Confection perfection

When it comes to mixing patterns it's often the case of the more the merrier, so never be afraid to experiment! Take inspiration from your main motif and let the colours flow

Ways with windows

Present fun motifs on acetate in different sized apertures – teamed with a bright paisley-styled pattern, they're sure to stand out from the crowd

Get personal

Children love having their name on a card – it makes them feel extra-special. Add lettering with clear, unmounted stamps on an acrylic block so that you can position letters precisely

Bunny girl

For a card that says 'happy birthday' in no uncertain terms, cram pretty patterns into as much space as possible. Doodling swirls is the ultimate in contemporary creativity

Foam formation

Use corrugated card and funky foam to create a tactile mosaic-effect that requires no written greeting – simply top with emellishments and a cartoon-style cake

Harmonious hues

Team bold pinks and blues with cool peppermint green on a fresh floral greeting that requires very little else

Patterns and prose

Humorous quotes are perfect for fun-loving friends and family members, so why not let pre-printed papers do the talking

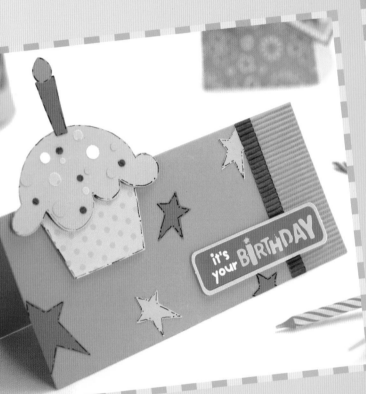

Icing on the cake

Highlight die-cut shapes with a fine liner, and mount a cake so that it protrudes above the top of a tent-fold card, to guarantee that your birthday wishes really stand out

Core of the matter

Tear paper upwards if you want the paper core showing – it's a great way of leading the eye to any all-important motifs above it

Falling Leaves

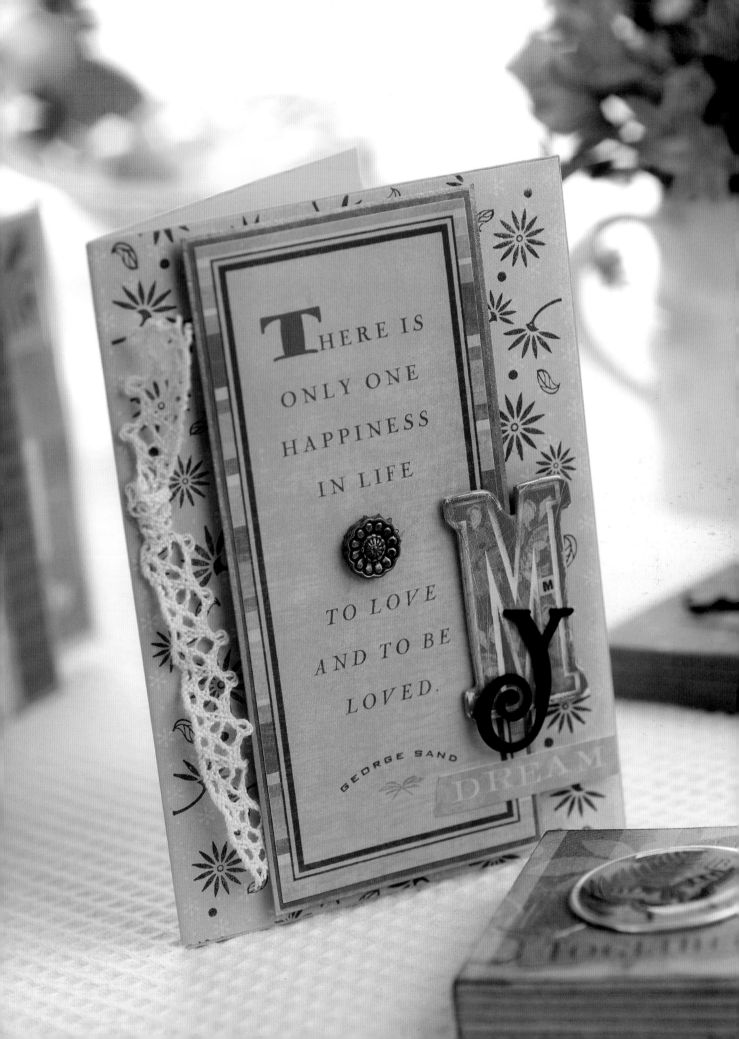

Ace of Spades

A green fingered grandpa would really appreciate this card on Grandparent's Day. Use dolls' house miniatures for perfectly scaled-down items that look enchanting.

technique
tearing

time
30 minutes

designer
Brenda Harvey

materials

Card: green

Paper: white, brown kraft

Tools: computer and printer, glue gun

Decorations: miniature gardening tools, string

1 Fold a white 14cm (5½in) card blank. Using a computer, print out the names of flowers and vegetables in green on to white paper using Bradley hand font. Tear the edges, glue on to brown kraft paper, 11cm (4½in) square, and layer this on to a slightly larger square of green card.

2 Print 'Happy Grandparent's Day Grandpa' in green on to white paper using Viner hand font. Tear the edges and layer on to green card.

3 Use a glue gun to firmly attach the handles of a rake and spade to the background – the message banner will cover up any glue that has spread. Use 3-D foam pads to secure the head of the rake, the bottom of the spade and the banner.

4 To finish, add a folded insert sheet and tie a length of garden string around the centre in a double knot.

tip

A hot-melt glue gun is the best way to firmly fix bulky decorations in place but it can be messy, so position your message over them to disguise any unsightly blobs

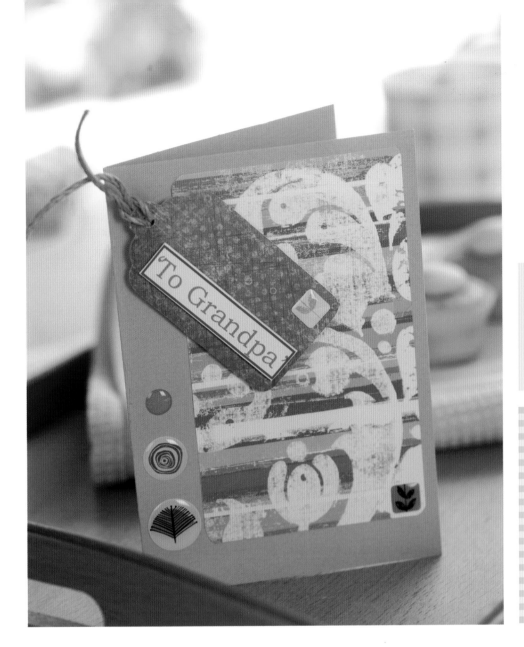

technique
punching

time
15 minutes

designer
Amanda Walker

materials

String

Card: blue

Paper: K&Co, Urban Rhapsody, striped and spotted

Tools: corner punch, computer and printer

Decorations: s.e.i epoxy stickers, Madera Island

Twirls & Swirls

The bright colours and bold patterns on this card are sure to bring a smile to your grandpa's face on his special day!

tip

Use a corner punch to ensure that each corner of the backing paper is evenly rounded

1 Make a blue blank, 15 x 10.5cm (6 x 4¼in), then glue a slightly smaller panel of stripe-patterned paper on top, rounding off the corners before sticking in place.

2 Cut out a gift tag from spotted paper, tie a length of string to the top, then stick with 3-D foam pads to the top left-hand corner of the card at an angle.

3 Fix three epoxy stickers along the left-hand side of the greeting, another to the lower right-hand side of the striped paper and one to the corner of the tag.

4 Finally type 'To Grandpa' in Bookman Old Style font in orange with a blue border around it. Print, then cut out and fix to the tag.

Pastel Perfect

Your grandma is sure to love this pretty floral-inspired greeting, which is ideal for showing her just how much you care this Grandparent's Day.

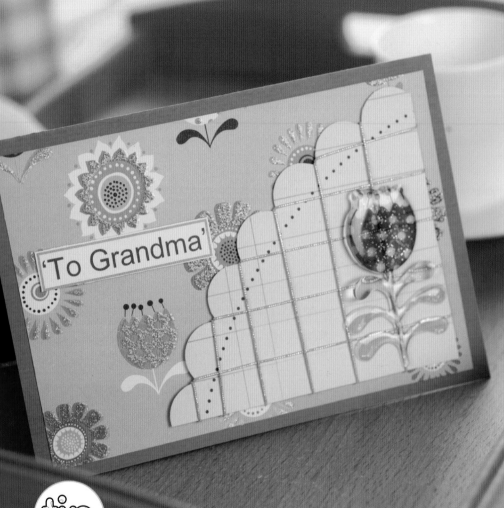

technique
spirelli

time
30 minutes

designer
Amanda Walker

materials

Card: pale blue, Making Memories scallop-edged, pink

Paper: floral

Tools: computer and printer

Decorations: pink elastic

tip

If you can't find ready-prepared scallop-edged card, then make your own by drawing a curved cloud like pattern on card and slicing with a craft knife

1 Make a pale blue card blank, 16 x 11cm (6¼ x 4¼in), then turn so that the fold is at the top. Stick floral backing paper, cut slightly smaller, with spray adhesive.

2 Cut a section from a scalloped circle to fit one corner and wrap the pink elastic vertically, then horizontally, around it. Anchor the ends with tape.

3 Stick this piece to the right of the card with 3-D foam pads. Type 'To Grandma' in Ariel font with a pink border. Print, cut out and stick to the left-hand side of the greeting.

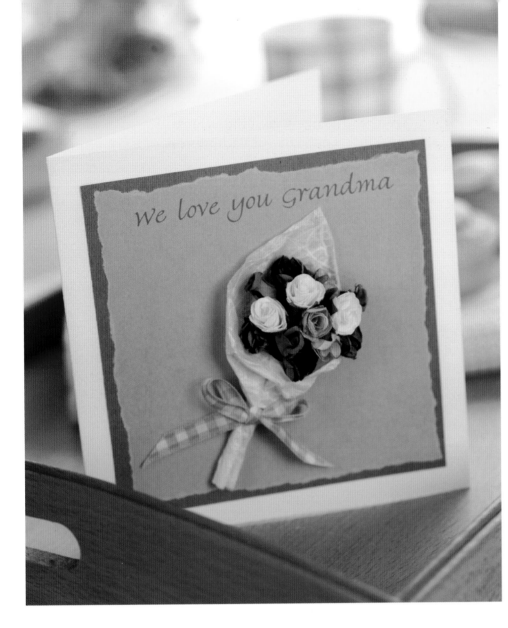

technique
paper crunching
time
25 minutes
designer
Brenda Harvey

materials

Card: white, pink

Paper: lilac,
white mulberry

Tools: computer and printer,
glue gun

Decorations: wire-stemmed
paper roses, pink gingham
ribbon

Bed of Roses

This beautiful bouquet of roses makes a lovely card for a very special Grandma, and best of all, the design can be easily adapted to suit a whole range of occasions.

1 Fold a 14cm square white card blank and layer with pink. Using a computer print out 'We love you Grandma' in pink on to lilac paper using Fine Hand font. Tear the edges and glue in place.

2 Cut white mulberry paper, 10cm (4in) square and screw it up tightly into a ball. Open it up, then flatten out. Form a selection of wire-stemmed paper roses into a bouquet, winding the stem of one around all of the others to fasten them together.

3 Lay the flowers down on the mulberry paper, add a few drops of hot-melt glue, and wrap the paper around them. Trim the ends and tie a length of pink gingham ribbon around the stems. Attach the bouquet to the card with a glue gun.

By screwing the mulberry paper into a tight ball, then flattening it out, you will soften the fibres and make it easier to work with

Light the Way

All you need to create the curved arms on this design is a simple circle cutter. If you don't own one, draw the half-circle shapes using a compass and cut out with scissors or a craft knife.

techniques
cutting, tearing

time
30 minutes

designer
Brenda Harvey

materials

Card: white, turquoise, orange; mirror, gold

Tools: circle cutter, computer and printer

Decorations: gold elastic cord

1 Fold a white 14cm (5½in) square card blank, then layer gold mirror card, 12.5cm (5in) square on top using 3-D foam pads. Cut a series of half-circle lines in gold mirror card with the circle cutter, 0.5cm (¼in) apart.

2 Start with the largest measurement first – which is 8cm (3¼in) in diameter – then cut every 0.5cm (½in) down to 3cm (1¼in). This will give you a set of half-circle shapes that can now be cut free from the backing sheet.

3 Discard the alternate pieces. This will leave three sections for the arms which, when placed in a 'nested' layout will give an even gap between them. Cut gold mirror card, 6 x 0.5cm (2¼ x ¼in), to form the central post of the candlestick, and glue this on to turquoise card 11.5cm (4½in) square.

4 Glue the 3cm (1¼in) diameter half-circle in place to form the base. Add the three 'arms' and glue slim strips of white card, 2.5 (1in)

long, above each to represent the candles. Using a computer print out 'Rosh Hashanah' in blue on to white paper, then tear the edges and glue in place, trimming the sides.

5 Cut seven tiny 'flames' from orange card and stick down. Layer the turquoise section on to gold mirror card with foam pads. Add a folded insert and tie a length of gold elastic cord around the centre in a double knot.

tip

Attach double-sided tape to card before you cut small, fiddly shapes, for a precise and mess-free way of fixing them in place

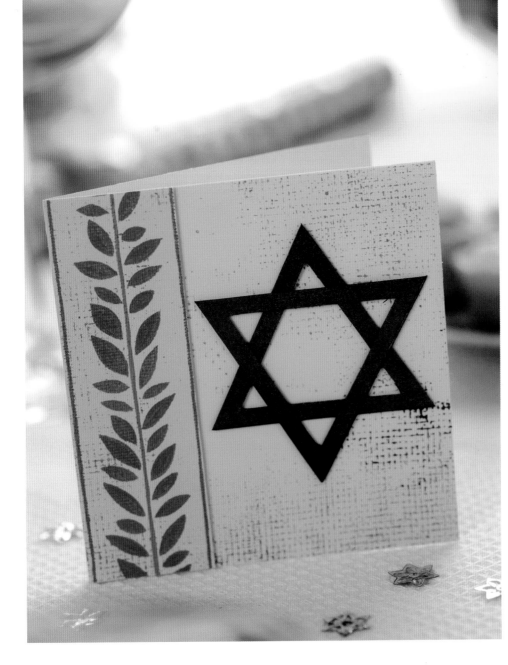

technique
pattern building

time
20 minutes

designer
Amanda Walker

materials

Card, yellow, blue

Paper: textured yellow, patterned leaf

Shining Star

This simple greeting, finished off with a bright blue star,
will make a thoughtful contribution to the Jewish New Year.

1 Make a yellow blank, 10.5cm (4¼in) square. Cut yellow textured backing paper to fit the front and use spray adhesive to fix it smoothly in place.

2 Trim a 3.5cm (1 ³⁄₈in) wide strip from leaf-patterned paper, then stick with 3-D foam pads to the left-hand side of the greeting.

3 Cut out two triangles from blue card. Stick them together, to make a star, then secure with 3-D foam pads to the right-hand side of the blank.

The star for this project is made from two equilateral triangles

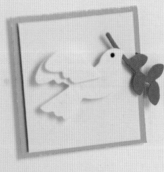

Flying High

Bring in the Jewish New Year in style with this elegant greeting complete with a beautifully peaceful dove and Hebrew 'Shalom'.

1. Fold A5 white card in half to form a vertical blank. Write 'Shalom' with an embossing pen, sprinkle with gold embossing powder, then heat until melted. Attach gold mirror card, 5cm (2in) square, at the top of the greeting using 3-D foam pads.

2. Using a QuicKutz machine and die, cut the dove shape out in white. Glue a tiny piece of black behind the eyehole and stick on to white card, 4.5cm (1¾in) square, with 3-D foam pads. Cut the olive branch in green and fix behind the beak.

3. To increase the 3-D effect of the dove, position a separate wing shape on top of the bird. To finish, carefully layer the white square on to gold mirror card with foam pads, ensuring that the narrow border is even on all sides. Fasten to the top of the greeting.

tip

If you're not confident writing the message freehand, try using a computer to print out your chosen text on lightweight card in a scripted font, then trace over the wording with an embossing pen

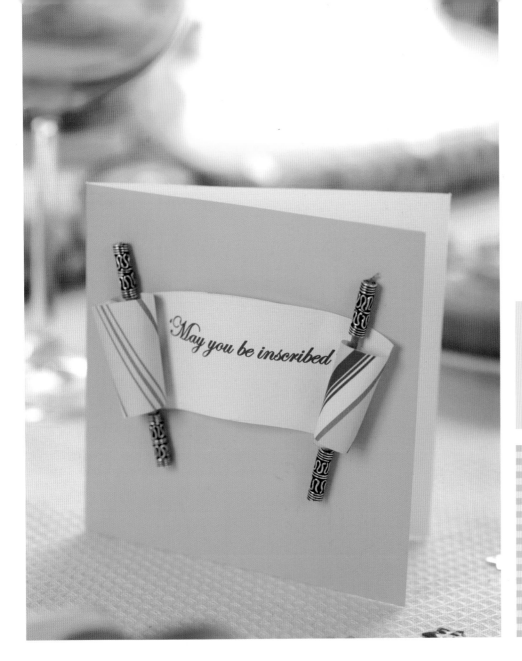

materials

Cocktail sticks

Card: green

Paper: DCWV floral printed stack, striped

Tools: computer and printer

Decorations: metal cylinder beads

Roll Up

Wish a special friend a Jewish New Year filled with good wishes by creating this simple scrolled design.

1 Make a green blank, 11cm (4³⁄₈in) square. Cut off the sharp ends of two cocktail sticks, then stick metal cylinder beads to each end using a little jewellery glue. From the patterned paper, cut a strip, 15 x 4cm (6 x 1½in).

2 Place tape at each end, then roll the two ends of the strip a little way around the two beaded sticks, on the wrong side of the paper so that the pattern appears as it is rolled. Fix the scroll to the front of the greeting.

3 Using your computer, type the words 'May you be inscribed' in a lilac scripted font and print on to white paper. Cut around the text to fit in the centre of the scroll and secure using double-sided tape.

Rescue beads from any old or unwanted garments – they can add a real 3-D emphasis to your designs

technique
tearing
time
20 minutes plus
drying time
designer
Brenda Harvey

materials

Gold glitter glue, Liquid
Pearl in white opal

Card: green, black

Paper: purple

Tools: computer and printer

Decorations: die-cut spider

Web Watch

The creative use of glitter glue and Liquid Pearl makes
this creepy spider appear alive and ready to jump!

tip

The simple
combination of black
with bright green and
purple is spot on
for a striking
Halloween design

1. Fold A5 green card in half. Draw a freehand spider's web shape, first with a pencil then outline with glitter glue, and leave to dry thoroughly. Die-cut a spider motif from a black blank and dot eyes on with Liquid Pearl.

2. Using a computer, type 'Don't get caught in the Spider's web!' in 'Cracked' font, then print out on purple paper and tear along the top and bottom edges.

3. Glue the message strip to a torn length of black card. Stick at the bottom of the greeting. Secure the spider in place with 3-D foam pads.

Funny Bones

These skeleton dies are guaranteed to create
a jolly spirit this Halloween, quite literally!

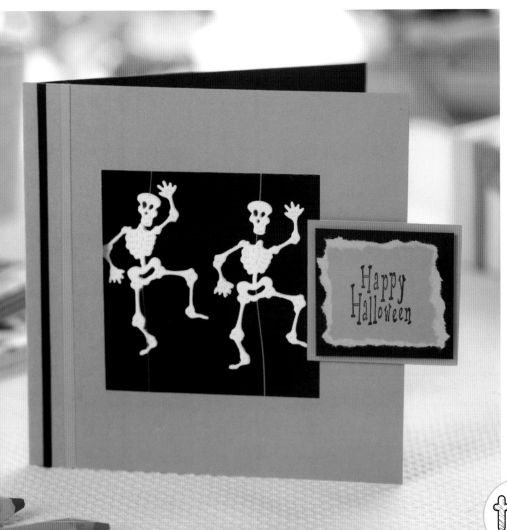

technique
tearing

time
25 minutes

designer
Brenda Harvey

materials

Fine nylon thread, black
ink-pad

Card: green, black, white,
orange

Tools: 'Happy Halloween'
stamp

Decorations: die-cut
skeletons

When using
cut-outs in an open
window format make
sure that the colour of
the inside page acts
as a good contrast

1 Fold a 14cm (5½in) square green card blank. Cut a black square the same size and stick it to the right-hand inside page. Trim a window, 8cm (3¼in) square from the front. Die-cut four skeletons from white card. Cut two lengths of fine nylon thread, long enough to run from the top to the bottom of the bodies. Glue the pairs together, sandwiching the thread in between.

2 On the inside, place double-sided tape across the top and bottom of the window. Position the skeletons so that they sit centrally in the aperture and press the nylon threads firmly into place. Add strips of double-sided tape to both sides of the window too. Cut an 8cm (3¼in) square from black card and attach to the inside of the window to tidy.

3 Cut a 5 x 5.5cm (2 x 2¼in) orange rectangle and mount a slightly smaller black panel on top. Stamp 'Happy Halloween' in black ink on green card, tear the edges and glue on to the layered orange and black panels. Attach to the right-hand edge of the greeting, as shown. Fix narrow vertical strips of black and orange to the left edge.

Spooky Looks

The combination of silver, black and purple are the perfect way of ensuring that Halloween party invitations are an absolute scream!

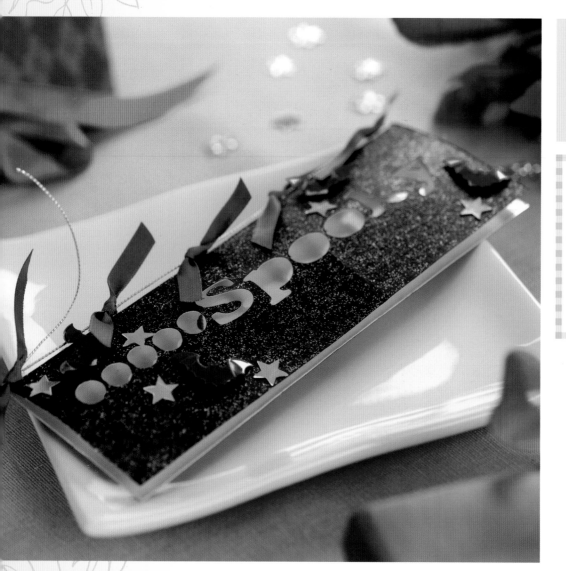

technique
die-cutting

time
40 minutes

designer
Jill Alblas

materials

Card: silver mirror, black glitter

Tools: die-cutting machine

Decorations: die-cut dots and wording, purple metallic bats, silver stars, purple ribbon, silver cord

1 Use the font and size of your choice to die-cut five or six small dots, and the word 'spooky', from silver mirror-card. Make a horizontal card blank from black glitter card and add dots and lettering to the front, as shown.

2 Stick silver mirror card to fit the inside back cover of the blank. Tie the fold with silver cord then knot five or six pieces of purple ribbon along the length cord. Decorate with a few metallic bat embellishments and some silver stars.

tip

Don't discard the die-cut letters. These can be used for other projects

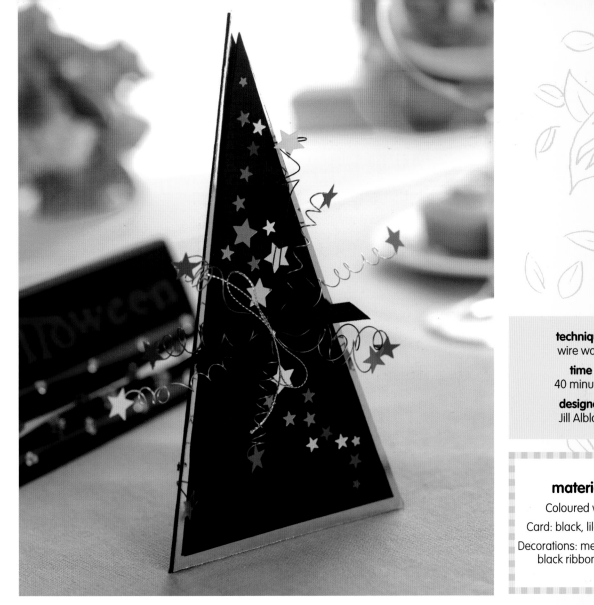

technique
wire work

time
40 minutes

designer
Jill Alblas

materials

Coloured wires

Card: black, lilac mirror

Decorations: metallic stars,
black ribbon bows

Star Turn

Coils of wire and brightly coloured stars bring a touch of drama
to this simple design.

1 Trim a black triangular blank 18.5 x 9.5cm (7¼ x 3¾in) and fix lilac mirror card to the front. Cut a slightly smaller triangle from black card and fix in the centre. Next, cut four different colours of wire, each about 25cm (10in) long and coil the ends around a pencil.

2 Use strong craft glue to fix a metallic star at the end of each wire then leave to dry. Use a glue dot to fix one of the wires across the centre of the blank, then fix the remaining three wires on top in the same way. Cover the wires, and give a neat finish, by gluing a couple of bows in the centre. Embellish with a selection of stars.

tip

Apply a few tiny spots of craft glue to the wire coils. This will help hold them firmly in place on the front of the blank

Black Magic

Black card provides an atmospheric backdrop for a bold design with a hint of fun that's perfect for a Halloween invitation.

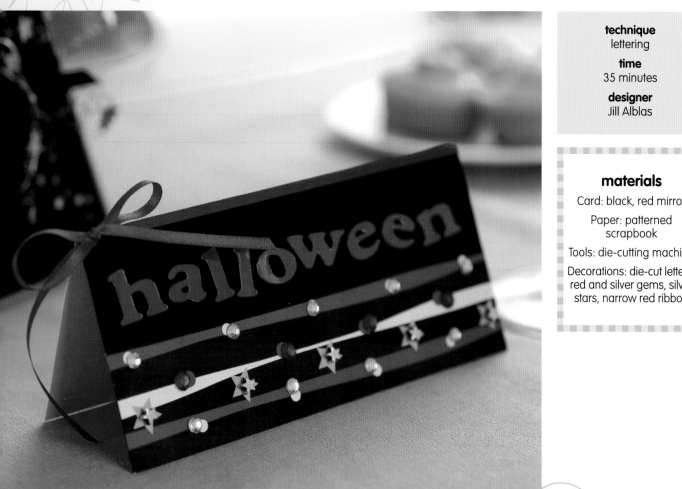

technique
lettering

time
35 minutes

designer
Jill Alblas

materials

Card: black, red mirror

Paper: patterned scrapbook

Tools: die-cutting machine

Decorations: die-cut letters, red and silver gems, silver stars, narrow red ribbon

1. Trim a horizontal black blank 7 x 15.5cm (2¾ x 6¼in). Die cut 'halloween' from red mirror card and fix in a wavy line about 3cm (1¼in) down from the fold.

2. Trim scrapbook paper about 3.5cm (1³⁄₈in) wide and fix along the bottom of the blank – we selected a black paper with stars and stripes.

3. Embellish the paper with sparkly gems and silver stars then tie the fold with narrow ribbon.

Arranging your word in a wavy line not only looks effective but also saves space and is much quicker and easier than lettering in straight line

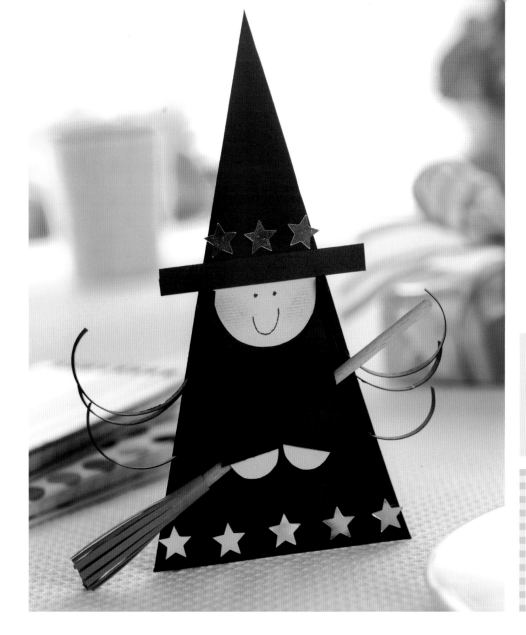

technique
fringing

time
15 minutes

designer
Jill Alblas

materials

Black pen, pink pastel, small wooden stick

Card: black, pink, brown

Decorations: metallic stars

Fright Night

This quick and easy design will be remembered long after most cards are discarded and forgotten.

1. Trim a triangular blank 17 x 9cm (6¾ x 3½in) and fix black card to cover the front. Make the brim of the hat from black card 1 x 7cm (⅜ x 2¾in) and fix across the blank, 8cm (3¼in) from the top. Cut a 3.5cm (1⅜in) diameter semicircle from pink card and fix under the hat. Use a black pen to add eyes and a smile then colour the cheeks with a little pink pastel. Trim six thin strips of black card. Curl the ends by running them along your thumbnail or the edge of a blunt knife then glue in position either side of the witch's face.

2. Fringe a scrap of brown card or paper. Wrap it tightly around the end of a small wooden stick, glue at an angle across the front of the blank, and leave to dry.

3. Trim two black card triangles for the sleeves and glue them on top of the broomstick with the tips either side of the witch's face. Make the hands from two small, pink card semicircles and glue them at the end of the sleeves. Embellish with metallic stars.

tip

If you're short of time, omit the broomstick and sleeves and simply decorate with additional stars

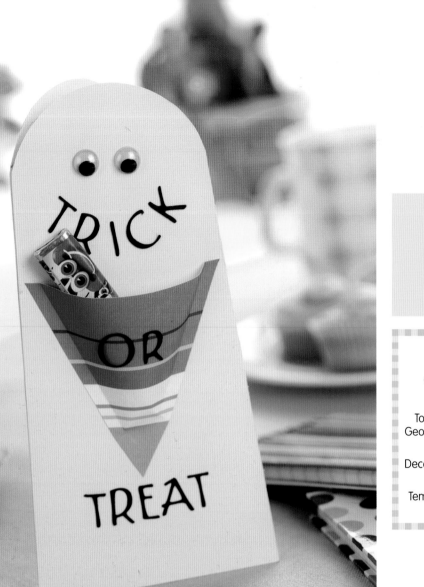

technique
folding

time
20 minutes

designer
Amanda Walker

materials

Card: white, black

Paper: striped

Tools: Cricut machine,
George and Basic shapes
cartridge

Decorations: goggle eyes,
sweets

Template: ghost-shaped

tip

Arranging
'trick' in an upwards
curve underneath the
eyes is the perfect way
to give the ghost
a cheeky grin

Ghostly Treat

Give trick or treaters a surprise when they come knocking at your
door, by getting them to choose their candy from this ghostly pouch.

1 From the template
provided, cut out the
ghost-shaped blank in white.
Trim 'Trick or Treat' in black with
the Cricut, using the 'George
and Basic shapes' cartridge.

2 Cut the triangle shape
on the front of the ghost
template from striped backing
paper. Score along the broken
lines indicated, then stick to
the front of the blank. Push the
two sides towards each other
to make a pocket.

3 Stick two goggle eyes
to the top of the greeting,
the 'Trick' letters in a curve
underneath the eyes, the 'or'
on the pocket and finally the
'Treat' at the base of the card.
Fill with sweets to complete.

Pumpkin Pie

Carve your own spooky pumpkin, without the mess,
by creating a scary bright orange greeting.

technique
cutting

time
15 minutes

designer
Amanda Walker

materials

Card: black, black glitter,
orange

Tools: computer and printer

Template: pumpkin

tip

When cutting
straight lines, use a
craft knife and metal
ruler for neat, precise
results

1 Make a black blank, 12.5 x 9.5cm (5 x 3¾in), then turn so that the fold is at the top. Lay the pumpkin template on to the base of the front, then draw the curved outer edges on to the card. Remove the template and cut along the curved lines.

2 Trim black glitter card to the same shape and stick to the front of the greeting with spray adhesive. Using the template provided, cut out the pumpkin shape in orange and fix on top with foam pads.

3 Type the words 'Happy Halloween' in Matisse ITC font with an orange border around it. Print and cut out the text, then stick at an angle to the top of the pumpkin head.

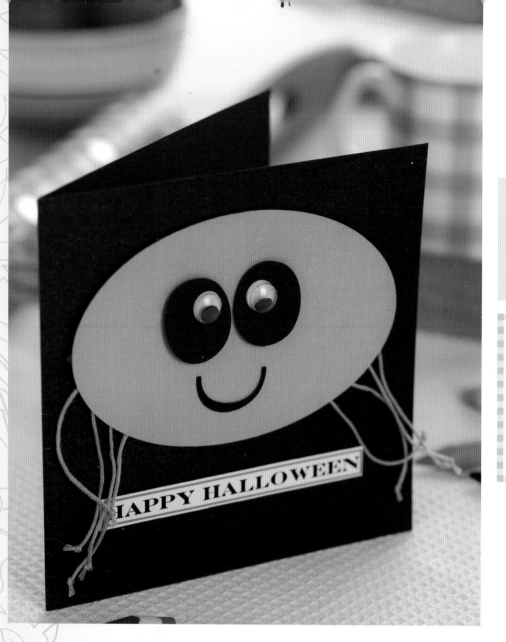

technique
cutting ovals

time
20 minutes

designer
Amanda Walker

materials

Card: navy pearlised, orange, black

Tools: computer and printer

Decorations: orange embroidery thread, goggle eyes

tip

The eyes for this card are used for soft toys and can be found in any haberdashery department

Creepy Crawley

This spooky spider, complete with moving eyes and string-like legs, is sure to be watching you at every turn!

1 Make a blank, 13.5cm (5¼in) square, from navy blue pearlised card. Trim an oval shape from orange card, then cut out eight, 8cm (3¼in) lengths of embroidery thread and tie a knot at the end of each one.

2 Stick the thread in groups of four to either side of the oval. Cut out two small ovals from black card, stick a goggle eye to each, then glue these to the front of the orange shape. To complete the face, snip a smiley mouth from black and fix in place.

3 Secure the completed spider on the front of the card with 3-D foam pads. Finally, type the words 'Happy Halloween' in Engravers MT font with an orange border around it. Print and cut out the wording, then stick to the base of the spider.

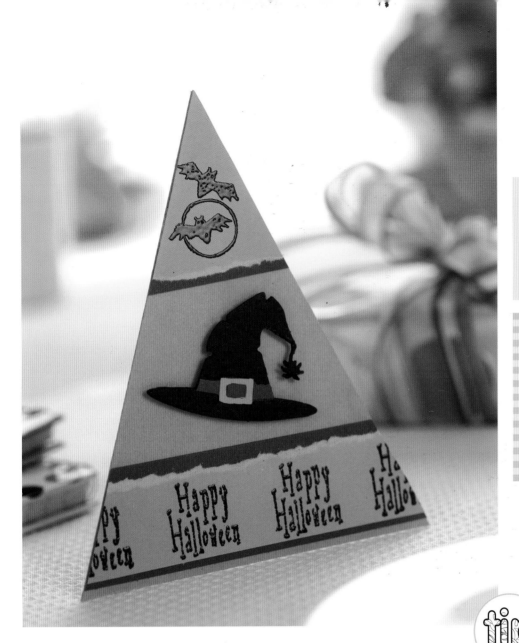

techniques
stamping, embossing

time
25 minutes

designer
Brenda Harvey

materials

Pigment ink, black
embossing powder

Card: orange, green, purple

Tools: 'Happy Halloween'
stamp, heat gun,
die-cutting machine

Hat Trick

The triangular shape of this fun greeting is
perfect for framing its spooky central motif.

tip

Using a
repeat-stamped
message over both edges
is a subtle way of adding
a sense of energy
and movement

1 Fold A5 orange card in
half. Make a pencil mark
4cm (1½in) above the bottom
right-hand corner and draw
two lines starting from this
point; one to the bottom of
the centre-fold and the other
to the top. Cut along these
guides through both layers
to form a triangular blank.

2 Stamp the 'Happy
Halloween' message
repeatedly across green card
using pigment ink and sprinkle
with black embossing powder.
Blast with a craft heat gun until
the powder has melted, tear
the upper edge and layer on
to a strip of purple card.

3 Print images of bats on
to a green blank and
heat emboss with black
powder, as before. Tear the
bottom and layer over purple.
Glue in place at the
top and carefully trim the
borders. Die-cut a hat from
black card, then add a purple
band and orange buckle.
Fix in place with foam pads.

Off the Bat

There's nothing more frightening than a bat on Halloween night,
so create this super scary card, with an extra surprise inside!

technique
apertures

time
30 minutes

designer
Amanda Walker

materials

Card: orange and black
Tools: Cricut machine
Templates: Bats and stand

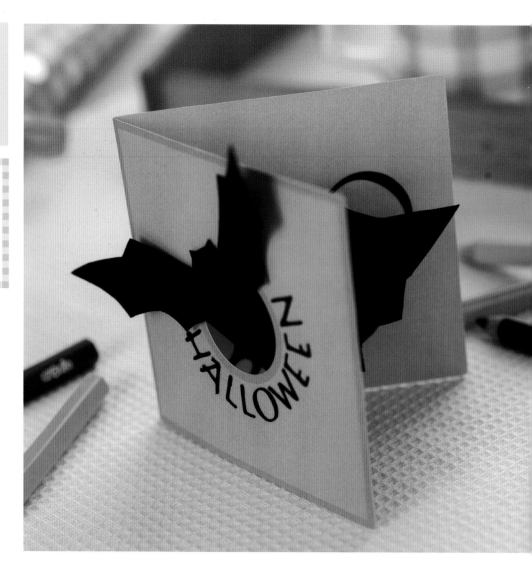

tip

A blank can
be made for this card
by cutting a 10cm (4in)
folded orange square and
trimming an aperture
from the centre

1 From the templates
provided cut out one large
and one small bat in black
card, then the stand in orange.
Score along all lines indicated.

2 Fold the large bat in half
and bend the wings
forward. Tape the base to the
centre crease of the orange
stand, then stick the stand
inside the greeting, either side
of the fold on the blank, in
a 'V' shape towards the top.

3 Stick the smaller bat to
the front so that it
appears to be flying out of the
hole. Use the Cricut to cut
'Boo' in black card and stick at
an angle to the inside, below
the bat. Trim letters to spell
'Halloween' and adhere
under the aperture.

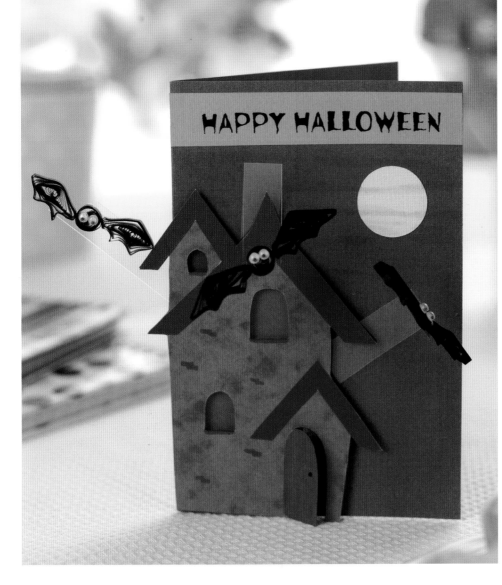

technique
quilling

time
50 minutes

designer
Eizabeth Moad

materials

Rub-down lettering, dark red and blue pens, clear and yellow acetate

Card: orange, purple, black, brown

Paper: tissue, black quilling

Tools: quilling tool

Decorations: goggle eyes

Templates: haunted house

Bat's Life

These sweet but spooky quilled bats are the ideal way
to add a little haunting horror to your greetings.

1 Use rub-down lettering to write 'Happy Halloween' on orange card. Trim, then mount to the top of a purple single-fold blank. Cut out the house motif from brown card then snip the door and score, so it opens outwards. Secure a small panel of black behind it and insert fine tissue (or a message) inside. Create eaves from brown then stick in place, as shown.

2 Position yellow acetate behind the windows, then colour the bricks in pen. Attach three strips of clear acetate to the back of the house, folding two of them at the ends. Mount the motif on to purple card using foam pads. Use a quilling tool and a black quilling strip 40cm (15¾in) long to make a loose closed coil.

3 Mould this into a batwing motif by pinching one end, then squeezing the shape to form two points. Create a second loose closed coil with black paper 20cm (8in) long and attach two goggle eyes. Make three bats in this way, then glue them to the acetate, as shown. Trim a circle from white card, secure and colour with blue pen for clouds.

tip

If you don't have any acetate in your workbox, try recycling plastic packaging instead

Trick or Treat

Zigzag cards are all the rage, and this spooky greeting, which uses fab Halloween die-cuts, is no exception!

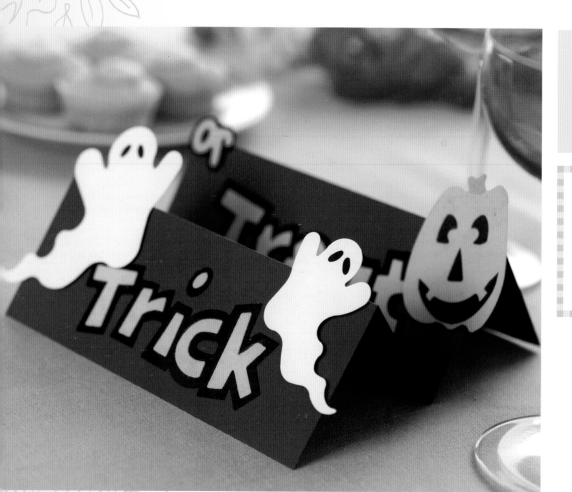

technique
folding

time
30 minutes

designer
Brenda Harvey

materials

Card: black, white, orange, purple, green

Tools: Sizzix machine, ghosts, pumpkins and trick or treat dies

tip

Score lines at 7cm (2¾in) intervals widthways along the purple card to ensure an evenly folded blank

1 Fold purple card, 28 x 18cm (11 x 7in) three times, each 7cm (2¾in) apart, to form a zigzag blank. Die-cut 'Trick or Treat' in black and orange, separate the inner and outer parts of each letter, then piece together again so that the text has a black outline and an orange centre (as shown).

2 Glue the words in place on to the first and third panel of the greeting. For the word 'or' you will need to glue the orange letters on to a small piece of black card, then trim around the outline leaving a black margin.

3 Die-cut the two ghosts in white card and glue a small section of black card behind the eyes. Trim the pumpkin in orange, then add the eyes in black and the stalk in green. Fix the ghosts and pumpkin in place with 3-D foam pads.

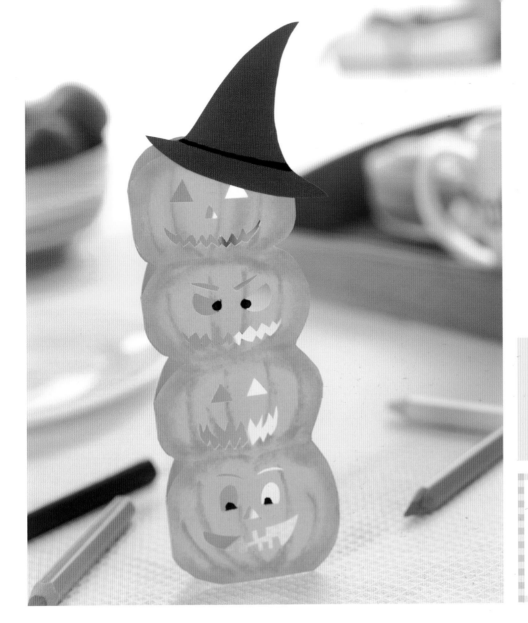

technique
inking

time
30 minutes

designer
Elizabeth Moad

materials
Orange ink-pad, black pen
Card: orange, purple
Templates: pumpkins, hat

Hats Off

A 'stack' of pumpkins, cut from a single fold card and coloured with ink-pads, has cut-out faces that allow the light to shine through making them extra scary!

1 Trace the pumpkins on to an orange single-fold blank using the template provided. Cut around the outer edge of the shapes, ensuring you are cutting through both the front and back panel of the card. Place the closed greeting on to scrap paper. Take a small, sponge then dab on to an orange ink-pad.

2 Rub the sponge over the edge of the card, gradually building up the shade. Dab a clean cotton bud into the orange ink, then rub on the greeting to create lines of colour along each pumpkin, as shown.

3 Open the greeting and place on to a cutting mat. Use a craft knife to carefully cut out the eyes, nose and mouth of each pumpkin. Colour the eyes of two of the shapes with black pen. Trim the hat motif from purple card and add black to the brim. Adhere to the top pumpkin, as shown.

tip

If you find that cutting out the facial features is a bit too tricky, simply colour them with black pen instead!

Festival of Light

This project is perfect if you're new to card-making. No special skills are needed and the design can be adapted to suit all sorts of occasions.

technique
fraying fabric

time
40 minutes

designer
Jill Alblas

materials

Satin fabric

Card: white

Paper: paisley-patterned scrapbook

Decorations: organza ribbons, silver cord and bells

1 Cover the front of a 12cm (4¾in) square card blank with paisley scrapbook paper. Use sticky tabs to fix white card 6.5cm (2½in) square in the centre. Cut satin fabric 8cm (3¼in) square, fray the edges and fix on top.

2 Loosely loop four toning organza ribbons and arrange them in the middle of the fabric. Fix in place with glue dots. Thread silver cord with tiny bells, tie it in a bow, then glue the bells in the centre of the ribbons.

tip

Spray adhesive is excellent for fixing paper and fabric evenly and cleanly without warping and air bubbles

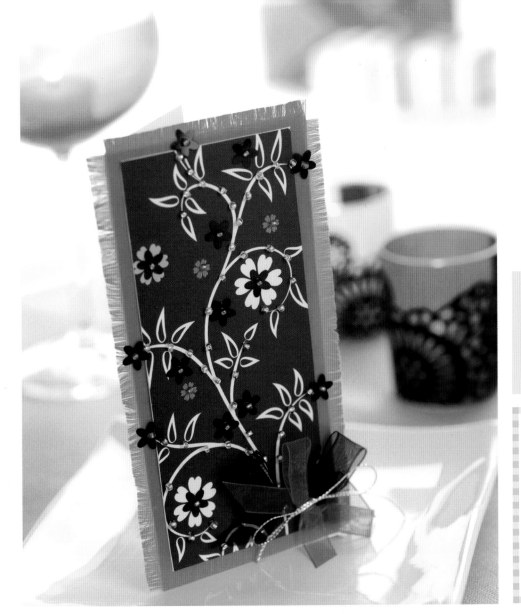

techniques
fraying, bead work
time
25 minutes
designer
Jill Alblas

materials

Fabric scrap

Card: white blank

Paper: scrapbook, floral patterned

Decorations: crystal and pink rocailles, black sequin flowers, black, pink and silver ribbons

Eastern Delight

Our card uses pretty scrapbook paper as the focal point. This quick and effective way of working is especially handy if you're short of time.

1 Trim a blank 15 x 7cm (6 x 2¾in). Cut fabric 16 x 8cm (6¼ x 3¼in) and fray the edges. We've used polyester stain but almost any fabric will be suitable so long as it can be frayed easily. Fix the fabric to the front of the blank then trim the frayed edge from the bottom, so that the card stands easily.

2 Trim scrapbook paper 14 x 6cm (5½ x 2¼in) and fix in the centre of the fabric. Working on a small section at a time, use strong craft glue to fix crystal rocailles along the stems of the patterned paper. Glue black sequin flowers as you please, fixing a pink rocaille in each centre. Add a few more rocailles for detail.

3 Lay the decorated card flat on your work surface. Tie bows from black, pink and silver ribbon and glue them, one on top of the other, in bottom right-hand corner of the card. Leave to thoroughly dry before moving.

Craft tweezers are a real bonus when gluing tiny beads and embellishments. They'll help you work neatly and accurately as well as keeping your fingers clean

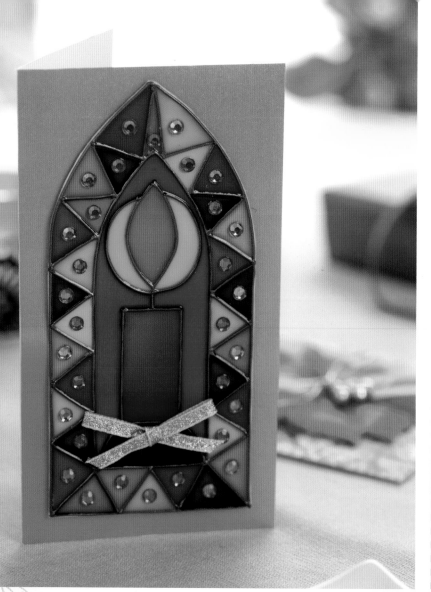

Light Touch

Our colourful card with its sparkly gems is bound to impress, yet you'll find it surprisingly easy to do, even if this is your first attempt at glass painting.

Major errors
in outlining can be
removed by allowing the
lead to dry then cutting
and lifting the mistake
with the tip of a sharp
craft knife

1 Tape the pattern flat on your work surface then tape acetate on top. Draw over the design with imitation lead outliner. Hold the nozzle just above the surface of the acetate and lay the outline down rather as if you're icing a cake. Don't worry if the lines are a little wobbly, this won't spoil the finished effect.

2 Leave the leading to dry. This will take about an hour but it does depend on the temperature of the room. Paint the design in the colours of your choice. Use the glass paint generously and think of the outline as the walls of a reservoir. The paint should be allowed to flow right up to the outline but not go over it. Leave to dry in a warm room for about 24 hours then trim around the outside.

3 Glue sparkly gems round the border. Leave to dry then apply glue to the back of the acetate so it'll be hidden by the gems. Adhere to white card and trim round the outside. Trim a blank 16 x 9cm (6¼ x 3½in) and fix gold card to the front. Use sticky tabs to fix the painted design in the centre. Tie a gold bow and glue it at the base of the candle.

Bright Spark

We've combined glass painting with handmade paper, sequins and beads to make this richly-decorated little card.

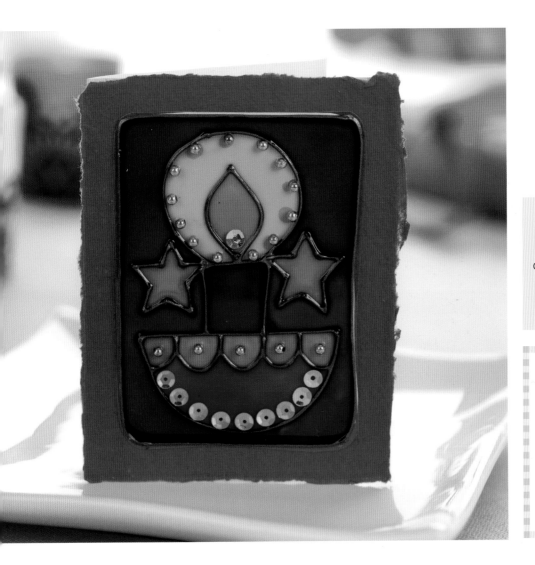

techniques
glass painting, tearing

time
one hour, 15 minutes plus drying time

designer
Jill Alblas

materials

Acetate, imitation lead outliner, glass paints

Card: white

Paper: purple handmade

Decorations: gold beads and sequins

Template: candle pattern

1 Tape the pattern to your work surface then tape acetate on top. Draw over the design with imitation lead. Leave the leading to dry for about an hour then paint in the colours of your choice. Leave to dry for at least 24 hours then use tiny spots of craft glue to embellish with gold beads and sequins.

2 Trim a blank, 10.5 x 8cm (4¼ x 3¼in). Tear purple handmade paper the same size and fix to the front of the blank, then cut white card, 8 x 6cm (3¼ x 2¼in) and glue in the middle.

3 Trim the acetate around the border. Apply spots of glue to the back (so they're hidden by the beads and sequins), then press gently on to the white card and leave to dry.

tip

Glass paint is very fluid and runs easily, so make sure your work surface is dry and flat

Fascinating Fall

Gloriously golden

Capture fall in all its golden
glory with patterned paper.
Cover a blank with a suitable
print then add gold sequin
leaves and a greeting in
coordinating colours

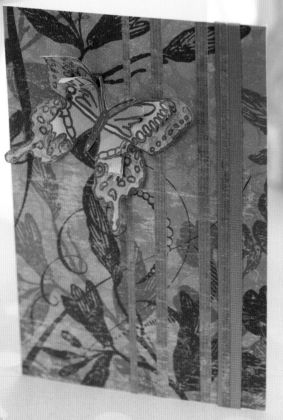

Flutter by

Experiment with making 3-D images
from rubber stamps on patterned paper.
Simply layer and curl the edges to give the
appearance of a butterfly in flight

Silver lining

Form cards into wonderful works of art by foil embossing. Fuss-free and cost-effective, it can completely transform a blank canvas into a stunning greeting

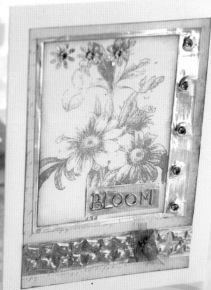

Lovely leftovers

Combine scraps of paper and leftover trim with vintage-style embellishments to create elegant cards with a real touch of class

Notable quote

Choosing an appropriate quote and making it the centre of attention is a particularly effective way of designing a masculine greeting. Add chipboard initials for a chunky yet personal touch

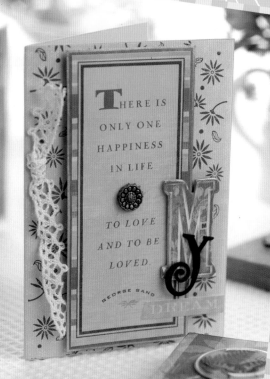

Let the mystery unfold

By making a zigzag card and decorating all the pages you'll increase the intrigue and excitement felt by the recipient!

Animal inspiration

Dog-lovers will immediately identify with a canine-inspired greeting, especially if it reflects a pet or breed they love. Stamp a motif on a torn panel and set it simply above a ribbon border edged with your message

All wired up

For a sporty masculine greeting with a real sense of energy, link your sentiment to a motif with a wire spiral so that it almost leaps from the card

Extend a greeting

Make even more of a handmade greeting by turning it into a booklet. Simply fold a margin down two blanks then punch holes in them and tie them together with ribbon

Let wire inspire

Linking motifs and greetings with beaded wire can transform a plain card to something extra special – and give it a real sense of movement

Added depth

Set your main motif on a panel on the inside
cover so that it shows through a bordered
square aperture on the front. Chalk around
the edges of the blank for depth of colour

Simply sensational

For a speedy yet stylish greeting, cover a blank
with patterned paper, edge with ricrac, dot
with paper blooms and trace a sentiment
before highlighting it with a white marker

In check

Rub-down sentiments are perfect for making
stylish cards in a hurry. Try transferring them
on to coloured oval panels and mounting on to
patterns so that they really catch the eye

Wonderfully weaved

Muted autumnal colours are perfect for masculine cards – but they don't have to be low-profile! Weave strips of different patterns, and set them close to decorative motifs, for excellent visual interest

Open your heart

Gatefold cards add to the intrigue of homemade greetings, and this is no exception. The central heart and feathery patterned paper in lilac and lemon combine to make a lovely card for many romantic occasions

Winter Wonders

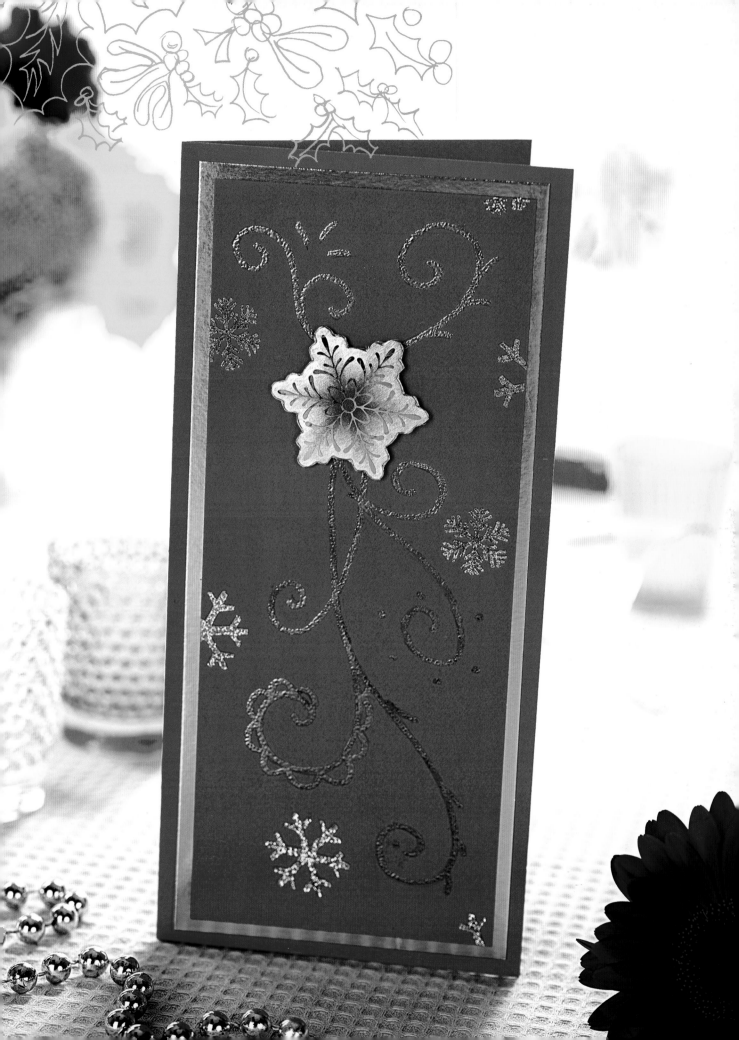

It's Thanksgiving!

The white and light chocolate brown flowers and brads add just the perfect amount of whimsy to this eye-catching composition.

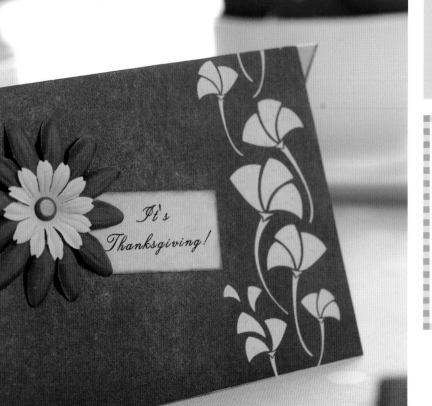

technique
inking

time
30 minutes

designer
Susan Cobb

materials

Pigment ink: pearlescent chocolate

Card: white blank

Paper: chocolate brown, ivory textured and ivory printed

Decorations: white and brown silk flowers, brown brads

tip

For a creative twist, trim a piece from the right and bottom of the card's front panel to reveal the contrasting ivory paper on the inside

1 With the fold at the top, trim about 1cm (³⁄₈in) from the right side and bottom of the card front only. Cover the remaining card front with chocolate brown paper an add an ivory print border to the right-hand side.

2 Write or computer print 'It's Thanksgiving!' on to ivory textured paper, cut a tag shape around the text and ink the edges. Layer a small white silk flower over a brown silk flower and fix with a brad. Add to the left side of the card front with a glue dot, then fix the tag under the flowers.

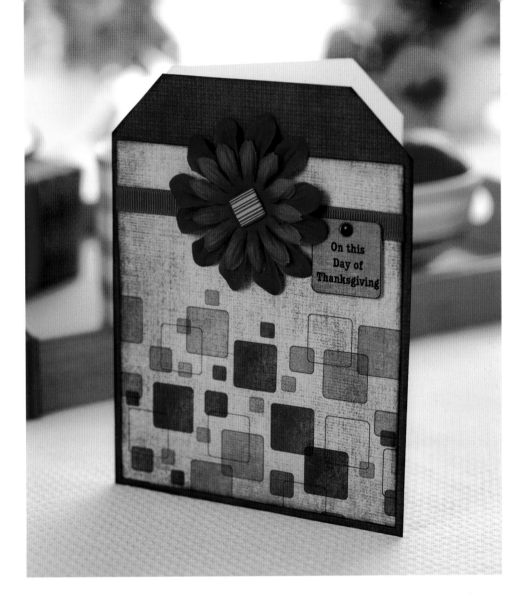

technique
inking

time
30 minutes

designer
Susan Cobb

materials

Brilliance archival pigment ink-pad

Card: white blank

Paper: rust textured, tan squared

Decorations: tan ribbon, rust flowers, small square tag, small black mini and striped square brad

My Many Blessings

The warm fall colours of this card work very well for the Thanksgiving theme, while the contemporary retro shapes give the design a fresh look.

1 Measure 2.5cm (1in) from each side of the top-right corner of the card, marking both points. Use a ruler to draw a line between the two points, then cut off the corner through both card layers. Repeat for the top-left corner, then cover the card front with rust textured paper and ink the edges.

2 Cut a 12 x 13.5cm (4¾ x 5¼in) rectangle of tan with squares border paper, placing the border at the bottom. Ink the edges and glue ribbon across the paper, about 2cm (¾in) from the top, securing the ends to the back. Glue the rectangle centred on the card front. Layer light and dark rust flowers and attach with square brad. Position, as shown with a glue dot.

3 Generate the greeting on a small square tag, add a black mini brad to the top and fix over ribbon with foam tape. For the inside: write on to a tag, ink the edges and glue in place. Knot rust grosgrain and attach with a glue dot to the tag bottom. Thread a thin strip of rust textured paper through the holes of a small black button, glue the ends to the back of the button, then attach the button to the tag top with a glue dot.

tip

Trim the top corners off at an angle to make a simple tag shape

Sew Cool

This card takes its inspiration from needlecraft – the pattern is reminiscent of a printed cotton whilst the sentiment is stitched using a sewing machine.

techniques
inking, stitching

time
35 minutes

designer
Sam Currie

materials

Pumpkin Pie ink-pad

Card: olive

Paper: Pumpkin Pie patterned

Tools: corner rounder punch, computer and printer

Decorations: olive grosgrain

tip

Fix the patterned paper to the card front using double-sided tape. Fix elements down with tape or glue to stop them moving when stitching. Tying a knot in a length of ribbon is a simple and neat way to create a 'bow'

1 Make a horizontal card from olive cardstock and round all four corners with a corner rounder punch. Trim a piece of Pumpkin Pie patterned paper, slightly smaller than the card front, then round the corners and ink the edges with Pumpkin Pie ink. When the ink is dry, use double-sided tape to stick a length of olive grosgrain to the left-hand side of the card, as shown, tucking the ends to the reverse side of the paper. Make a knot in a small piece of the same ribbon, cut the ends on a diagonal, then fix to the ribbon as a 'bow' with a glue dot.

2 Type 'Happy Thanksgiving' on your computer using the Harry Paul font. Print on to white paper, trim down and lightly ink the edges with Pumpkin Pie ink. Trim a small rectangle of olive cardstock, tear the lower edge and glue the greeting to the card. Fix this to the patterned paper using double-sided tape and zigzag stitch across the top.

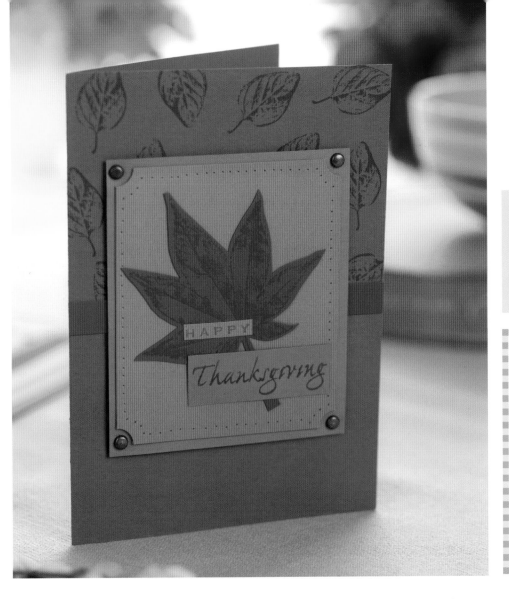

techniques
inking, stamping

time
30 minutes

designer
Sam Currie

materials

Stamps: large and small leaves, 'Happy Thanksgiving'

Ink-pads: cocoa, red, orange, olive

Card: cocoa, red, olive, orange

Tools: ticket corner punch, paper pricker

Decorations: vintage pewter brads

Make an Impression

Celebrate the holiday season with a sublte pattern made using a leaf stamp and cocoa cardstock in rich brown tones.

1 Make a cocoa-coloured card blank, mask off the bottom half, then randomly stamp small leaves on the top half using cocoa ink. Cut a narrow strip of red card to fit the width of the blank and stick it in place underneath the stamped leaves.

2 Cut a rectangle of olive cardstock and a smaller rectangle of orange. Punch the four corners of the orange cardstock with a ticket corner punch, then use a paper pricker to create holes around the outside. Stick the pricked orange rectangle to the olive and fix a vintage pewter brad to each corner.

3 Stamp a large leaf in red ink on red cardstock. Cut the image out carefully and stick to the centre of the orange card. Stamp the 'Happy Thanksgiving' greeting in orange and olive ink. Cut out the two words and glue to the card front, as shown. Mount the finished piece on to the card using 3-D foam pads.

tip

Use marker pens to colour small details on a stamp for more precision, like the 'Happy Thanksgiving' greeting. Use a paper pricker to made neat holes for brads

technique
apertures

time
25 minutes

designer
Jill Alblas

materials
Red wire
Card: gold, red
Tools: circle cutter
Decorations: metal roses,
willow ring, pearl flowers,
narrow red ribbon

tip

This card is quick and easy to make but it's important to allow adequate time for the glue to dry and set

Nature's Bounty

When Thanksgiving is over, this pretty willow ring can be removed from the card and used as a table or Christmas tree decoration.

1 Cover the front of a 12cm (4¾)in square blank with gold card. Trim red card to the same size and cut an 8cm (3¼in) diameter circle from the centre. Use sticky tabs to fix on the front of the blank.

2 Use strong craft glue to fix five metal roses around a 7cm (2¾in) diameter willow ring. Wind red wire around the ring and twist the ends together. Glue pearl flowers between the roses. Tie a wire bow, coil the ends, then glue between two of the roses. Tie a bow from narrow ribbon, glue in the centre, and leave to dry.

3 Place the blank flat on your work surface. Make sure the fold is at the top otherwise your card will topple over with the weight of the ring. Glue the back of the ring, press it in the centre of the blank, then leave to dry and set thoroughly before moving.

Save the Date

Invite your friends and family round for a holiday feast with this classy embossed greetings card.

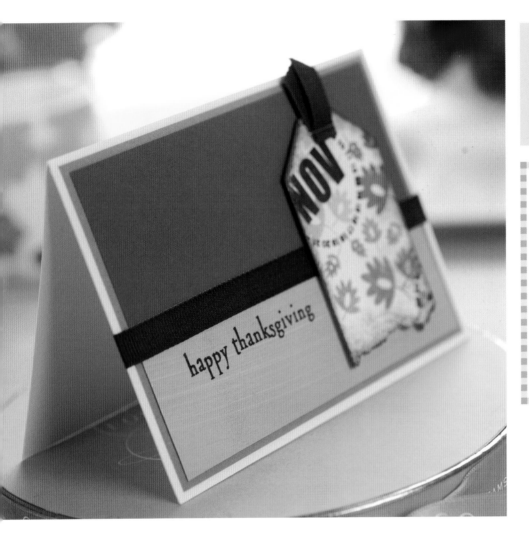

techniques
stamping, tearing

time
20 minutes

designer
Tracey Daykin-Jones

materials

Stamps: leaves, 'Nov' date circle

Clear embossing powder

Ink-pads: lettuce and red pepper

Card: cream, cocoa, mid-brown, light green

Tools: stapler

Decorations: chocolate grosgrain

1 Take a cream A6 horizontal card blank and layer a panel of cocoa card to the centre leaving a small border. Add a second layer: mid-brown to the top and light green to the bottom. Stick a length of chocolate grosgrain across the join, securing the ends on the inside with double-sided tape.

2 Stamp leaves on to cream card using lettuce and red pepper dye pads. Trim to a tag shape, tearing bottom edge for added texture. Stamp 'Nov' date circle at the top of the tag.

3 Rub both ink-pads across all the edges of the tag and leave to completely dry. Staple chocolate grosgrain ribbon to the top of tag and attach it to the right of card with 3-D foam pads.

Stamp leaves several times before re-inking for a more varied tonal effect

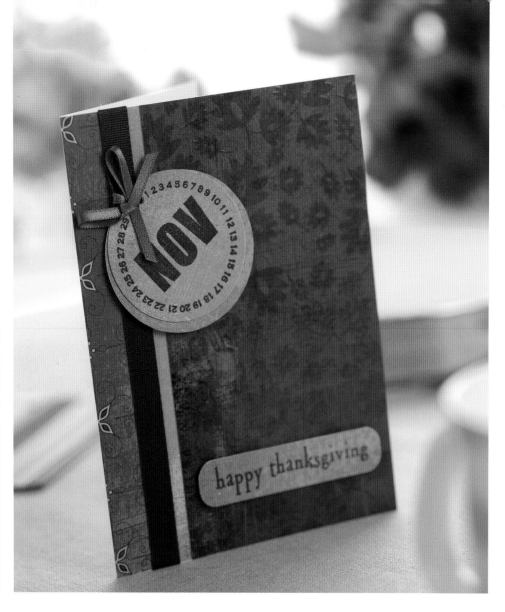

techniques
stamping, embossing
time
25 minutes
designer
Tracey Daykin-Jones

materials

Stamps: leaves, 'Nov' date circle, 'happy thanksgiving'

Clear embossing powder

Ink-pads: Versamark, pine cone

Paper: Basic Grey Girlfriend, DFelish, Romance and Charmed

Tools: circle cutter, hole punch, corner rounder

Decorations: light brown ribbon, brown grosgrain

When trimming circles with a circle cutter, lean on a thick piece of board for a clean cut

Give Thanks

Employ warm patterned papers and subtle embossing to mark this family holiday with a stylish card.

1 Take an A6 card and stick a narrow strip of Girlfriend paper from Basic Grey Blush collection down the left edge. Add a narrow strip of DFelish paper adjacent to the brown paper using double-side tape.

2 Stamp leaves from November Clear Design set on to Romance paper several times using Versamark ink and clear emboss. Trim and stick to the card front,

as shown. Trim a 4.5cm (1¾in) circle from Delish paper. Stamp 'Nov' date circle on to the orange circle using pine cone ink and clear emboss.

3 Trim a second slightly bigger circle from Charmed paper and stick it behind the orange one using double-sided tape. Punch a single hole in the top of the circles, pull through narrow light brown ribbon, then tie this to

a longer length of brown grosgrain ribbon. Stick the ribbons vertically down the left of the card securing the ends on the inside with double-sided tape. Use foam pads to secure the circles. Stamp the greeting on to Charmed paper using pine cone ink and clear emboss. Trim, round corners, and stick to the bottom of card using 3-D pads.

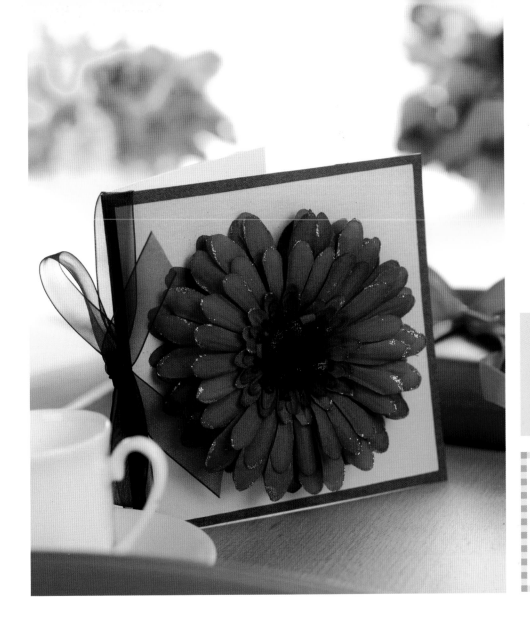

technique
3-D effects

time
25 minutes

designer
Jill Alblas

materials

Card: brown, gold
Tools: hot glue gun
Decorations: silk gerbera, organza ribbon

Petal Power

Silk flowers are brilliant for making quick and easy cards with a definite 'wow' factor.

Our design can easily be adapted for all sorts of occasions. Think of flowers in full bloom for Mother's Day or Easter and warm reds for Christmas cards

1 Cover the front of a 14cm (5½in) square blank with brown card then trim a slightly smaller gold square and fix in the centre.

2 Use wire cutters to trim the stem from a silk gerbera, snipping as close to the flower head as you can. If possible use a hot glue gun to fix the flower to the card –

the adhesive grips very quickly and cuts down on drying time. Otherwise apply strong craft glue generously to the centre on the back of the flower. Position the flower in the middle of the card, press down firmly and leave to dry thoroughly. Use spots of glue to keep the outer petals firmly in place on the card.

technique
glass melting

time
one hour
plus baking time

designer
Jill Alblas

materials

Embossing metal, craft foam, Colour Melt Crystals

Card: silver

Decorations: silver sequins, pink rocailles, silver cord

Template: candle

Glass Act

This is a great way to make your own card embellishments. The method can also be used to create mobile hangers and Christmas decorations.

If this is your first time, it's worth trying a test piece before making the candle embellishment

1 Tape embossing metal to a sheet of craft foam or a pad of newspapers. Tape the pattern on top and carefully draw over the design with a ball-point pen. Remove the pattern and draw over again so the design is firmly embossed. Cover a baking tray with aluminium foil. Remove the metal from the pad and place it, raised side up, on the baking tray.

2 Heat your oven to 180° and make sure the room is well ventilated. Carefully cover the embossed design with Colour Melt Glass Crystals and place in the pre-heated oven. Check the glass regularly as melting times can vary. After about 15 minutes the crystals will have bonded together and have a lumpy appearance. After about 30 minutes the crystals will have melted to a smooth finish. Remove from the oven and leave to cool.

3 Trim a silver blank, 13 x 8.5cm (5$\frac{1}{8}$ x 3$\frac{3}{8}$in), and cut a window, 10.5 x 6cm (4$\frac{1}{4}$ x 2$\frac{1}{4}$in), from the centre. Apply clear glue to the back of the melted glass border and fix to the front of the blank. Embellish with silver sequins and pink rocailles around the outside then fix a silver bow at the base of the candle.

Party Time

This simple candle design is particularly easy to outline and paint. If you've never tried glass painting before but have always wanted to have a go, this is the ideal project to start with.

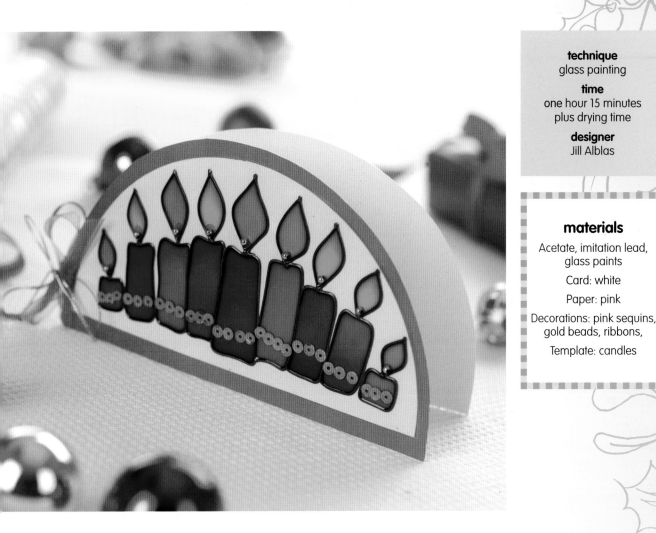

technique
glass painting

time
one hour 15 minutes
plus drying time

designer
Jill Alblas

materials

Acetate, imitation lead, glass paints

Card: white

Paper: pink

Decorations: pink sequins, gold beads, ribbons,

Template: candles

1 Tape the pattern to your work surface, tape acetate on top and cut to shape. Use imitation lead to outline the candles. Hold the nozzle just above the surface and lay the outline down (as if you're icing a cake); don't worry if the outline is a little wobbly as this won't spoil the final effect. Leave to dry then paint in the colours of your choice. Use the glass paint generously and allow it to flow right up to the leading but not go over it. Allow the painting to dry for at least 24 hours.

2 Make a white blank 18 x 10cm (7 x 4in) and draw a semicircle to cover the front. Adjust one side of the circle so the blank is held together with a minimum of 3cm (1¼in) along the fold. Cover the front with bright pink paper. Trim a slightly smaller white card semi circle and fix in the centre.

3 Glue a row of pink sequins near the bottom of each candle and a gold bead at the base of each flame. Leave to dry then apply glue to the back of the acetate so it's hidden by the beads and sequins. Gently press the acetate on the white card and tie the fold with toning ribbons.

A warm, dust free airing cupboard is perfect for drying glass paint

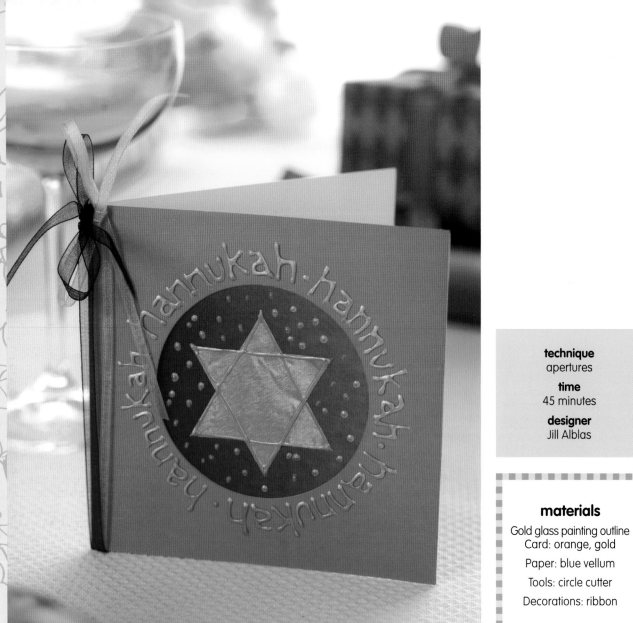

technique
apertures

time
45 minutes

designer
Jill Alblas

materials

Gold glass painting outline
Card: orange, gold

Paper: blue vellum

Tools: circle cutter

Decorations: ribbon

Draw a 7.5cm (3in)
diameter circle on
paper and practise
writing before working
on the card. This will
help you space the
words and achieve
the best result

Make a Date

We've used 3-D outliner for our card; if not available the lettering
could be foiled or simply handwritten with a gold pen.

1 Trim a blank 12cm (4¾in)
square and cover the front
with orange paper or card.
Cut a circular window 7.5cm
(3in) in diameter in the centre.

2 Fix blue vellum to the
back of the window.
Trim two equilateral triangles,
with sides 5cm (2in) long, from
gold card. Glue one triangle
on top of the other, to make
a star, then fix in the centre
of the vellum.

3 Use gold glass painting
outliner to write the
word 'hannukah' around the
window, to draw around the
star and to dot the vellum.
Leave to dry then tie the fold
with ribbons.

Family Fold

Our striking Hannukah card can be adapted by simply changing the lettering to suit the occasion. The design would work just as well for an anniversary, a wedding or 'good luck' card.

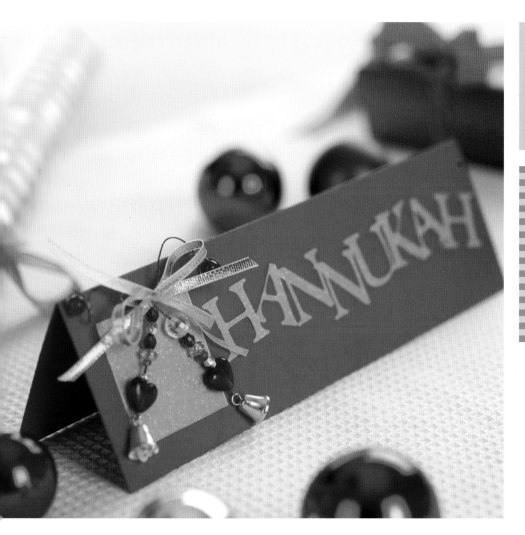

technique
beading

time
35 minutes

designer
Jill Alblas

materials

Red wire

Card: red, gold glitter

Tools: die-cutting machine

Decorations: gold bell, small red and gold beads, gold ribbon

1. Trim a red card blank 21 x 6cm (8¼ x 2¼in). Place the blank on your work surface so the fold is at the top. Fix gold glitter card 4cm (1¼in) square at the left-hand side of the blank.

2. Thread a gold bell on red wire then twist the wire so the bell is held firmly in place. Thread with six or seven small red and gold beads then coil the end of the wire by winding it around a pencil. Thread a bead on the end of the wire and twist to hold in place. Repeat with a second piece of wire. Use strong craft glue to fix the beaded wires across the gold square. Tie a couple of gold ribbon bows and glue on top to give a neat finish.

3. Die cut 'HANNUKAH' from gold glitter card. Arrange the letters along the blank, in a wavy line, and glue in place.

The length of the card can be varied according to the size of your lettering. The best way is to complete the design, leave to dry, then trim to an appropriate length

technique
embossing

time
15 minutes

designer
Francoise Read

materials

Purple gelly roll pen, glitter glue

Card: purple, lilac, silver, white

Decorations: text and black crown peel-offs, star and brad stickers

tip

Make the most of peel-offs by colouring in with glaze pens for a stunning effect

Crowning Glory

Use gelly roll pens to give a glossy new dimension to a sleek and striking seasonal greeting.

1 Place three black crown peel-offs on lilac card. Use waste pieces from a silver sheet to fill in selected areas. Add colour with purple gelly roll pen and glitter glue. Leave to dry before cutting out.

2 Use an empty ball-point pen to emboss four squares on to purple card. Trim and mount first on to lilac, then silver, and stick centrally on a white blank, 13.5cm (5¼in) square.

3 Mount the coloured crowns on to three of the embossed squares with foam pads. Fill the empty square with tiny peel-off text. Add stars and place a brad sticker in each corner.

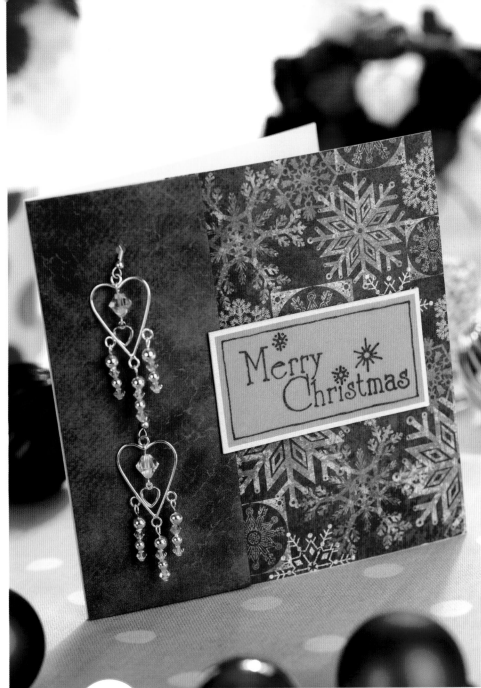

technique
beading

time
40 minutes

designer
Corinne Bradd

materials

Silver jewellery head pins, heart-shaped chandeliers and fish-hook earrings, metallic gel pen

Paper: snowflake and coordinating, vellum

Tools: long-reach punch

Decorations: silver-plated beads, Swarovski crystals

These earrings are surprisingly simple to make and look stunning embellishing a card

Present Day

Beads glorious beads can provide a clever way of combining a Christmas gift with a greeting.

1 Cut and fold a large square blank, covering the front with snowflake paper. Stick a coordinating sheet to card, the same height but less than half the width. Punch small holes, 2cm (¾in) and 8cm (3¼in) from the top.

2 Thread silver-plated round beads and Swarovski crystals on to head pins then attach them to heart-shaped chandeliers fitted to fish-hook earrings. Pass through the holes and secure behind with tape.

3 Fix the gift panel to the front of the blank with 3-D foam pads, lining up with the fold. Hand write a greeting on vellum with a metallic gel pen. Add seasonal doodles then mount on to white and attach to the front of the card.

materials

Embossing pen and silver powder

Card: pink, silver mirror

Decorations: large pink snowflake sticker

tip

Allow stickers to go over the edge. Trim, then use the little bits elsewhere

Think Pink

Embossed silvery swirls enhance ethereal snowflakes on a card that really stands out from the crowd.

1 Trim hot pink card, 19.5 x 8cm, (7¾ x 3¼in) and draw swirls using an embossing pen. Sprinkle with silver powder and heat.

2 Fix a large pink and silver snowflake sticker to silver mirror card. Cut out with a craft knife and stick it to the embossed panel with foam pads, as shown.

3 Add a selection of snowflake stickers, then matt onto mirror card, 20 x 9cm (8 x 3½in). Attach to the centre of a pink blank, 21 x 10cm (8¼ x 4in).

Feeling Festive

Chalks can create subtle whispers of tone and are perfect for achieving a vintage chic, delicately distressed look.

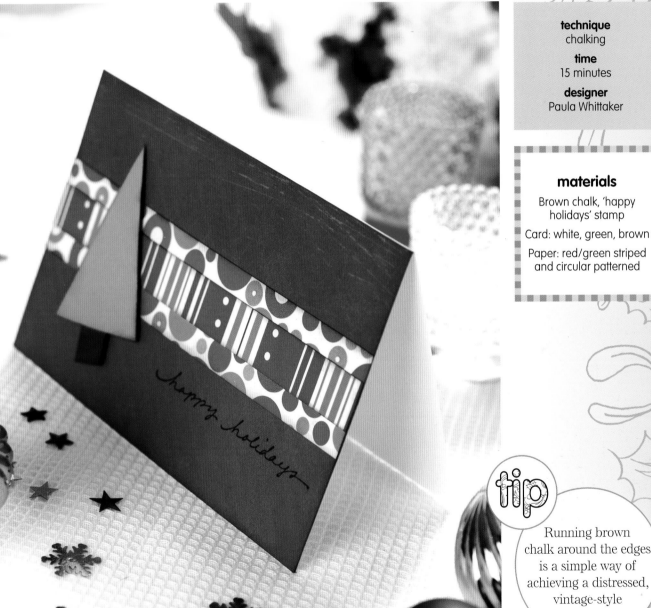

technique
chalking

time
15 minutes

designer
Paula Whittaker

materials

Brown chalk, 'happy holidays' stamp

Card: white, green, brown

Paper: red/green striped and circular patterned

tip

Running brown chalk around the edges is a simple way of achieving a distressed, vintage-style

1. Cover the front of a white top-fold blank, 18 x 11.5cm (7 x 4½in), with red paper. Run a brown chalk pad along the edges to give an aged effect.

2. Across the centre of the card, stick a 4cm (1½in) wide strip of striped paper, then mount a 2cm (¾in) wide circular patterned banner across the top and bottom, chalking the edges before sticking down.

3. Cut a triangle from green card and a small rectangle from brown, rub all edges with brown chalk. Attach to the left of the blank (in a the shape of a tree), using foam pads. Stamp a sentiment in the bottom right.

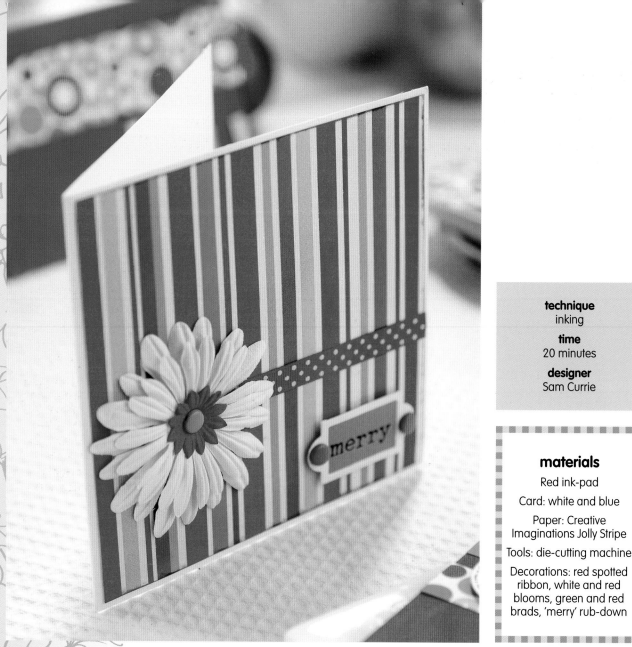

technique
inking

time
20 minutes

designer
Sam Currie

materials

Red ink-pad

Card: white and blue

Paper: Creative Imaginations Jolly Stripe

Tools: die-cutting machine

Decorations: red spotted ribbon, white and red blooms, green and red brads, 'merry' rub-down

Blooming Merry

If chilly Christmas scenes aren't your thing then look to spring for inspiration. With cheery colours and a chirpy flower, this card is the perfect antidote to the winter blues.

1 Cut a panel of Jolly Stripe paper slightly smaller than a square blank. Lightly ink the edges red, allow to dry, then attach the striped panel to the card with double-sided tape. Stick a strip of red dotted ribbon two-thirds of the way across the card using narrow double-sided tape.

2 Layer two white and one red bloom together with a with a green brad. Apply a 'merry' rub-down to a scrap of blue card. Die-cut a small book plate from white card, attach the blue, and fix two red brads either side. Use foam pads to fix the greeting to the bottom-right of the card.

tip

Why not cut out shapes of flowers from remnants of fabric with a die-cutting machine? Use spray starch to stiffen and bend the fabric into shape

Perfect Presents

Say goodbye to traditional Christmas reds and greens with Creative Imaginations' Jolly Dot paper: there's not a holly wreath or icicle in sight!

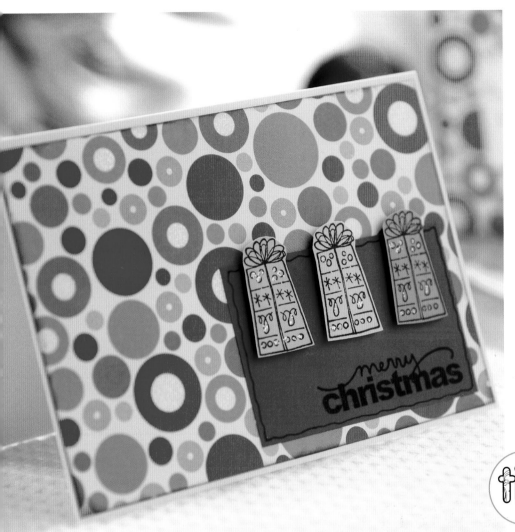

technique
stamping

time
20 minutes

designer
Sam Currie

materials

Red and black ink-pads, Christmas gift and 'merry Christmas' stamps, glitter glue, black gel pen

Card: white, blue, pink, green and red

Paper: Creative Imaginations Jolly Dot

tip

These 3-D gifts will quite literally make your card stand out from the crowd

1 Cut a rectangle of Jolly Dot paper slightly smaller than a white card blank. Lightly colour the edges of the paper with red ink, allow to dry, then fix to the front of the blank with double-sided tape.

2 Stamp three Christmas presents in black on to blue, pink and green card. Trim around the images then embellish with glitter glue and leave to dry. Cut a rectangle of red card and stamp 'merry Christmas' in the bottom-right corner in black.

3 Draw a wavy line around the edges of the rectangle with a black gel pen and stick to the bottom-right corner of the card. Use foam tabs to stick the stamped presents along the top half of the rectangle, as shown.

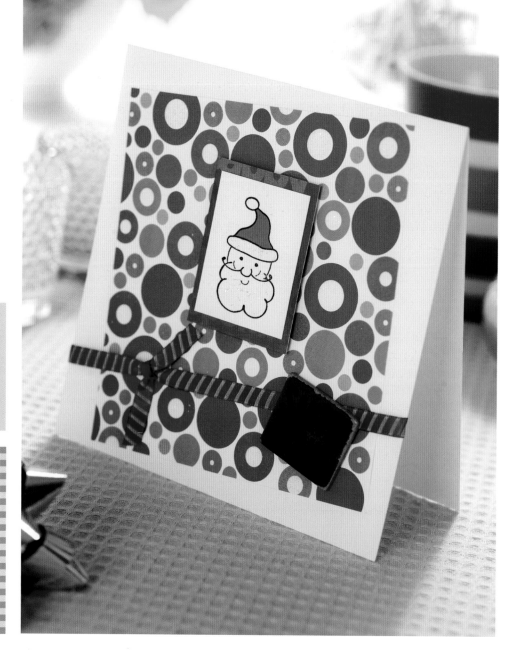

technique
stamping

time
25 minutes

designer
Paula Whittaker

materials

Santa stamp, red pen, glitter glue

Card: white, red

Paper: Creative Imaginations Jolly Dot

Decorations: ribbon, ready-made sentiment

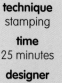

tip

Adding panels at an angle is a great way to make simple cards look more sophisticated

Santa Baby

Colour can be added to stamped outlines in many ways. The felt tip and glitter glue on this cheery card were particularly easy to use.

1 Take a white blank, 14cm (5½in) square. Trim spotted patterned paper, 12 cm (4¾in) square, and attach centrally, but at a sight angle, with double-sided tape.

2 Stamp a Santa face on white card; colour the hat with a red pen then fill in the white beard details and hat trim with glitter glue. Cut out and stick on to red.

3 Fix the panel slightly above centre with foam pads. Add a length of knotted ribbon, at an angle, about two-thirds down. Glue a sentiment in the bottom-right.

Dotty Joy

Bring out the fun and frolics of Christmas with this jubilant card. The bright colours and delightful dots are sure to bring cheer to any dreary December day.

technique
embossing

time
20 minutes

designer
Sam Currie

materials

Red ink-pad

Card: white, green, blue glitter

Paper: Creative Imaginations Jolly Dot and Jolly Phrase

Tools: Spots and Dots embossing folder, die-cutting machine, circle punch

Decorations: white bloom, red dot sticker

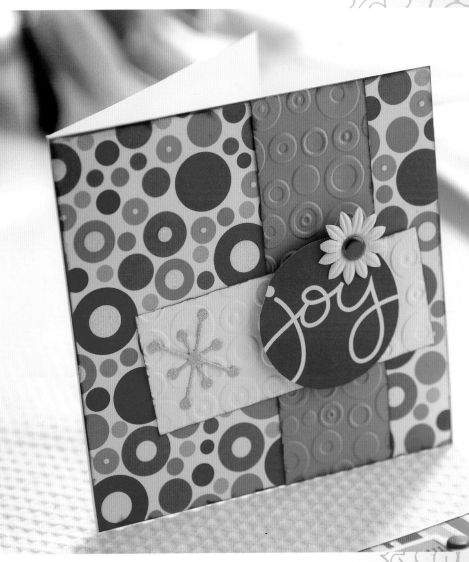

tip

Contrast shapes like circles and squares for an eye-catching effect

1 Trim a square of Jolly Dot paper to cover the front of a white blank and ink the edges red. Cut two strips of card, one white and one green, and emboss using a Spots & Dots embossing folder. Ink the edges of the strips red then stick them to the card front as shown.

2 Die-cut a sparkle from blue glitter card and stick to the left of the white card strip. Punch a 'joy' circle from Jolly Phrase paper. Embellish a small bloom with a red dot sticker in the centre. Fix to the right of the punched circle and attach to the card with foam pads.

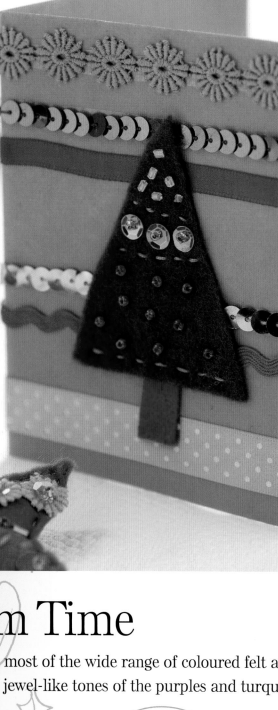

technique
stitching

time
20 minutes

designer
Sally Southern

materials

Felt: purple and turquoise
Card: lilac
Tools: beading needles
Decorations: ribbons, braids, beads

Trim Time

Make the most of the wide range of coloured felt available by using variations of one shade – like the jewel-like tones of the purples and turquoises in this precious-looking card.

tip Make sure you have beading needles before you start – there's nothing more annoying than not being able to get your needle through the hole of your bead!

1 Cut lengths of ribbons and braids slightly longer than the width of a lilac card blank. Arrange them into stripes and glue across the front using PVA, folding the edges inside the card and around the back.

2 Cut a triangle of purple felt and a small rectangle in turquoise to make the trunk. Decorate the purple shape with stitches and beads and stick the tree and trunk on to the front of the card.

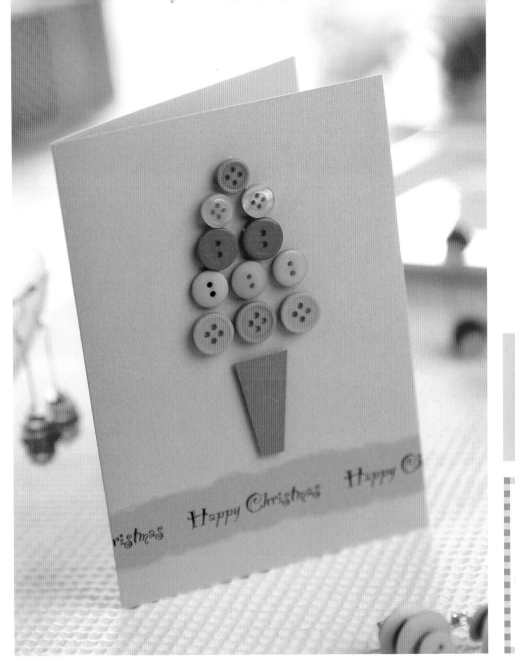

technique
tearing

time
15 minutes

designer
Brenda Harvey

materials

Buttons: assorted sizes in shades of lavender and pink

Card: lavender, bright pink

Paper: pink

Tools: computer and printer

Beautiful Buttons

The versatility of the button is perfectly illustrated on this card, on which shades of lavender and pink combine to create a contemporary twist on a traditional festive motif.

1 Fold an A5 lavender card in half to form a blank. Using a computer, print out your chosen message on to pink paper, tear the edges and glue to the card.

2 Build up five rows of buttons to form the tree shape and attach with small foam pads. Cut a pot shape from bright pink card and glue in place.

tip
Use a piece of felt or a beading board to lay out your design before sticking the buttons down. This will make it easier to plan the pattern sequence

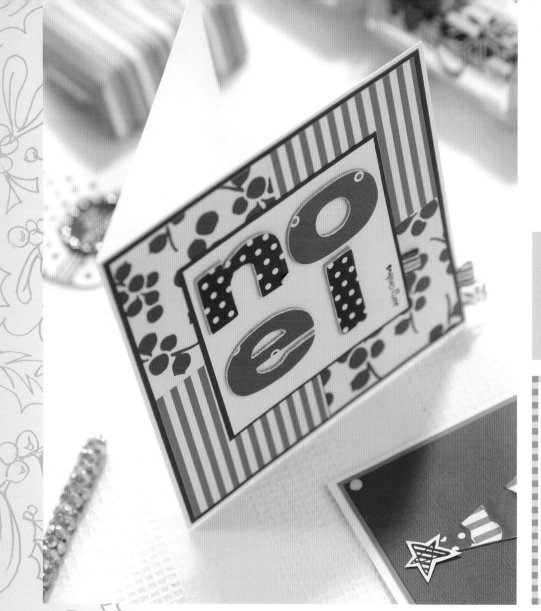

technique
stamping

time
15 minutes

designer
Maria McPherson

materials

'Merry Christmas' stamp, black ink-pad

Card: white, red

Paper: Pipers Piping, Drummers Drumming, Maids a Milking, Turtle Doves – American Crafts Christmas

Decorations: ribbons, chipboard letters

Tis the Season

The collaboration of traditional colours with voguish designs will allow you to produce top-class Christmas cards that cater for all tastes.

1 Cover a square white card blank with red. Cut out two rectangles, 2 x 7cm (¾ x 2¾in) from each of the Pipers Piping and Drummers Drumming papers and attach to the red card, as shown. Make two small ribbon loops, secure to the back with double-sided tape then stick to the card face.

2 Cover the chipboard letters with Maids a Milking and Turtle Doves paper. Cut a 10cm (4in) square from white card and mount it on to a slightly larger square of red. Attach the letters and stamp 'merry Christmas' in the corner. Make another ribbon loop and tape to the back so that only a little is exposed. Stick to the centre of the card.

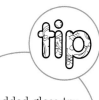

tip

For added gloss try painting the chipboard letters and dotting them with 3-D paint

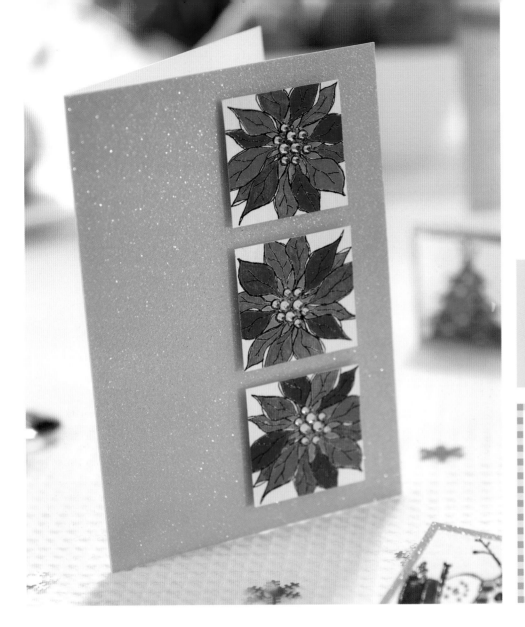

Festive Flower

Capture the beauty and dazzling colour of the poinsettia with this striking card, and try adding crystals for a seasonal finish!

1 Cover an A6 blank with sparkling lime card. Cut out three squares of textured white card, stamp a poinsettia on each one using black ink, then clear emboss. Trim the stamped squares to fit the poinsettia images.

2 Colour the poinsettias with red and green brush pens. Hot-fix small citrine crystals to the flower centres. Stick the bejewelled poinsettias vertically down the right of the card using 3-D foam pads.

tip

For a truly unique card, stamp the flowers at different angles to make each one look individual

technique
mounting

time
10 minutes

designer
Lisa Steed Davey

materials

Card: white, silver, three
shades of purple

Decorations: festive motifs
and sentiment sticker

Tall Order

By using themed motifs in an oddly-numbered block you can create
a quick and simple greeting with strong visual impact.

1 Make a white blank, 18
x 7.5cm (7 x 3in). Cut out
4cm (1½in) squares from three
different shades of purple card
and another three, slightly
smaller, from silver.

2 Stick a different
embellishment on to
each silver square. Mount
these on to the purple panels.

3 Use 3-D foam pads
to stick centrally on to
the blank in an evenly spaced
row. Take a silver 'Merry
Christmas' embellishment
and stick underneath.

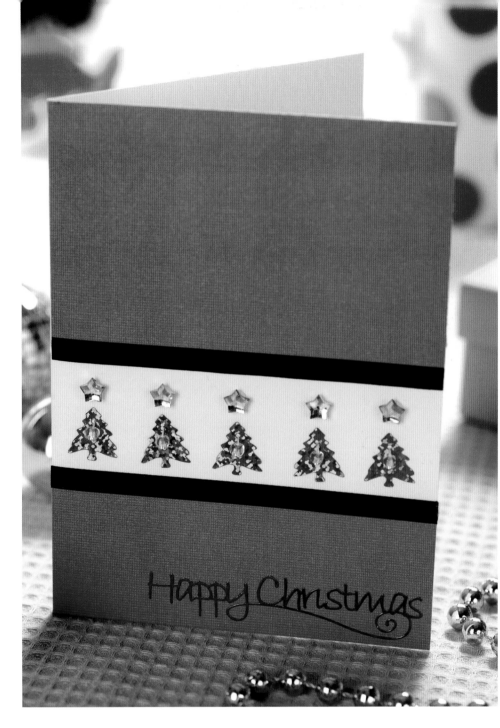

materials

Card: white

Paper: lilac

Decorations: mauve ribbon, seasonal peel-off sentiment, pink trees, silver beads, star gems

Tree's a Charm

Ribbons are a perfect way of hiding unsightly joins, but in this card they provide a platform for some dazzling decorations too!

1 Make a white blank, 16 x 11cm (6¼ x 4¼in). Cut two rectangles from lilac paper to fit the width of the blank, one 4cm (1½in) deep and the other 7cm (2¾in).

2 Stick the smallest lilac panel along the bottom of the card. Glue mauve ribbon along the join, and place a peel-off sentiment in the bottom right-hand corner.

3 Stitch pink trees with silver beads above the ribbon. Fix star gems with foam pads. Stick the remaining lilac panel to the top of the card, with ribbon over the join.

tip

When using stitching or brads, always add an insert to keep things neat

technique
weaving

time
25 minutes

designer
Jill Alblas

materials

Card: pink mirror, white, plasma

Decorations: coordinating ribbons, metal embellishment

tip

Stick the ribbons with double-sided tape so that they remain securely and smoothly in place

Festive Frills

Ribbons provide texture and a criss-cross of colour on a stylish card that will practically jump off the mantelpiece!

1 Fix pink mirror card to the front of a square blank then stick an 8cm (3¼in) square of white card to the centre. Cut an 8cm (3¼in) square of plasma. Trim eight lengths of ribbon 6cm (2¼in) long. Place a row of four ribbons in the centre of the plasma. Use tiny pieces of double-sided sticky tape to hold the ends in place.

2 Position the remaining four ribbons in a row running the opposite way to the first. Carefully weave them under and over the first line of ribbons to give a woven effect and fix the ends in place. Use a foam pad to attach the plasma on the white card and to add a metal embellishment to the centre.

Pink and Perky

Ditch traditional red and green and capture some seasonal spirit with your favourite feminine shades this Christmas.

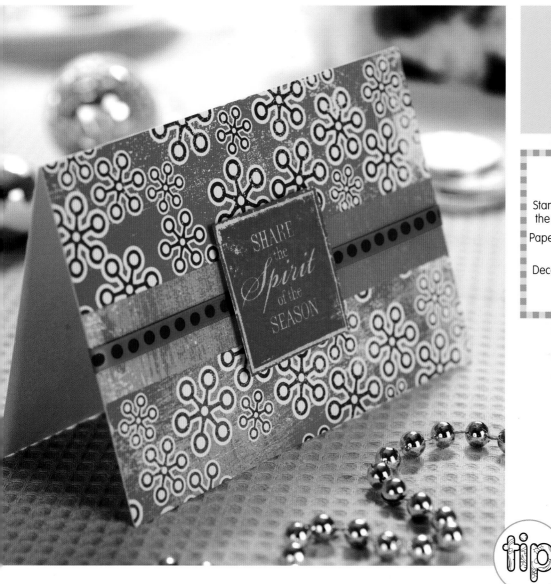

technique
stamping

time
10 minutes

designer
Paula Whittaker

materials

Stamp: 'Share the Spirit of the Season', red ink-pad

Paper: pink patterned, light and dark pink

Decorations: blue spotted ribbon

1 Take a top-fold blank, 10.5 x 15.5cm (4¼ x 6¼in), and use double-sided tape to cover with pink patterned paper trimmed to fit, making sure all edges line up neatly.

2 Cut a 2.5cm (1in) strip of dark pink paper, stick it across the centre of the card, then stick blue spotted ribbon along the middle.

3 On light pink paper, stamp 'Share the spirit of the season' using bright red ink. Trim around the printed panel closely, and stick centrally with foam pads.

tip

Christmas doesn't have to be all red and green – experiment with different colours for great effects

Happy Hubby

Create a simple card to show the man in your life how much you care at this special time of year – this simple style is amusing too!

technique
overhanging design

time
15 minutes

designer
Paula Whittaker

materials

Paper: Snowflake and Snowman patterned

Decorations: red grosgrain, chipboard letters

tip

Don't be afraid to let designs overhang edges, but ensure envelopes are large enough

1 Take a white top-fold blank, 19.5 x 18cm (3¾ x 7in). Trim snowflake paper, the same width as the blank and 5.5cm (2⅛in) deep, and stick to the bottom half of the card with double-sided tape.

2 Attach bright red grosgrain ribbon across the middle of the card, hiding the join of the paper. Cut a snowman from patterned paper and stick to the right, overlapping the edges.

3 To finish, arrange an assortment of upper and lower case chipboard letters to spell 'Husband' in the top left-hand corner, above the ribbon. Stick down when happy with the layout.

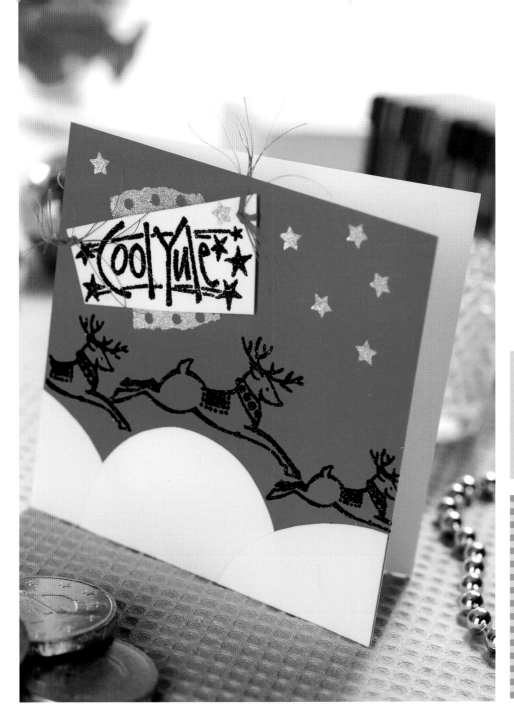

technique
transferring motifs

time
20 minutes

designer
Glennis Gilruth

materials

Magic Motifs: Santa and Reindeer, Cool Yule; red and blue glitter

Card: light blue, white

Paper: silver

Tools: circle punch

Decorations: turquoise thread

Super Cool

It takes just a little glitter to add glorious glamour to your festive greetings – and it's fun to use too!

1. Make purple glitter from red and blue. Apply the largest reindeer motif at the centre of a blue blank, 12.5cm (5in) square, and sprinkle. Shake off excess, then position the two smaller motifs.

2. Cut three white curves and fix at the bottom. Apply the large 'Cool Yule' to white, add glitter and cut it out. Pierce the top corners and add knotted strands of turquoise thread.

3. Punch small circles in torn silver paper, fix the worded panel over it and attach it, at an angle, to the top left-hand side of the card. To finish, add silver stars wherever space permits.

tip

Trim around motifs whilst still on the backing for easy application

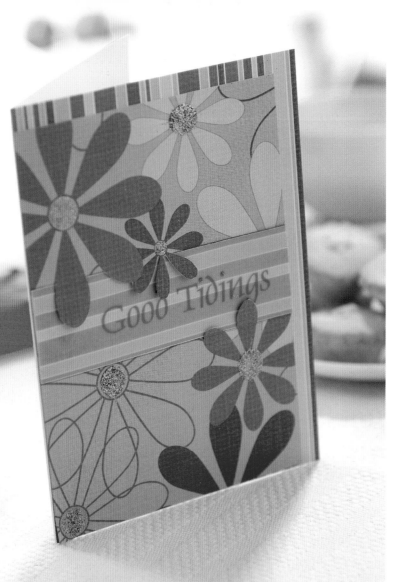

materials

Glitter glue, glitter

Paper: Scrapook Sally word sheet, Ski Bunny and striped scrapbook papers

Let some of the petals curl away from the surface of the card for a really stunning 3-D effect

Pretty Petals

Start the New Year off on the right foot by rustling up this Good Tidings card in fresh pinks and greens.

1 Cut a 17 x 12cm (6¾ x 4¾in) rectangle from Ski Bunny paper. Cut out 'Good Tidings' from a Scrapbook Sally word sheet and stick this to a 12cm (4¾in) strip of strip scrapbook paper. Lay this across the middle of the flowered paper and mark the position with a light pencil line.

2 Remove the strip and cut around any petals that enter the marked position with a craft knife. Use spray adhesive to carefully position the greeting underneath the trimmed petals. Cut out another flower, sticking just the centre to the edge of the card, so the blooms curl away from the surface.

3 Dot glitter glue in the flower centres and sprinkle glitter on to them. Stick the decorated panel on to a slightly larger rectangle of striped scrapbook paper and transfer them to the front of a card blank.

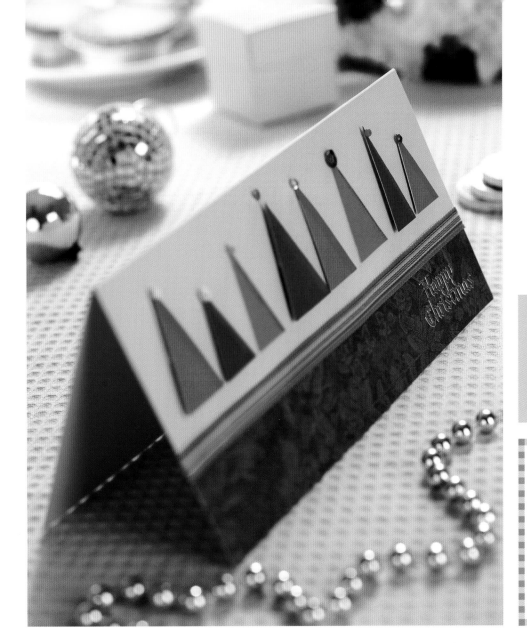

technique
peel-offs

time
15 minutes

designer
Annette Simpson

materials

Felt pens

Card: green and pink, green and blue textured

Paper: green printed

Decorations: bright ribbon, 'Happy Christmas' peel-off, gems, beads and sequins

Green Day

Add a little glitz to some simple geometric shapes and watch in wonder as they transform into stunning Christmas motifs.

1 Use green card, 19.5 x 21cm (7¾ x 8¼in), to create a top-fold blank. Cut printed paper, the same width and 3.5cm (1⅜in) deep, and fix across the bottom with double-sided tape.

2 Stick bright ribbon over the join and fix a 'Happy Christmas' peel-off on to the bottom-right corner. Cut eight triangles from pink, green and blue textured card in various sizes, then add detail with markers or felt-tip pens.

3 Secure the trees in a row, some flat and others with 3-D pads. To finish, add a gem, sequin or bead to the top of each one.

Coordinate the trees with your choice of ribbon, or use one colour in different shades

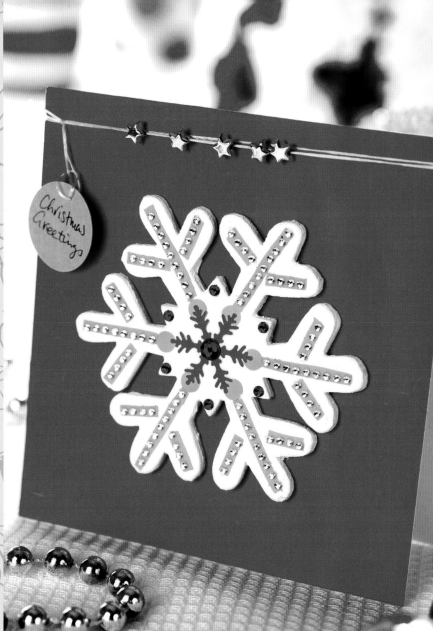

technique
punching
time
20 minutes
designer
Glennis Gilruth

materials

White matt emulsion

Card: red

Paper: lime green

Tools: circle punch

Decorations: large blank and small red snowflakes, red self-adhesive gems, starry elastic thread, greetings circle

Blank motifs provide endless opportunities for truly original, customised cards

Funky Flakes

Take a blank motif and transform it, almost Cinderella-like, to a bold and bright seasonal greeting.

1 Apply white matt emulsion to a snowflake blank. Leave to dry, then attach narrow strips of lime green paper along the branches of the motif.

2 Add a punched green circle to the inner end of each strip and a red snowflake in the centre. Affix small red self-adhesive gems, as shown.

3 Stick the snowflake centrally to a top-fold square red card blank. Wind a trim of starry silver elastic around the fold and thread with a small greeting circle.

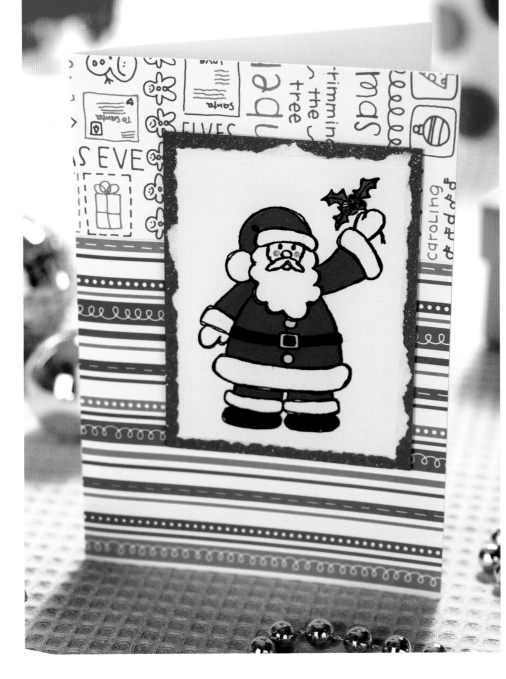

techniques
stamping, tearing
time
15 minutes
designer
Tracey Daykin-Jones

materials
Black ink-pad,
clear embossing powder,
brush pens
Card: white, sugar-coated
red
Paper: festive striped and
doodled
Tools: Santa stamp,
hot glue gun
Decorations: red crystals

Cool Yule

Hone your stamping and tearing skills to present a santa motif on
a bold, bright card that's bound to bring some festive cheer.

1 Stick festive striped paper
to the bottom two thirds
of an A6 blank and a seasonal
doodled design to the
remaining top section.

2 Stamp Santa on to white
using black ink; clear
emboss and colour with brush
pens. Using a ruler as a guide,
tear the edges, 8 x 6cm (3¼ x
2¼in), and mount on to red
sugar-coated card
9 x 7cm (3½ x 2¾in).

3 Hot-fix three red crystals
on to the holly berries
and mount the stamped panel
to the right of the blank.

When tearing, control
the edges by placing
a ruler and pulling
swiftly towards you

Snow Party

Keep your Christmas cards clean and contemporary – without getting too minimal or abstract – by using light-coloured papers and a stamped image motif.

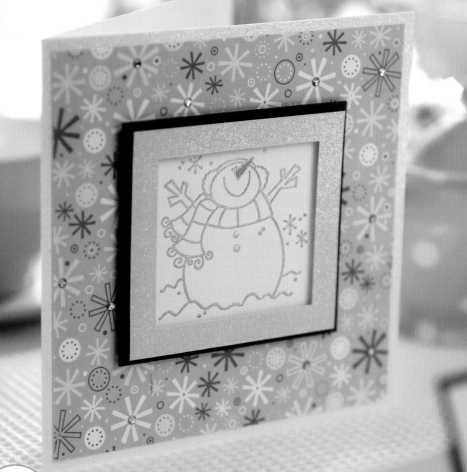

technique
stamping

time
40 minutes

designer
Tracey Daykin-Jones

materials

Silver embossing powder, brush pen

Card: white, sugar-coated lily white, blue and blue glitter

Paper: snowflake patterned

Decorations: snowman stamp, clear and blue crystals

tip

Rather than shade the whole stamped image, take one element and add a splash of colour with vibrant brush pens

1 Take a 14cm (5½in) white blank and cover the front with lily white card. Layer a panel of snowflake paper on to the top of this leaving a small border. Stamp a snowman image on to white card and silver emboss. Trim and mount on to blue card

2 Create a frame from blue glitter card and attach to the front of the image using foam pads. Attach this section to the centre of the card with double-sided tape and colour the nose with a brush-pen. Attach clear and blue crystals randomly to the snowflake paper.

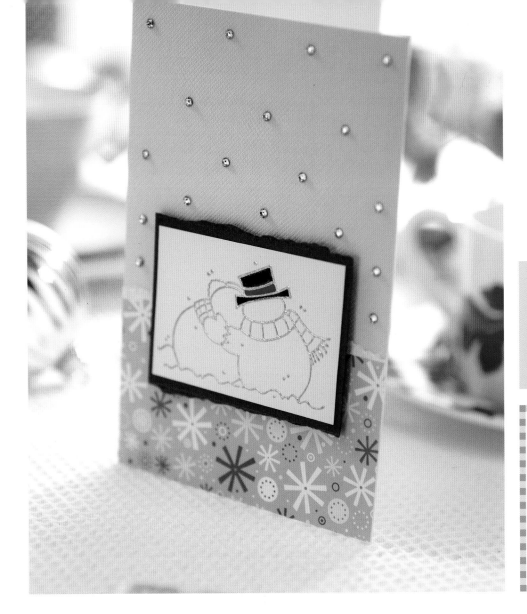

Cuddle Up

Light blue paper teamed with white card gives this greeting a crisp wintery look.
Perfect to give to a partner, its cuddlesome couple are sure to melt some hearts.

1 Cover an A6 blank with pistachio card. Tear the top of a piece of snowflake paper and stick this to the bottom of the blank with double-sided tape. Stamp the motif on to white card and silver emboss. Trim and colour the hat using brush pens.

2 Take a piece of blue card, a little larger than the stamped white panel, and tear the top and bottom edges. Mount the stamped image on to it and fix this on the main card with foam pads. Attach clear crystals to the background.

tip

If the nibs of your brush pens start to dry out, just run them under lukewarm water

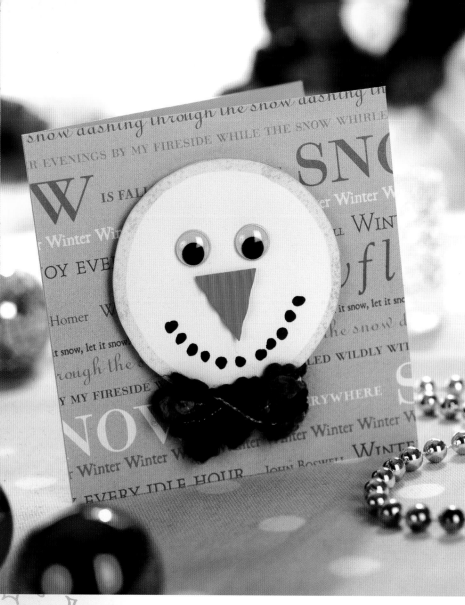

Other fun festive
embellishments
could be cotton wool
for Santa's beard
or a red button for
Rudolph's nose

Big Freeze

Orange corrugated card represents a carrot-nose on this fun greeting
that the kids will love to help you with!

technique
embellishing

time
15 minutes

designer
Annette Simpson

materials

Light blue marker pen,
black felt tip

Card: white, orange
corrugated

Paper: snow-themed

Decorations: fluffy wool,
goggle eyes

1. Cover a square blank with blue and white snow-themed paper using double-sided tape to secure. Cut a large circle from white card then edge around the inside with a blue marker pen.

2. Glue on two goggle eyes and a triangular nose cut out from orange corrugated card. Draw a series of black blobs with a felt pen, as shown, to form a smile.

3. Stick a slim rectangle of card behind the head, so that it protrudes at the bottom, to make a neck. Wrap fluffly wool around it and fix with tape. Trim off any excess, then mount with foam pads.

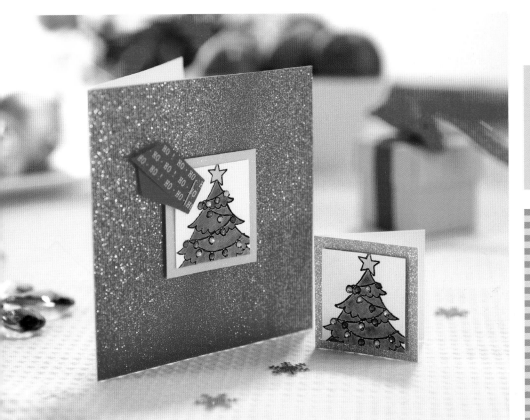

technique
stamping
time
30 minutes
designer
Tracey Daykin-Jones

materials

Black ink-pad, clear embossing powder, glitter pot solutions or brush pens

Card: red sugar-coated, white, yellow glitter

Tools: hot glue gun, stapler

Decorations: tree stamp, crystals in various colours, decorated red ribbon

Twinkle Star

The Christmas tree would be missed from any festive celebrations, so make it your focal point and use a glittering background as a perfect setting.

1 Cover a blank 12cm (4¾in) square card with red sugar-coated card and put to one side. Stamp a tree image on to white card using black ink and clear emboss. Colour the picture with glitter solution or brush pens. Once this is dry trim away the stamped border.

2 Mount this on to yellow glitter card then hot-fix various tiny coloured crystals to the Christmas baubles. Staple red 'ho ho ho' ribbon to the left of the tree using a green staple. To complete, attach this section to the centre of the card using foam pads.

tip
When using brush pens or glitter solution for your highlights apply two coats for a rich finish

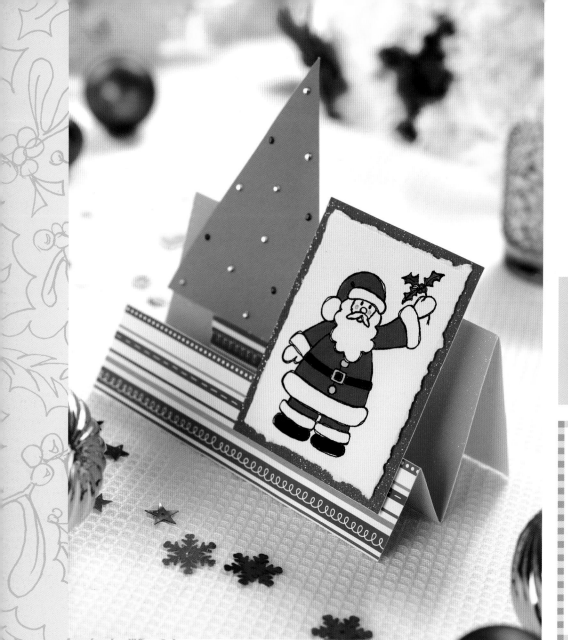

techniques
stamping, tearing

time
20 minutes

designer
Tracey Daykin-Jones

materials

Black ink-pad, clear embossing powder, brush pens

Card: white, lime and red sugar-coated

Paper: festive striped

Tools: hot glue gun

Decorations: santa with holly stamp, siam crystals

Christmas Lights

Fold and cut your own card blanks to make eye-catching and individual designs that really stand out from the crowd.

tip

Clear emboss the stamped image prior to colouring, this stops the ink bleeding

1 Take A5 white card and score three lines, the first 7cm (2¾in) from the top narrow edge, the second 14cm (5½in), and the third 17.5cm (7in), then crease. Stick lime sugar-coated card on the second panel and festive Christmas striped paper to the front.

2 Stamp Santa on to white card using black ink; clear emboss and colour using brush pens. Tear the edges aound the motif and mount on to red sugar-coated card using 3-D foam pads. Trim a plant pot shape from the striped paper and stick to the sparkly lime panel.

3 Attach the stamped image to the bottom of the striped section of the card. Trim a large triangle from lime card and hot-fix clear and light siam crystals randomly across it, to represent lights. To finish, stick the tree to the lime panel, above the striped plant pot, with 3-D foam pads.

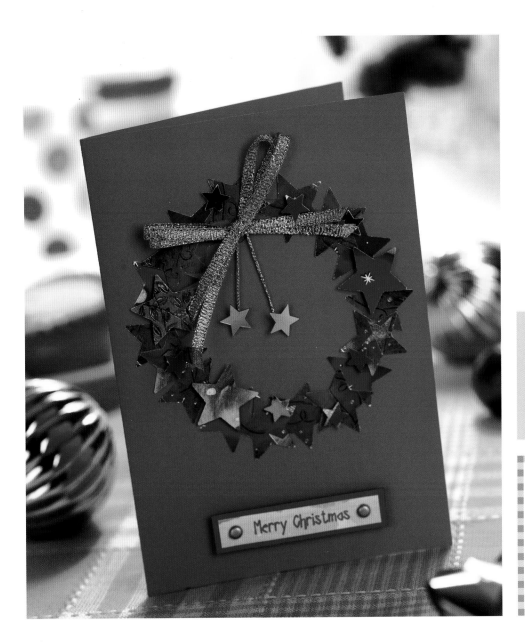

technique
punching

time
30 minutes

designer
Julie Nyanyo

materials

Card: green, red, gold

Tools: star punches in two sizes

Decorations: gold thread, ribbon and brads

Good Wreath

Never underestimate the power of the paper punch – it's a top-notch little tool that can add elaborate finishing touches or create designs that take centre stage.

1. Punch lots of stars from decorative green card. Take an A6 blank and draw a faint circle on the front. Using the line as a guide, glue on the stars to form a wreath.

2. Punch smaller stars from red and gold card, then attach with foam pads cut in half. Fix a length of gold thread using a glue dot and add a bow from gold ribbon.

3. Secure a gold star to each of the thread ends. Matt a greeting on to a slim green strip, add a gold brad to each end, then attach using foam pads.

tip

Recycle by cutting greetings and punching stars from last year's cards

technique
tearing

time
20 minutes

designer
Corinne Bradd

materials

Gold wire, hooks

Paper: yellow and orange – pale, bright and spotted

Decorations: mini metallic bells, ribbon bows, peel-off border

tip

Adding bells to a card will enhance the air of intrigue and excitement long before the envelope is open!

Jingle Bells

Reminiscent of school nativities and stories of Rudolph, this card is fabulously festive – and you don't have to be a child to enjoy it!

1 Make a tall thin blank and cover with pale orange paper. Using a coin or bottle-top as a guide, draw three small circles in the top half and cut them out with a sharp knife.

2 Tear 2cm (¾in) wide strips of yellow, orange and spotted paper. Glue these diagonally across the card and trim off any excess at the edges. Re-cut the holes with a sharp blade so they are neat.

3 Bend short pieces of gold wire into hooks and attach to three small bells. Position one in each circle, securing to the card with tape. Cover the ends with ribbon bows and add a gold peel-off border.

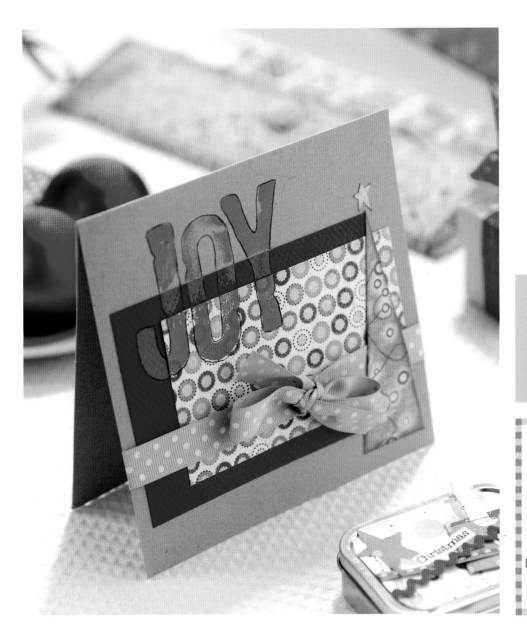

technique
stamping
time
30 minutes
designer
Kirsty Wiseman

materials

Green ink-pad, fine black marker pen

Card: Kraft, red, Sleigh Bells

Paper: Cookie

Tools: star punch

Decorations: spotted ribbon, 'Joy' stamp

Jump for Joy

Recreate the excitement and intrigue of a brown paper package with this joyful card, which also has overlapping complementary patterned papers for a two-tone twist.

1 Cut Kraft card to 15 x 30cm (6 x 12in) and fold to form a horizontal blank. Snip red card to 9 x 13cm (3½ x 5⅛in) and stick towards the bottom-left of the blank. Trim sleigh bells card to 7 x 12cm (2¾ x 4¾in) and glue to the red, as shown. Tie spotted ribbon in a bow across the bottom portion of the card.

2 Trim a long triangle from Cookie paper to form a tree shape. Ink the edges then punch out a star and stick to the top of the tree. Stamp the word 'joy' on to the blank, as shown, and colour each letter green. Allow the colour to dry, then carefully trace around the edges with a fine black marker to define the text.

Outlining text with black marker helps it to stand out and creates a dramatic impact

technique
creative computing
time
30 minutes
designer
Brenda Harvey

materials

Card: black, silver mirror

Paper: swirl-patterned

Tools: computer and printer

Decorations: self-adhesive crystals

Mono Magic

Add a touch of class to your New Year celebrations with a sleek black and white design for a special bash.

1 Fold A5 card in half lengthwise, then cover the bottom two-thirds of the blank with swirl patterned paper. Use a fun font on your computer to print out 'Let's Party' on to white paper.

2 Attach the message to a rectangle of black card, then layer on to silver mirror. Fix the greeting to the blank with 3-D foam pads and add self-adhesive crystals for extra sparkle.

tip

For a really contemporary feel, leave plenty of white space on your designs – don't try to cover every square centimetre of the surface with pattern

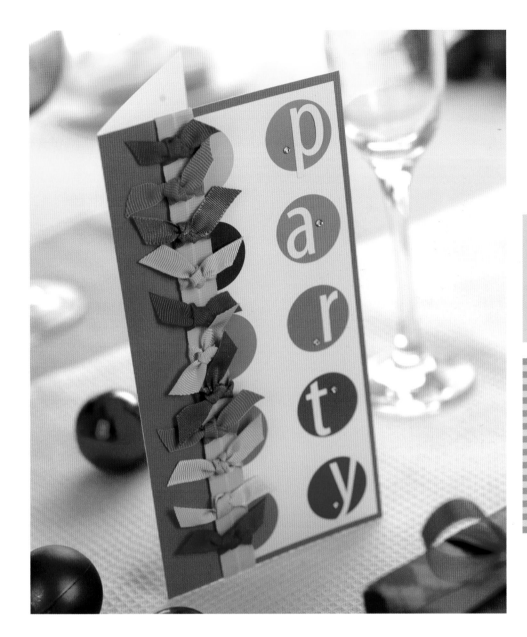

technique
ribbon work

time
25 minutes

designer
Tracey Daykin-Jones

materials

Paper: pink, large dot patterned

Tools: hot glue gun

Decorations: two-tone grosgrain, white sticker letters, clear crystals

Midnight Hour

This bright and cheerful party invite is a visual feast – and a great way to welcome the New Year!

1 Take a DL card and cover the front with pink paper. Stick a length of two-tone grosgrain ribbon to a narrow piece of card (for stability) leaving excess ribbon at either end. Tie several different coloured grosgrain ribbons around this strip and trim the ends with sharp scissors. Stick a piece of large dot paper to the right of the card using double-sided tape. Stick ribbon column to card so that it butts up to the edge of the dot paper.

2 Fold excess ribbon at top and bottom to inside of card, securing in place with double-sided tape. Fix white sticker letters down the right of card, alternating positions within the coloured dots. Finally hot-fix a single clear crystal to each circle for that essential sparkle!

tip

Create your own dot paper by punching out large circles from coloured scraps and sticking on to white card

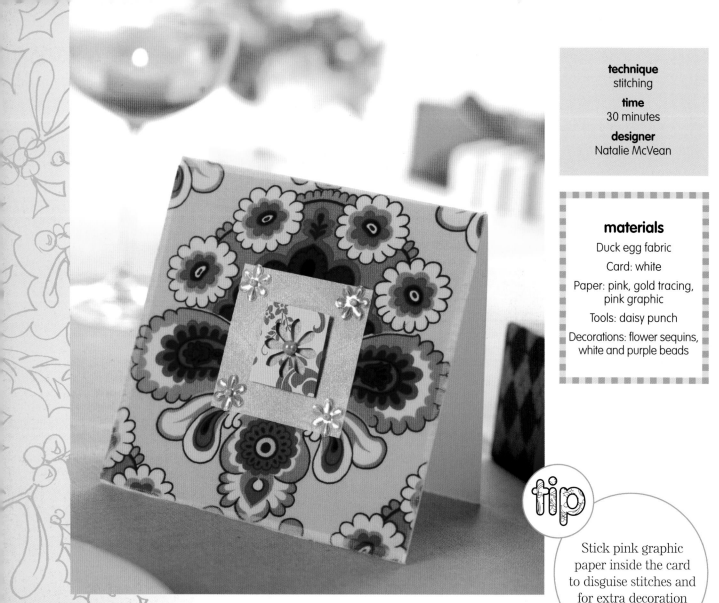

technique
stitching

time
30 minutes

designer
Natalie McVean

materials

Duck egg fabric

Card: white

Paper: pink, gold tracing, pink graphic

Tools: daisy punch

Decorations: flower sequins, white and purple beads

tip

Stick pink graphic paper inside the card to disguise stitches and for extra decoration

Full Bloom

Invite friends and family to a special bash with this stylish card, which uses the negative shape left by a punch as its focal point.

1. Fold a 12cm (4¾in) square white card blank. Using ironed Duck Egg Fabric, centre the design of fabric to your card base, attach using double-sided tape. Trim around edges of the fabric to fit and fray slightly.

2. Cut a 6cm (2¼in) square of gold tracing paper, centre this on the card. Attach gold paper to card by stitching on a flower sequin and white bead to each corner. (When stitching the flower and bead together you need to pull the thread through both and return it back through the sequin, so not to form a border). Form knot on back after fourth stitch.

3. Punch a daisy out of pink graphic paper and cut a 3cm (1¼in) square around it. Fix to the centre of gold paper with a semicircular sticky foam pad on each corner.

4. Stitch a purple bead to the centre of the punched out daisy and form a knot on the back (inside the card).

5. Cut white card, 11.8cm (4¾in) square and attach to the inside, covering visible thread, to finish.

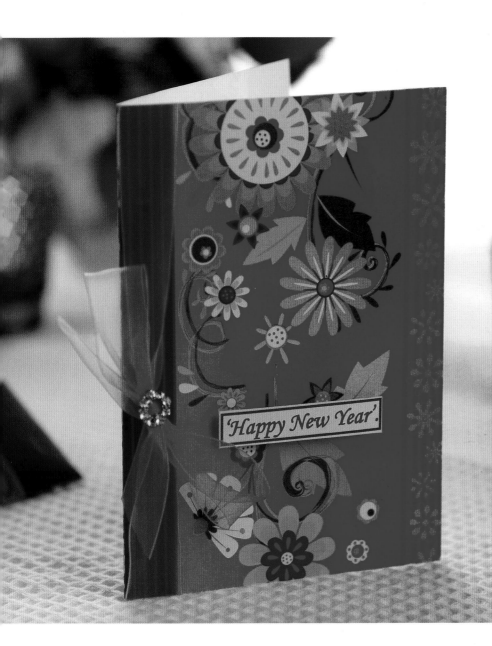

technique
creative computing

time
30 minutes

designer
Amanda Walker

materials

Paper: pink flowery

Tools: computer and printer

Decorations: diamanté buckle, organza ribbon

Party People

Bring the New Year in with a bang by using bright, contemporary papers to make an invite that brings a traditonal celebration right up to date.

1 Cover a blank with pink flowery scrapbook paper. Thread a diamanté buckle on to one end of organza ribbon. Place ribbon inside the card and tie in a bow on the front, positioning the buckle in the centre.

2 Type the words 'Happy New Year' in Monotype Corsiva font, size 20pt. Print out in pink with an aqua border, on to white paper, then cut around the lettering and stick to the front of the greeting with 3-D foam pads.

Using spray adhesive makes it easy to reposition the papers accurately and also ensures a smoother, more professional finish

Winter Warmers

Grin and tonic

If you can't be present in person for someone's special day, send a smile on a greeting instead! Mount a suitable stamp on retro-patterned paper for a design that oozes classical chic

happy birthday

Painted to perfection

Versatile acrylic paints make excellent substitutes for paper panels. Once the paint is dry, try stamping designs in the same colours for extra visual appeal

Gifts galore

Your best friend will simply love this stylish greeting with presents piled high. Mount card in carefully chosen colours and stamp a sweet motif in the middle

Blooming marvellous

Layer paper blooms to give a tactile 3-D decoration that sits centre-stage behind a faux window – apart from a sentiment, very little else is needed

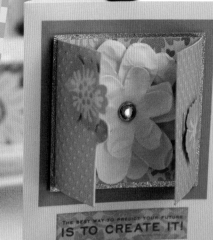

Pick out a pattern

Make the most of odd scraps of patterned paper by cutting out a motif and layering it on to the same image on the paper

Shimmer and shine

Foil embossing produces striking accents and a wealth of interesting looks. This floral metal border provides the perfect presentation for the layered and patterned papers that it frames

Shapely stickers

Stickers can be practical as well as pretty! Use them to keep decorative elements, such as ribbons, in place and to draw attention to other areas of your designs

Pretty presentations

Present three similar embellishments on the same card – but in different ways – to keep visual appeal strong and alluring. Foam pads are fun little fixers that ensure dimension too!

Tag along

For a fun kinetic element, employ a little DIY dash. Make a tag that can be attached with thread or beads so it can dangle deliciously in front of the main motifs!

Silver sensations

A patterned panel introduces just the right amount of colour to a silver-themed greeting without detracting from its sophistication. For a real 'wow' factor, allow layered petals to splay out over the edge of a top-fold card

Window dressing

Silver mesh taped behind a square aperture provides the perfect setting for a bejewelled die-cut flower, with glimmering hearts and flowers providing additiona decorative detail

Pattern satisfaction

The simple yet strong blue and yellow circles of the paper in this card inspired the presentation of the greeting itself – stamped in yellow ink around a central blue heart

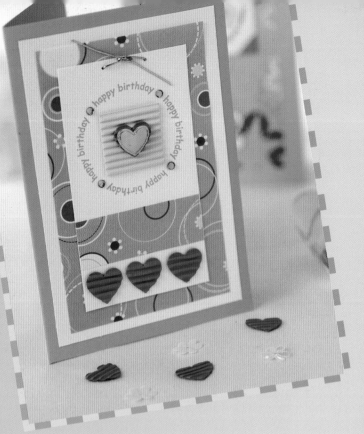

A posy of petals

Present paper blooms, backed on to card, along the curved edge of a quarter-circle blank for an unusual and ultra-feminine greeting

Flutter-by butterfly

Create an illusion of movement by fixing a butterly motif with foam pads in the top corner, then trailing sequin stars and flowers around the card front to the bottom edge

Wing man

The effective use of chalks in this universally appealing card is a subtle way of giving a familiar motif a contemporary edge

Fashionable folds

Zigzag-fold a card with a contrasting central panel for a fresh and fashionable greeting, and add flower sequins and a matching central motif for additional impact

Simply stylish

For a speedy yet stylish greeting let doodle-effect patterned paper play a starring role on a lilac card blank. It looks sensational topped with a ribbon and tag-style sentiment

Just For You

Templates

Enlarge all templates on
a photocopier by 200%

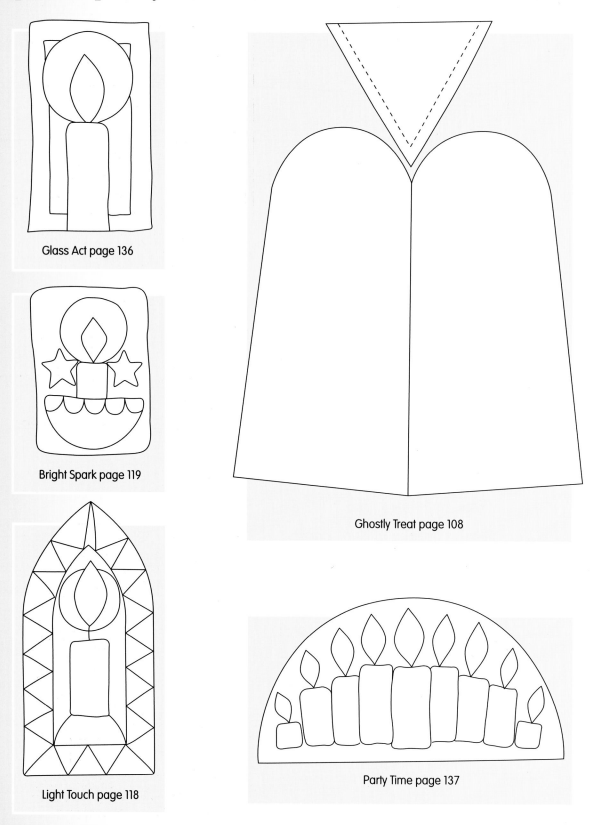

Glass Act page 136

Bright Spark page 119

Ghostly Treat page 108

Light Touch page 118

Party Time page 137

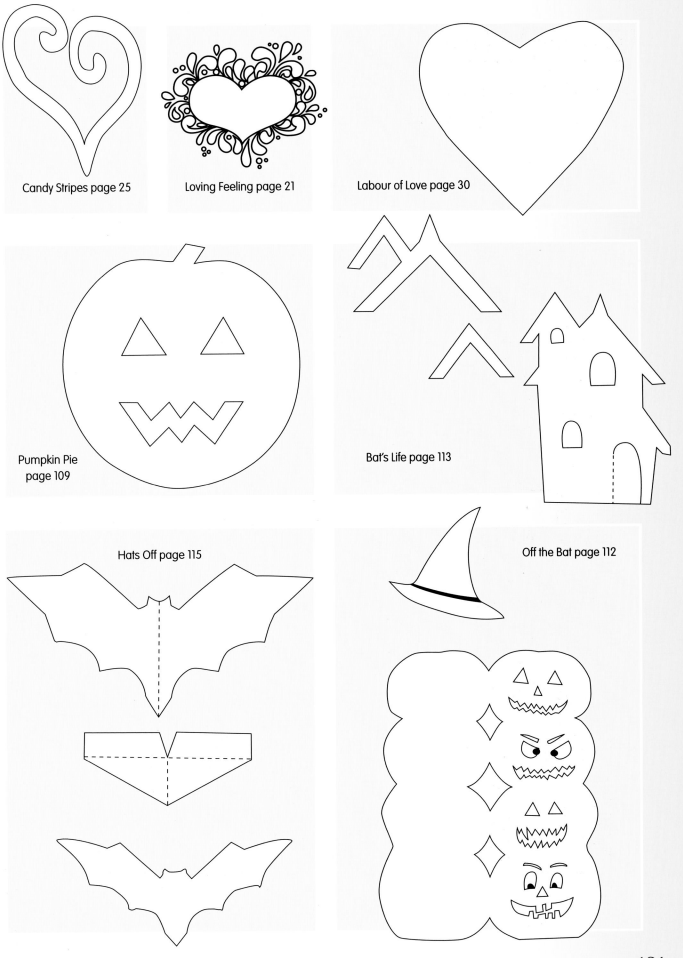

Candy Stripes page 25

Loving Feeling page 21

Labour of Love page 30

Pumpkin Pie
page 109

Bat's Life page 113

Hats Off page 115

Off the Bat page 112

Suppliers

Fan Out (p.15) Basic Grey backing papers and Infuse paper pad, www.charmedcardsandcrafts.co.uk papers, www.kars.biz

Bowled Over (p.16) backing papers, www.kars.biz

Pocket Money (p.17) oriental papers, www.allaboutcrafts.co.uk, 01782 396 847; oriental coins, www.cardsandcraft.co.uk

Some Like it Hot (p.18) KI Memories Fire Word Whispers papers, www.purplecow.com

From the Heart (p.19) silver jewellery, www.hobbycraft.co.uk

Flower Power (p.20) mesh heart embellishments, www.cardmakingcrafts.co.uk

Loving Feeling (p.21) Pebeo paints, www.purplenimbus.com 02380 901 914

Be Mine (p.22), All Hearts! (p.23) Im-packs background images, CD-Rom Set 1, Letraset, www.letraset.com

Heart to Heart (p.24), Candy Stripes (p.25) X-cut punch, small folk heart, www.therange.co.uk, 0845 678 9798; Anita's acrylic paints, www.hobbycraft.co.uk, 0800 027 2387, red ceramic folk heart button, www.buttonmad.com, 01832 274 881

Sweet Nothings (p. 26) Basic Grey papers, Making Memories pewter love charms, www.stampeezee.co.uk

With Love (p.27) decorative paper and 3-D foam pads, www.hobbycraft.co.uk, 0800 027 2387

Crafty Tipple (p.28) inks, stamps and memory glass, www.thestampbug.co.uk, 01285 750 308

Beautiful Angel (p.29) foam and patterned papers, www.hobbycraft.co.uk, 0800 027 2387,

Labour of Love (p.30), stranded embroidery thread, www.dmccreative.com

Think Pink (p.31) foam and embellishments, www.hobbycraft.co.uk, 0800 027 2387,

Layered Hearts (p.32) patterned papers, embellishments and card, www.madaboutcards.com

Silver Lining (p.33) heart splash stamp, www.urstruly.co.uk, 01787 319 612; Pebeo paints, www.purplenimbus.com, 02380 901 914

Green with Envy (p.34) Mellow Yellow (p.35) heart embellishments, patterned papers and card, Card Making Crafts, www.cardmakingcrafts.co.uk

Romantic Intentions (p.36) stamps, www.sforstamps.co.uk, 01355 570 999

Blind Date (p.37) Basic Grey papers, lettering and pewter letters, www.stampeezee.co.uk, 024 7659 1901,

Daisy Days (p.38) scrapbook paper by Sandylion, www.calicocrafts.co.uk; pearl flowers, www.rayher-hobby.de

Emerald Island (p.39) Tsukineko pen, www.craftycritters.com

Spring Green Shamrock (p.40) circle shape cutter, www.fiskars.com

Green Day (p.41) craft punch, www.handyhippo.co.uk

Dairy Queen (p.42) Hole Story (p.43) papers, www.craftcentral.ws; transfer lettering, www.letraset.com

Bunny Show (p.44) hammer card, Woodware and Carlcraft punches, www.stampeezee.co.uk

Shelling Out (p.45) stamp, www.heroarts.com; papers, www.thecardfairy.co.uk

Cafe Culture (p.46) papers, SE1 Kitty's Place, www.therange.co.uk

Lucky Stripe (p.47) Custom-made Happy Easter stamp, www.sforstamps.co.uk; papers, www.thecardfairy.co.uk

Chic Chics (p.48) ribbon and Basic Grey Lily Kate bamboo card, www.stampeezee.co.uk., 02476 591 901; Fiskars Shape Cutter Plus, www.fiskars.com

Animal Farm (p.49) aperture cards, www.craftcreations.co.uk

Good Eggs (p.50) Inkadinkadoo Bohemian Flourishes stamps, www.scrapshed.co.uk; Making Memories Circus Meadow rub-on booklet, www.scrapbookcentral.co.uk

Lime Lights (p.51) Sassafras patterned paper, Less Scrumptious, www.jillybeansscrapyard.co.uk

Pot Luck (p.52) Desire memory thread, www.sewandso.co.uk

Cutie Pie (p.53) duckling stamp, www.happystampers.co.uk; fuchsia crystals, www.craftworkcards.co.uk

Free Range (p.54) thread and aida, www.dmccreative.co.uk

Citrus Chic (p.55) bunny window stamp, Stampendous, www.thestampman.co.uk; border stickers and Savvy Monochromatic card, Creative Pastimes, 0188 373 0033

Top Spot (p.64) card, www.inspiremepapers.co.uk, 0845 120 0155; Amercian Traditional Designs papers, www.craftaway.co.uk, 01527 545 122; Doodlebug paper frills, www.craftsulove.co.uk

Just to Say (p.65) Fancy Pants paper, www.paperarts.co.uk, 01453 886 938,

Happy Snapper (p.66) Papermania products, www.therange.co.uk; K&Co Wild Saffron range, www.charmedcardandcrafts.co.uk

Mother's Pride (p.67) Hello Petal (p.68) materials, www.thepapermillshop.co.uk, 01539 564 951

Candy Colours (p.69) Sassafras Less Scrumptious patterned papers, www.jillybeanscrapyard.co.uk

Girl Power (p.70) Daisy Dots stamps, www.sharonbennettstamps.co.uk; Peeo Touch paint, The Range, 01752 725 572; Letraset ProMarker in blossom pink, www.letraset.com

Bloomin' Marellous (p.71) papers and mummy-to-be images and sentiments, www.pinkpetticoat.co.uk, 0114 273 7768; scalloped punches, www.art-of-craft.co.uk, 01252 377 677

Rainbow Brights (p.72) scrapbooking papers, Dena's Closet Retro Collection All Occasion paper book, www.stampeezee.co.uk

Buckle Up (p.73) Basic Grey decorative words and Infuse paper collection, www.scrapydos.co.uk; Making Memories pink velvet ribbon and buckle, www.therange.co.uk

Green Shoots (p.74) Efco mini garden implements and ladybird embellishment, www.sinotex.co.uk/efco

Green Fingers (p.75) laser-cut sheets, www.rayher-hobby.de; quilling papers, www.jjquillling.co.uk, 01482 843 721

Best Man (p.76) It's a Man's World (p.79) Seabreeze paper and eyelets, Doodlebug stockists

Lacey Days (p.77) Letraset rub-down transfer lettering, www.letraset.com/craft, 01233 624 421; Pebeo paint, www.pebeo.com; Lacé template, www.kars.nl

Number One (p.78) Bandai badge-maker, www.bandai.co.uk; Letraset rub-down lettering, www.letraset.com/craft, 01233 624 421; star paper, www.americancrafts.com

Zig & Zag (p.80) Sizzix machine and dies, www.sizzix.co.uk; punches, www.paperworkscardcraft.co.uk, 01527 852 052

Stars & Stripes (p.83) K&Co glitter paper, www.charmedcardsandcrafts.co.uk

God Bless America (p.84) punches, www.paperworkscardcraft.co.uk, 01527 852 052

Ace of Spades (p.94) garden miniatures, www.calicocrafts.co.uk, 01353 624 100,

Twirls & Swirls (p.95) K&Co backing papers, www.charmedcardandcrafts.co.uk; epoxy stickers, www.papermaze.co.uk

Pastel Perfect (p.96) Ally's Wonderland backing paper and epoxy sticker, www.willowtreecrafts.co.uk, 01923 678 363

Bed of Roses (p.97) paper roses, www.craftcreations.co.uk, 01992 781 900,

Shining Star (p.99) Trend Line backing paper, www.kars.biz

Flying High (p.100) Quickutz die, www.craftsulove.co.uk, 01293 863 576

Roll Up (p.101) DCWV paper stack, www.jillcraft.co.uk; cylinder beads, www.kars.biz

Web Watch (p.102) Funny Bones (p.103) Sizzix machine and dies, www.sizzix.co.uk; Liquid Pearls, www.stampin.com; Hero Arts stamp, www.heroarts.com

Ghostly Treat (p.108) Ally's Wonderland Rhubarb Pie striped backing paper, www.willowtreecrafts.co.uk, 01923 678 363; goggle eyes, www.debscardsncrafts.co.uk

Pumpkin Pie (p.109) glitter paper, www.craftpaperandcard.co.uk, 0113 293 6589

Creepy Crawley (p.110) goggle eyes, www.debscardsncrafts.co.uk

Hat Trick (p.111) Sizzix machine

and die-cuts, www.sizzix.co.uk, Hero Arts stamp, www.heroarts.com

Off the Bat (p.112) Cricut, www.clickoncrafts.co.uk

Bat's Life (p.113) rub-down lettering, www.letraset.com/craft, 01233 624 421; Jane Jenkins quilling papers, www.jjquilling.co.uk 01482 843 721

Trick or Treat (p.114) Sizzix machine and dies, www.sizzix.co.uk

Hats Off (p.115) card blank, www.craftcreations.co.uk 01992 781 900

Festival of Light (p116) 7gypsies paisley scrapbook paper, www.7gypsies.com

Eastern Delight (p.117) Studio Light scrapbook paper, www.studiolightcrafts.co.uk

Light Touch (p.118) Bright Spark (p.119) Party Time (p.137) glass paints, www.marabu.com; Lefranc & Bourgeois imitation lead outliner supplied by Oasis Art and Craft Products Ltd., 01562 744 522

It's Thanksgiving (p.128) My Many Blessings (p.129) all materials from HOTP stockists

Sew Cool (p.130) Make an Impression (p.131) all materials, www.stampinup.com

Nature's Bounty (p.132) metal roses and pearl flowers, www.rayher-hobby.de

Give Thanks (p.134) Basic Grey papers and other materials from general craft stores

Glass Act (p.136) colour melt crystals , www.homecrafts.co.uk

First Noel (p.140) Basic Grey papers, www.paperworksandcraft.co.uk

Wing Man (p.141) Basic Grey Dasher collection, Partridge in a Pear Tree, www.charmedcardsandcrafts.co.uk, 020 8659 0737; Blade Rubber stamps, www.bladerubberstamps.co.uk, 020 7831 4123

Crowning Glory (p.140) Francoise Collection peel-offs and Sakura gelly glaze roll pens, www.craftbarnonline.co.uk , 01342 836 097; shape embossing board, www.art-of-craft.co.uk, 01252 377 677

Present Day (p.141) silver-plated beads, chandeliers and Swarovski crystals, www.thesilvercorporation.co.uk

Think Pink (p.142) Paper Cellar sparkly snowflake stickers, www.papercellar.com, 0871 871 371; large stickers, Papermania, www.docrafts.co.uk; embossing pen and powder, www.clarkcraft.co.uk, 0800 037 1420

Feeling Festive (p.143) Rubber Soul 'happy Christmas' stamp, www.bladerubberstamps.co.uk, 020 7831 4123; Creative Imaginations Jolly Dot and Jolly Stripe papers, www.itsonceuponatime.co.uk, 01793 759 280

Blooming Merry (p.144) chipboard letters, www.craftworkcards.co.uk, 0113 276 5713; Cuttlebug machine, www.sirstampalot.co.uk

Perfect Presents (p.145) Creative Imaginations papers, Ellison dies and Dovecraft stamps, www.crabapplecrafts.co.uk, 01928 787 797; Aunty Sarah's Bloomers and American Craft brads, www.sarahscardsltd.co.uk, 01925 244 0460

Santa Baby (p.146) Creative Imaginations Jolly Dot paper, www.itsonceuponatime.co.uk , 01793 759 280; Kate &Co Santa stamp, www.charmedcardsandcrafts.co.uk, 020 8659 0737

Dotty Joy (p.147) Creative Imaginations papers, Ellison dies and Dovecraft stamps, www.crabapplecrafts.co.uk, 01928 787 797; Aunty Sarah's Bloomers and American Craft brads, www.sarahscardsltd.co.uk, 01925 244 0460,

Trim Time (p.148) felts and threads from www.art2craft.co.uk, 01424 715 701

Beautiful buttons (p.149) colour-themed button packs from www.buttoncompany.co.uk, 01243 775 462

Tis The Season (p.150) Maya Road Foundations chipboard letters, www.clickoncrafts.co.uk; American Crafts Christmas papers, www.scrapmagic.co.uk

Festive Flower (p.151) sugar-coated card, www.craftsulove.co.uk

Tall Order (p.152) Tree's a Charm (p.153) Papermania embellishnments and DoCraft snowflakes, www.docrafts.co.uk

Festive Frills (p.154), hi-tack narrow double-sided tape, www.impexcreativecrafts.co.uk, 0208 900 0999

Pink and Perky (p.155) Basic Grey Sophie paper collection, Uptown Crafts, www.mailordercrafts.co.uk, 01524 388 609; Hero Art Share the Spirit stamp, www.thestampbug.co.uk, 01285 750 308

Happy Hubby (p.156) Basic Grey Jack Frost paper and Blitzen letters, www.charmedcardsandcrafts.co.uk, 020 8659 0737

Super Cool (p.157) Glue Dots Magic Motifs, Santa and Reindeer, Funky Christmas words and Magic Dust, www.gluedotsuk.co.uk, 01535 616 290

Pretty Petals (p.158) Ski Bunny paper, www.bananafrog.co.uk; Scrap Sally word sheet, www.paperworkscardcraft.co.uk

Green Day (p.159) Starform Happy Christmas peel-offs, www.art-of-craft.co.uk, 01252 377 677; papers, www.memorycreations.co.uk, 0871 504 6151

Funky Flakes (p.160) Efco snowflake, Sinotex, 01737 245 450, www.sinotex.co.uk

CoolYule (p.161) Fun Stamps Holly Santa, www.itsonceuponatime.co.uk , 01793 759 280; Doodlebug sugar-coated card, www.creativemaking.co.uk, 0870 042 4096

Snow Party (p.162) Cuddle Up (p.163) Penny Black stamps and Pebbles papers from www.happystampers.co.uk, 01383 822 902, Doodlebug sugar-coated card, www.creativemaking.co.uk

Big Freeze (p.164) DCWV printed paper, www.trimcraft.co.uk; goggle eyes, www.handyhippo.co.uk, 01753 539 222

Twinkle Star (p.165) sugar- coated card, www.craftsulove.co.uk; Twinkling H2Os, www.sirstampalot.co.uk

Christmas Lights (p.166) Fun Stamps Holly Santa, www.itsonceuponatime.co.uk, 01793 759 280; Doodlebug sugar-coated card, www.creativemaking.co.uk, 0870 042 4069

Good Wreath (p.167) The cutting edge card blanks, www.eco-craft.co.uk, 01257 792025; Anchor gold thread, www.coatscrafts.co.uk, 01325 394 237; gold bow,

www.cardmakingcrafts.co.uk

Jingle Bells (p.168) mini metallic bells, www.bakerross.co.uk, 0870 458 5440

Jump for Joy (p.169) Basic Grey Fruitcake collection, www.atripdownmemorylane.co. uk, 01787 210 282; Holiday paper, www.papersalon.com; die-cuts, www.kardzkraftznkutz. co.uk, 01262 672 696

Mono Magic (p.170) papers, www.docrafts.co.uk

Midnight Hour (p.171) American Crafts,www.liz-craft.co.uk, 01782 751 700

Full Bloom (p.172) Amy Butler Full Bloom Duck Egg/French wallpaper fabric, www.quitthome.com/AmyButler; Anna Griffin pink graphic paper, www.craftsulove.co.uk; Woodware daisy punch and flower sequins, www.melflowers.co.uk

Party People (p.173) Decorative papers, www.trimcraft.co.uk

Index